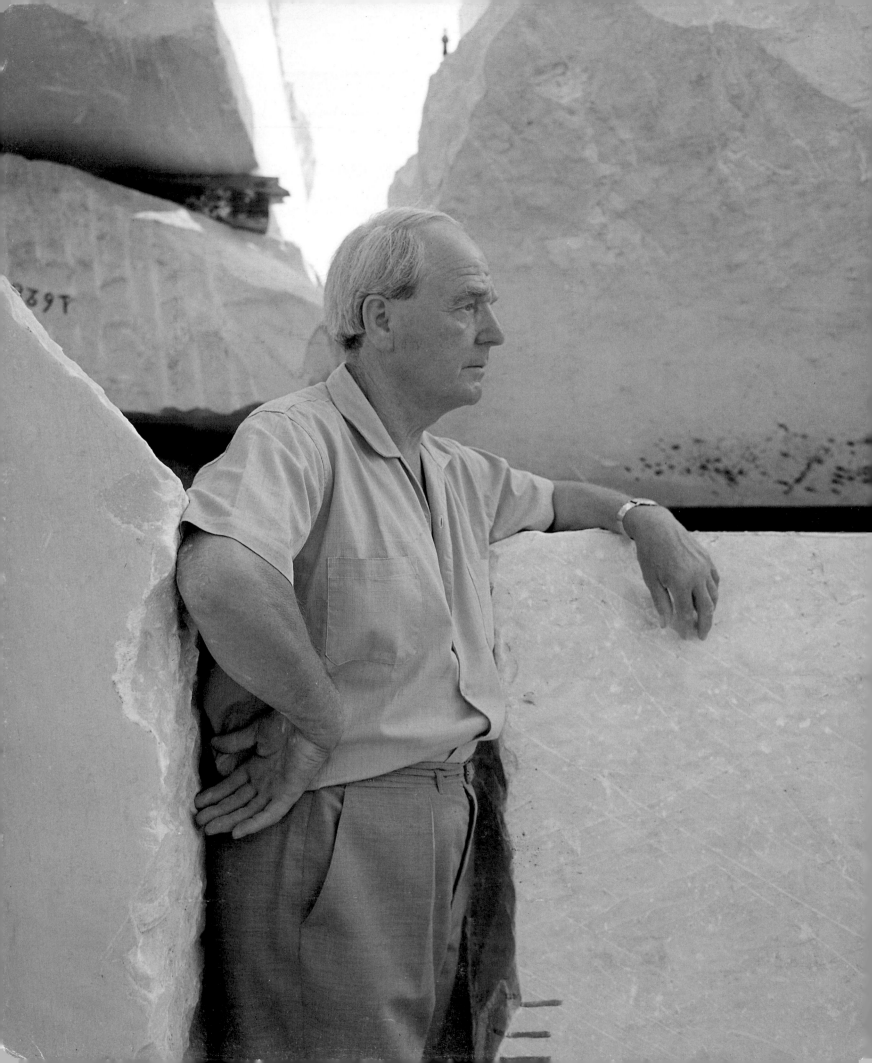

HENRY MOORE:
The Human Dimension

HMF Enterprises Limited
in association with The British Council

Contents

Copyright © The Henry Moore Foundation
1991
Introduction and captions copyright
© Norbert Lynton 1991

First published in Russian by the British
Council 1991

English edition published by
HMF Enterprises Ltd for the Henry Moore
Foundation in association with the British
Council 1991

Distributed to the booktrade worldwide by
Lund Humphries Publishers Ltd
16 Pembridge Road, London W11 3HL

ISBN 0 85331 610 4

British Library Cataloguing in Publication
data is available.

Compiled by Ann Elliott and
David Mitchinson
Designed by Tim Harvey
Edited by Angela Dyer
Russian text edited by I. E. Danilova
English translation by Felicity Cave
and Rachel Gomme

Printed in Great Britain by
The White Dove Press

Frontispiece: Henry Moore in the marble
quarry at Querceta, in the Carrara mountains
of northern Italy.

PREFACE

by Henry Meyric Hughes
HEAD OF VISUAL ARTS, BRITISH COUNCIL, LONDON

Henry Moore never visited the Soviet Union, but he had long been interested in exhibiting there – this idea went back at least as far as the 1960s – and we are delighted at last to have been given the opportunity of sharing his work with audiences in Leningrad and Moscow.

It is a great privilege for the British Council to collaborate for the first time with the Benois Museum at Petrodvorets, and to work once again with the State Pushkin Museum of Fine Art in Moscow. The showing in Moscow of Britain's most renowned sculptor of the twentieth century fits perfectly into the Pushkin Museum's current series of monographic exhibitions of work by Modern European Masters.

The intimate scale of the rooms in the Benois Museum and the exquisite proportions of the white marble hall at the Pushkin gave us the idea of putting together an exhibition of Moore's smaller-scale work, the carvings and maquettes which were closest to his hand. We also decided to focus on Moore's humanity and trace his love of the human form and its relationship with nature and the landscape.

Presenting an exhibition of this nature always involves large numbers of people, many of whom are named elsewhere in the catalogue. However, I should most especially like to thank the following for their help with the realisation of the project: Mme Irina Antonova and her staff at the State Pushkin Museum, particularly Alla Butrova, Inna Orn, Irina Kokkinaki and Sergei Kuskov; and Dr Vadim Znamenov, Director of the State Museum Reserve at Petrodvorets and his colleagues; Nina Vernova and Nikita Vasiliev. With all these colleagues, old and new, we have enjoyed a close and warm working relationship. Particular mention should be made of the advice received from Dr Irina Danilova in selecting the work for the exhibition, and in persuading us to increase the number of Shelter Drawings, which she deemed to be of particular interest to the Soviet public.

The essays by Irina Kokkinaki and Sergei Kuskov provide an interesting counterpart to the informative account by Professor Norbert Lynton, and we hope that these first studies of Moore's work in the Russian language, and now in this English edition, will reach as wide a public as possible.

I should like to extend warm thanks to those who have provided us with loans and various forms of assistance. Sir Alan Bowness, David Mitchinson and their supporting staff at the Henry Moore Foundation have been unfailingly helpful; without the continuing generosity of the Henry Moore Foundation, its financial support and the many loans from their collection, this exhibition would not have been possible. The Tate Gallery has lent us a number of important works, and these are listed in the catalogue along with the generous loans from other public and private collections.

Finally, I should like to thank my British Council colleagues both in the British Embassy in Moscow and here in London. Terry Sandell, the Cultural Counsellor, and Penny Steer, Cultural Attaché, ably assisted by Lena Skorokhodova, have liaised between us and our Soviet partners; Ann Elliott and Richard Riley in this department have devoted their time, energy and enthusiasm to organising the exhibition and coordinating arrangements at the London end.

During his lifetime Henry Moore came to be regarded as something of an ambassador for British art and for a humane, yet questioning view of the world. Since his death in 1986 the fame of his work has continued to grow. The British Council has been associated with exhibitions of his work from the time of his triumph at the 1948 Venice Biennale onwards, throughout the Americas, Europe and the Far and Middle East. We are happy and proud to have this opportunity of introducing his work to a wide public in the Soviet Union.

PREFACE

by V. V. Znamenov
DIRECTOR OF THE STATE MUSEUM-PARK, PETRODVORETS

The State Museum-Park in Petrodvorets is honoured to welcome visitors to the exhibition of one of the greatest artists of the twentieth century, Henry Moore.

The harmonious unity of nature and decorative art at Peterhof provides a fitting background for the work of the English sculptor. At the same time this exhibition is the logical outcome of the ancient traditional links between Peterhof, England and English culture.

Peter the Great commissioned the casting of the lead sculpture for the original decoration of the main fountain of the imperial residence – the Grand Cascade – from England, and it was he who ordered that the main hall of his favourite palace Mon Plaisir should be decorated in 'English' style. 'English' paths were laid in the lower park during the reign of Catherine II, and the building of New Peterhof, initiated by her, was marked by the landscaping of the English park and the erection in the beginning of the 1780s of the English palace, the masterpiece of the architect G. Quarenghi. The Peterhof palaces were filled with the works of English painters and masters of decorative and applied art. In the Grand Palace it is still possible to see the vast 'Etruria' dinner service, from the mass of the so-called royal work from the Wedgwood factory. The famous 'Green Frog' service was also kept at Peterhof for a long time. In the second half of the nineteenth century the English architect A. Menelas created the Alexandria park and added to the decoration of Peterhof numerous constructions in the Gothic style. This was in keeping with the taste of the Emperor Nicholas I, who had visited England many times and for whom the 'Cottage' palace was built along the lines of the English villas which were fashionable at the time. The royal yacht *Queen Victoria* rocked on the waves of the Baltic Sea, when she berthed at the quay of Alexandria. The works of Byron and Thomas More were kept in the palace library and the owner of the 'Cottage' and his family never tired of reading the novels of Sir Walter Scott. The later monuments of Peterhof are also evidence of respect for English culture. Several magnificent buildings were built to the design of N.L. Benois in his beloved English Gothic style.

The Benois family museum is dedicated to the idea of the openness of Russian culture and its close links with Western European countries. The museum houses the work of members of the Benois dynasty which gave the world a pleiad of distinguished figures in the world of art, including Sir Peter Ustinov who took part in the creation and the opening of this museum.

It can be said with certainty that the work of Henry Moore will leave no one untouched and will bring great pleasure to art lovers. The exhibition will be an outstanding event in the cultural life of our country. I should like to express a special debt of gratitude to the British Council, the Henry Moore Foundation and all those who have helped in this very worthy cause.

PREFACE

by Irina Antonova
DIRECTOR OF THE STATE PUSHKIN MUSEUM OF FINE ART,
MOSCOW

It is with great satisfaction that the State Pushkin
Museum of Fine Art is exhibiting the works of Henry
Moore, the outstanding sculptor of the twentieth
century whose work has had a considerable influence
on the art of sculpture in our century, but is as yet little
known to the Soviet Public.

At the Museum we consider part of our task should
be introducing our visitors to the works of the leading
figures in the world of twentieth-century Western art
who are not represented in our art collections. The exhi-
bition of the legacy of Moore could become a reference
point in the process of familiarisation with modern
sculpture. At the same time Moore's world is original,
integral and a very personal artistic world, and in this he
is no less interesting than in his role as exponent of the
general sculptural tendencies of his time. Particularly
significant and valuable is the extensive inclusion in the
exhibition of the artist's graphic works which, to some
extent, stand on their own in his creative output.

The exhibition is without doubt topical and will
provoke great interest, both in the general public, who
will discover another twentieth-century classic, and in
progressive artistic circles for whom Moore has long
since been the embodiment of the contemporary quest
in sculpture.

The Moore legacy is important for the interpretation
of the interaction of tradition and innovation in contem-
porary art. In responding to the avant-garde of his time
Moore also discovers links with the deepest roots of
culture and with ancient monumental art. He enables
us to understand anew the role of tradition, a tradition
organically linked with the unceasing creative experi-
ment of the artist's quest which is of great significance
for the aesthetic education of new artistic generations.

We are grateful to the British Council and the Henry
Moore Foundation for making this exhibition possible
and for such a generous and lovingly selected exhibition.

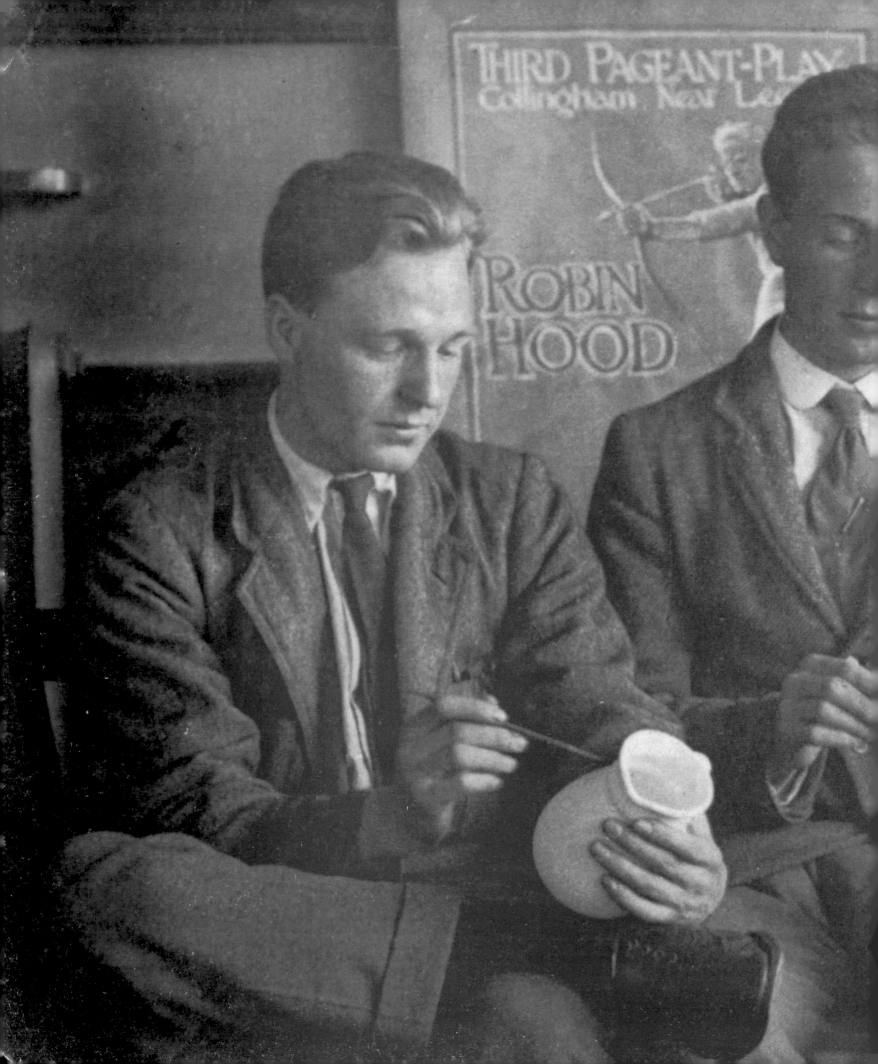

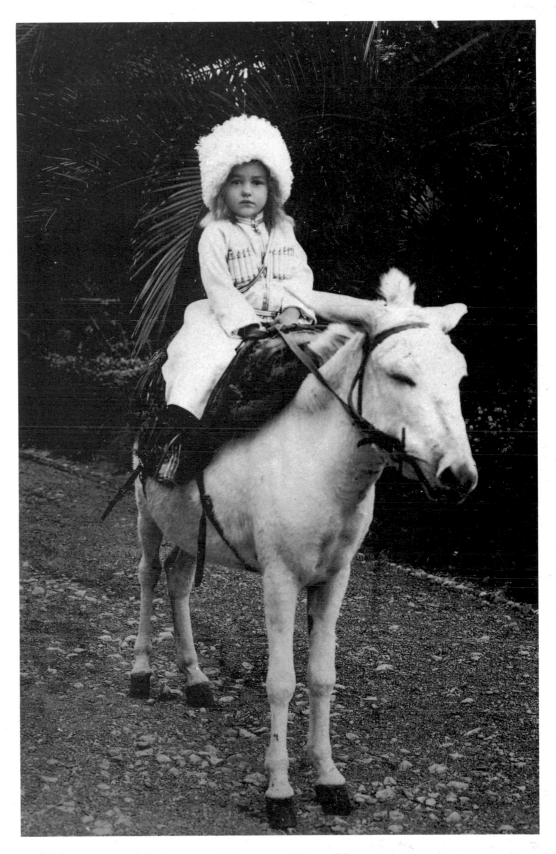

Above: Irina Radetsky, aged six, in the Caucasus Mountains. Born in Kiev in 1907, she lived in Moscow and St Petersburg before leaving Russia for Paris in 1919.

Henry Moore (left) with his schoolfriend Raymond Coxon at the pottery class, Castleford Grammar School, c.1919. The marble carving **Head of the Virgin** 1922 (cat.2) was given to Coxon as a wedding present in 1926 and bought back by the Foundation in 1988.

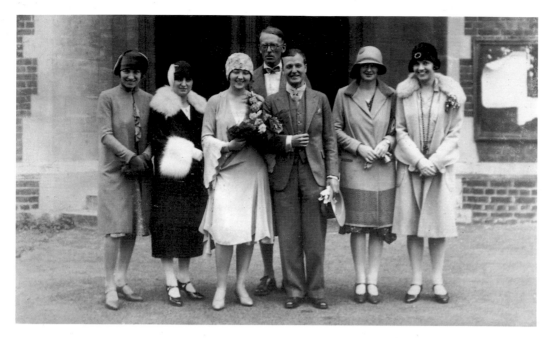

Left: The marriage of Henry Moore and Irina Radetsky in London, July 1929.

Opposite: Henry Moore in 1944 photographed by Lee Miller at a London Underground station during the filming of *Out of Chaos*; the scene re-created the conditions experienced in the wartime blitz.

Below: Henry and Irina at their first home in Hampstead, where Moore also had a studio.

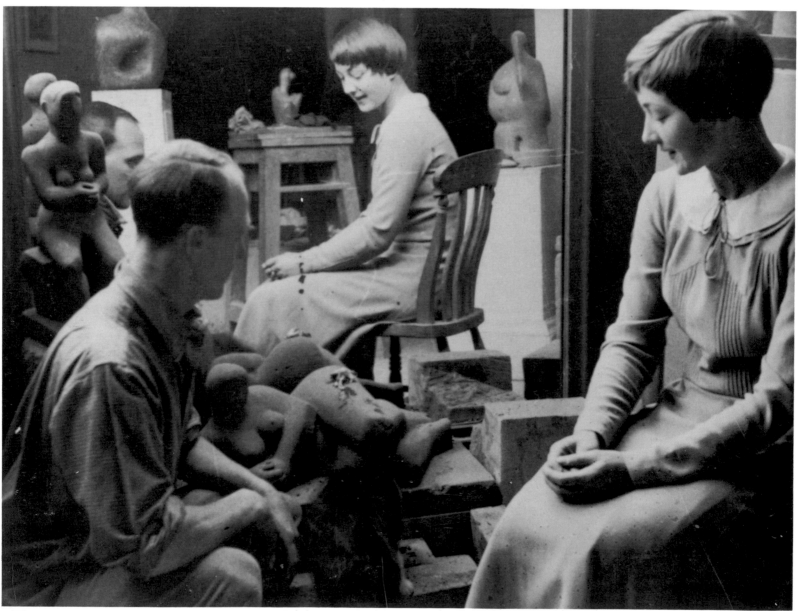

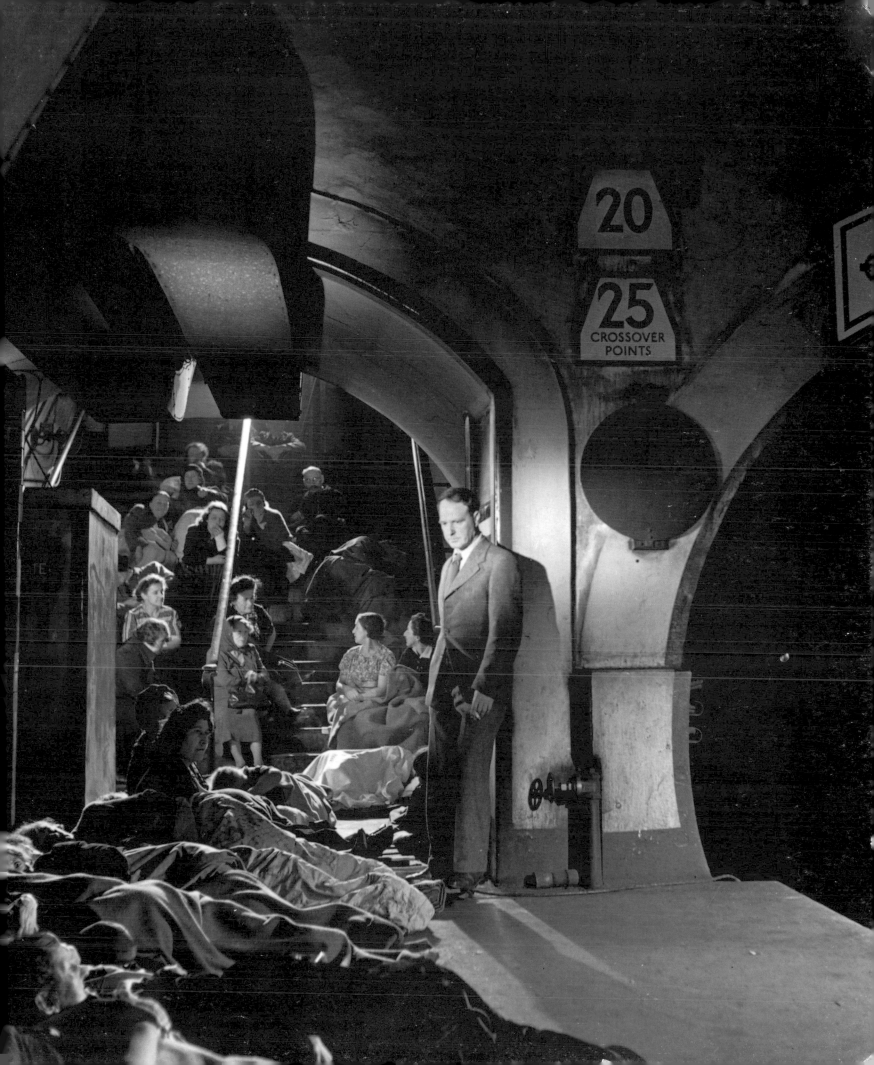

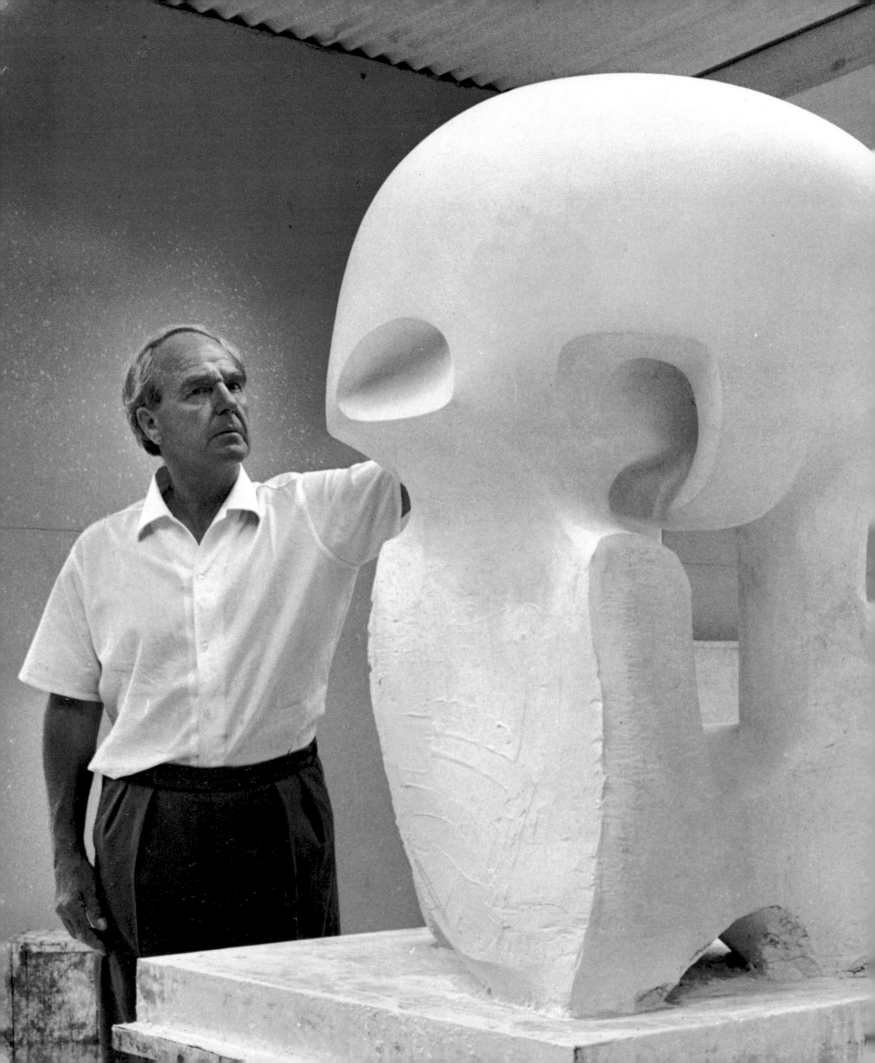

Left: The artist in his studio at Perry Green with the plaster for **Atom Piece (Working Model for Nuclear Energy)** 1964–65 (see cat.92).

Overleaf: A corner of Moore's maquette studio at Perry Green showing a selection of plasters and found objects.

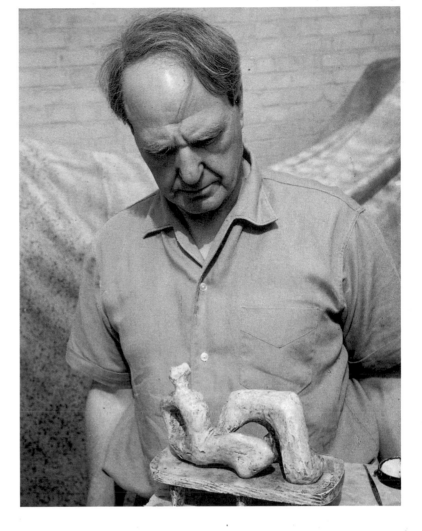

Right: Henry Moore with the plaster **Maquette for Unesco Reclining Figure** 1956 (see cat.76).

Below left: Henry Moore with Marc Chagall at the Rembrandt Tercentenary celebrations in Amsterdam, 1956.

Below right: Henry Moore working in the old maquette studio at Perry Green, 1963. Note **Composition** 1931 (see cat.26) behind the artist.

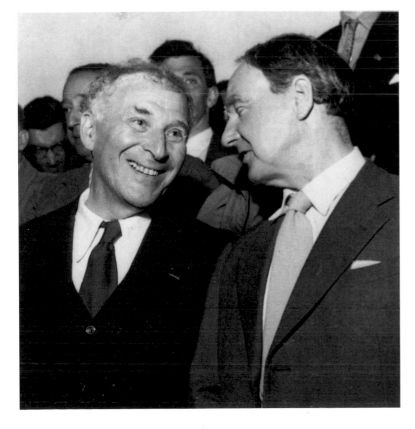

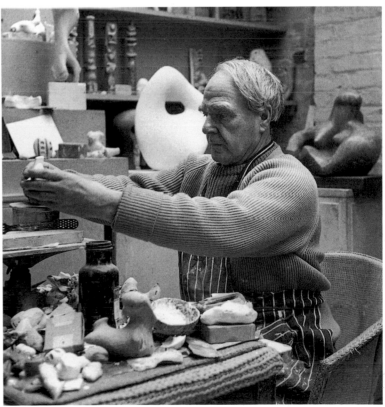

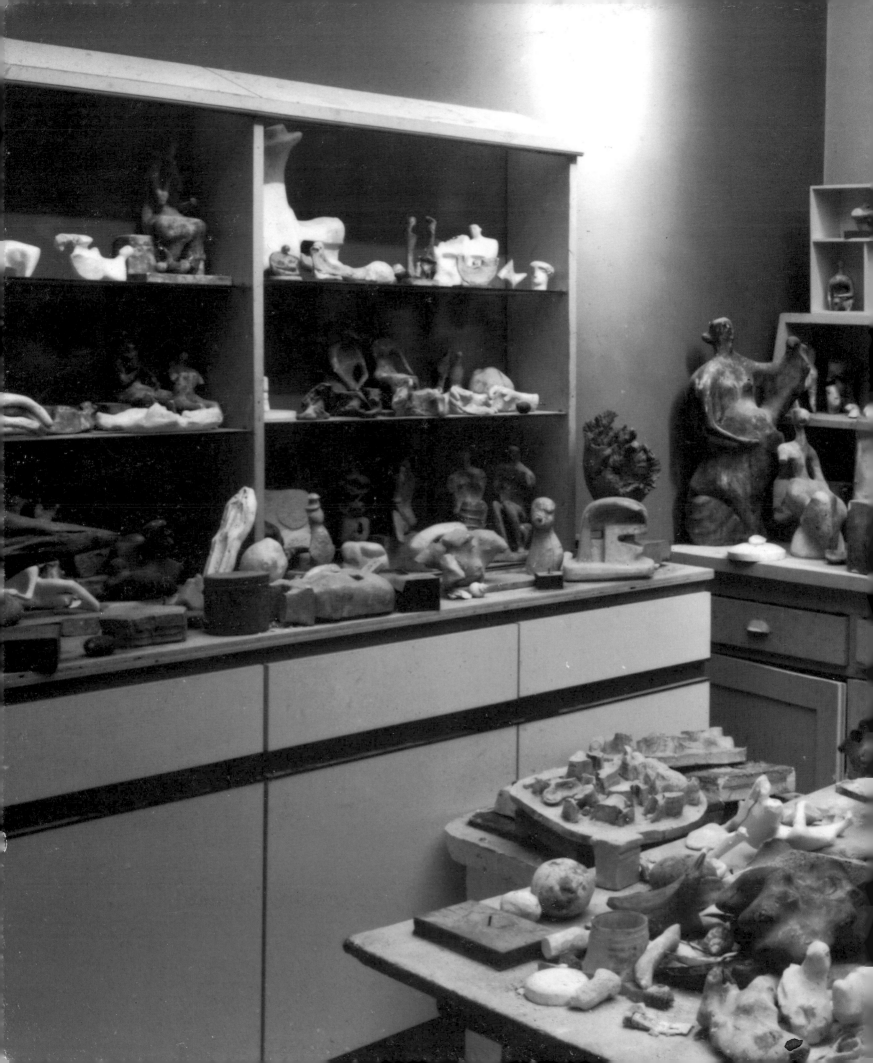

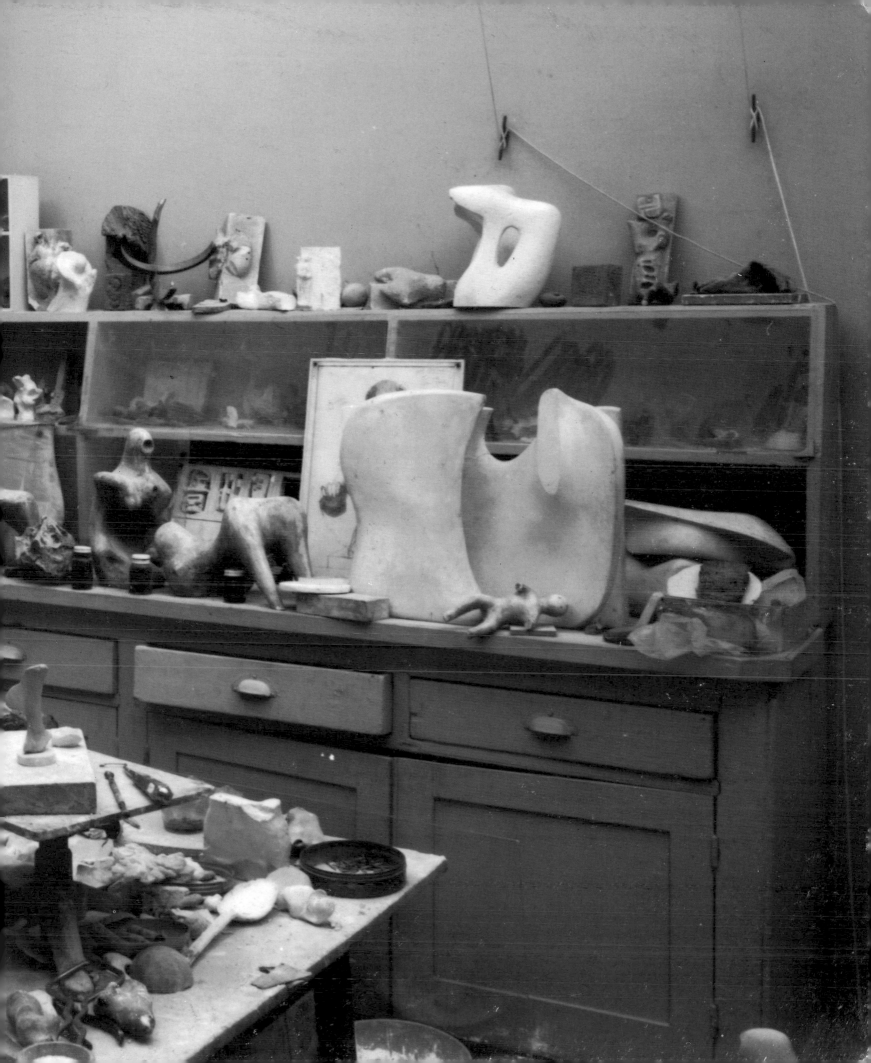

Opposite: Henry Moore with **Family Group** 1948–49 (cat.60) in the courtyard of the Museum of Modern Art, New York, in 1965.

Below: A break for lunch at the Henry Moore Foundation during negotiations for the Russian exhibition: Sir Alan Bowness talks to Nina Vernova, Chief Curator from the State Museum Reserve at Petrodvorets, with Alla Butrova, head of the Foreign Relations and Exhibitions Department at the State Pushkin Museum of Fine Art in Moscow, and her colleague Irina Kokkinaki, and John Farnham and Malcolm Woodward, two of the Foundation's sculpture assistants.

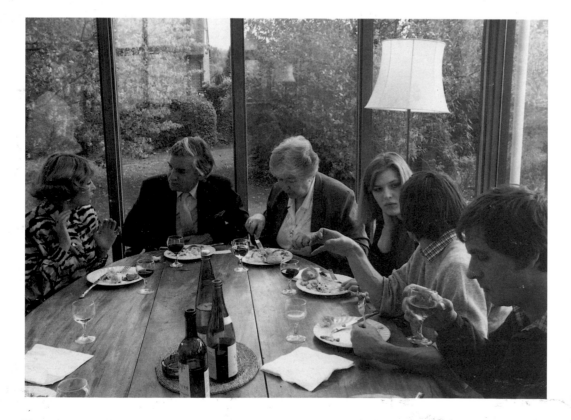

Overleaf: Henry Moore at his home, Hoglands, Perry Green, Hertfordshire, in the early 1950s.

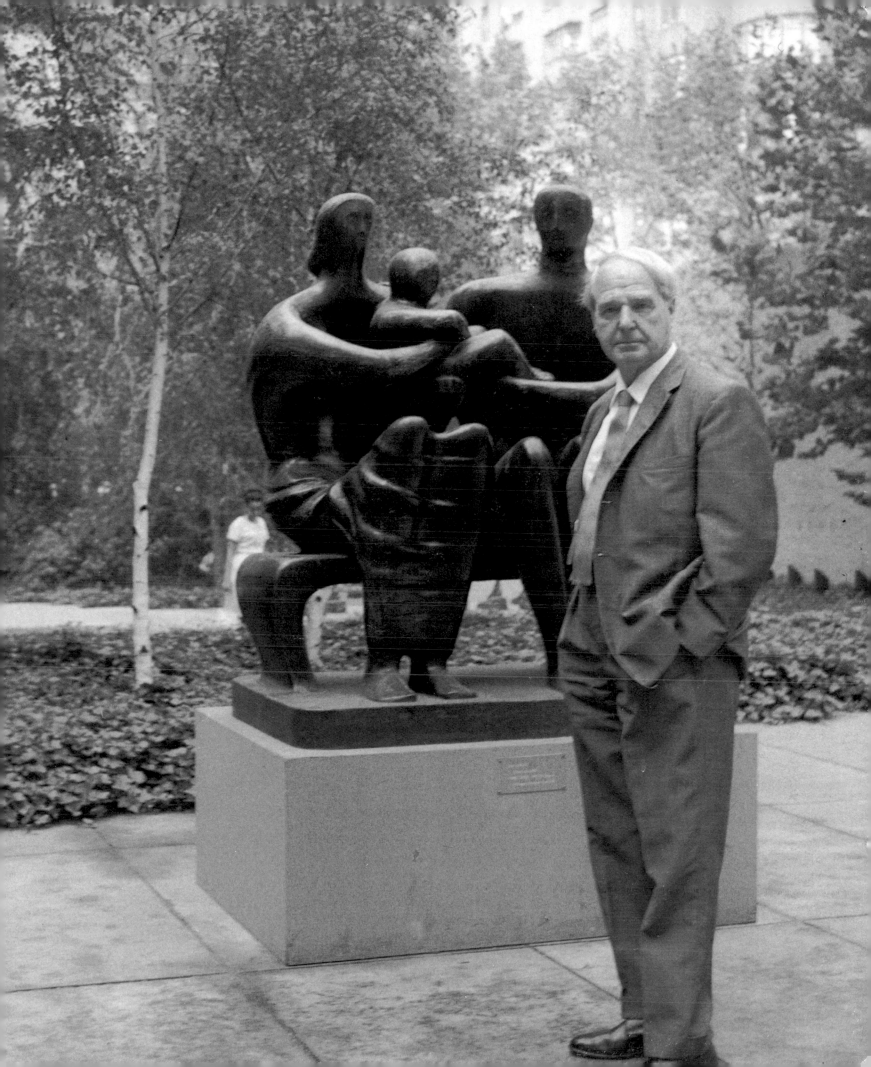

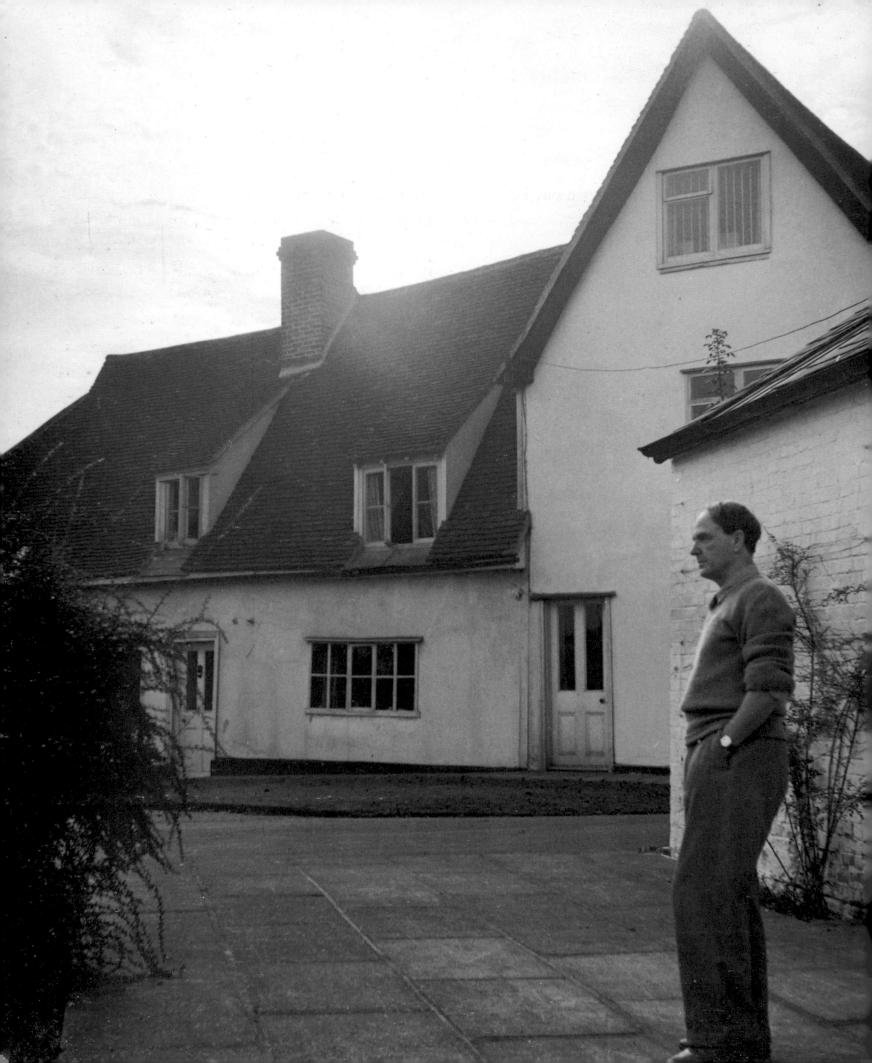

The Humanity of Moore

by Norbert Lynton

'Man himself is mute; it is the image that speaks.'
BORIS PASTERNAK

'Keep ever prominent the world of tradition – the big view of sculpture.'
HENRY MOORE

Modernism – the avant-garde art produced by those who challenged tradition in the first decades of this century – is often represented as inimical to normal human considerations. This view of it was expounded most tellingly by the Spanish philosopher Ortega y Gasset. In *The Dehumanization of Art* (1925) he argues that modern art's essential characteristic is the search for purity at the expense of humanity. It is 'an artistic art', unpopular, elitist, alien. It refuses to involve people 'in human destinies'. It manifests a 'loathing of human forms'. Moreover, it is 'stripped of all spiritual content . . . it does not have grave importance'. Yet he confirms that artists cannot usefully go back in art. The new path will be found.

Nineteenth-century art, Ortega says, spoke to a widening public through realism and habituated us to this realism as art's norm. Yet this is itself a monstrosity: 'the works of art of the nineteenth century, far from representing a normal art, are perhaps the greatest anomaly in the history of taste . . . an aberration without parallel in the evolution of aesthetics'. Dehumanisation is thus a corrective, an extreme reaction to what it refutes.

Anyone considering the question of modern art and humanity has to face Ortega's analysis, first seen as an attack on modern art and then as a kind of justification for it. He was not of course alone in being troubled by the general loss of traditional beauties and themes, of fine figures, convincing scenes staged by means of light and perspective, of agreeable or dramatic landscapes, noble or amusing stories, generally of an art that comforts when it does not positively uplift. He voiced his world's doubts in the face of the claims made for modern art, and gave them philosophical validation.

Tolstoy's *What Is Art?* (1890) was a major stimulus to Ortega. We hear Tolstoy's voice in some of Ortega's sentences; moreover the Russian's thought underlies that of the Spaniard even though their conclusions differ. Tolstoy's message is that art lost touch with humanity when it became humanist in the Renaissance, addressed itself to an educated public and turned away from, or treated in obscure ways, religious themes that should be common property. It became inaccessible in economic as well as aesthetic terms. 'Art is a human activity consisting in this, that one man consciously by means of certain external signs, hands on to others feelings he has lived through, and that others are infected by these feelings and also experience them': that is Tolstoy's position. Art that cannot connect human beings by speaking of shared aspirations does not deserve the name of art. It is counterfeit art. Real art bonds mankind. Modern art, say both Tolstoy and Ortega in similar ways, gives priority to factors remote from this humanity, dividing mankind into those who cannot understand it and those who say they can.

Tolstoy demanded realism. He despised the

Symbolism that had become prominent in Western Europe and was making its seductive impact on Russia. He gave his support to the wide-ranging realism of the Russian Wanderers gaining ground since the 1870s as a radical alternative to the art of the academies. This realism was of Western origin but devoted itself pointedly to Russian and Slav subjects and was thus (as Lenin too found) the right art for Russia's vast public.

Did Henry Moore read Tolstoy on art? He certainly read the novelist. He said it was 'novelists if anything who have had the biggest influence on me', mentioning Hardy, D. H. Lawrence and then Tolstoy, Dostoevsky and Stendhal as especially important [1960; James 49–50]. It is easy to understand that he would not want to spend much time on aesthetics. Few artists do. Yet he read Roger Fry's *Vision and Design* (1920) and wanted us to know how important that was to him. He tells us that he found the book by chance in the Leeds Reference Library, mentions the essay on African sculpture, and adds that Fry 'opened the way' to the British Museum and 'to other books' [1947; James 49]. Later, partly to stress how far he had gone on, he added that 'once you'd read Roger Fry the whole thing is there' [1961, James 33].

Fry admits that Tolstoy's attitude to great works of the past (including his own novels) is 'preposterous' but acclaims his dismissal of aesthetic systems founded on beauty as aim and object, and specifically his concern 'that Greek sculpture had run prematurely to decay through an extreme and non-aesthetic admiration of beauty in the human figure'. Moore caught from Fry, and perhaps also from Tolstoy, an early aversion to Renaissance and classical art. But Moore need not have read *What Is Art?* in order to have been aware of Tolstoy's ideas. Aylmer Maude's translation had come out in 1898. Tolstoy's views were widely discussed among artists of all sorts and among critics of all the arts. Yet if Fry 'opened the way to other books' one of

those could well have been *What Is Art?*. 'I think that one may date from the appearance of *What Is Art?* the beginning of fruitful speculation in aesthetic', wrote Fry. For him Tolstoy was the foundation of modern thought about art, freeing us from the Greeks' great error. Moore would have registered that.

He is echoing Tolstoy when he speaks of wishing his sculpture to 'communicate feelings and emotions' [1952; James 84]. He is also echoing Kenneth Clark, director of the National Gallery from 1934, who befriended and in the true sense patronised Moore, Graham Sutherland, Victor Pasmore and others, buying their work and supporting them in order to tend what he considered the valuable new growth in British art. In a discussion on 'Art and Life', broadcast by the BBC and printed in the *Listener* for 26 November 1941, Clark came out with a characteristically bold/unbold statement: 'Well, I must come clean, I suppose, and confess that I think art has everything to do with life; it is, if one can venture a sort of definition, a concentration of human emotions and experiences communicated in a controlled and intelligible manner through an appropriate medium' [James 77]. The discussion was chaired by that fine man of letters V. S. Pritchett; the other contributors were Moore and Sutherland.

It is less likely that Moore knew Ortega's book, or at any rate knew it early enough for it to have influenced his conception of art. Its constant premise was the assumption about purpose and meaning here referred to as humanity: the conviction that art had to originate in the artist's emotional life and touch the emotional life of others through thematic material common to humankind. Tolstoy insists that 'In every period of history and in every human society there exists an understanding of the meaning of life which represents the highest level to which men of that society have attained . . . This understanding is the religious percep-

tion of the given time and society . . . And it is by the standard of this religious perception that the feelings transmitted by art have always been appraised.' Moore the Yorkshireman would not have spoken in such terms, and would probably have jibbed at the word 'religious' (though one of his most loved sculptures stands in a church and represents a well-known religious image), yet the spirit of those words permeates his work. Its world-wide renown or, better, the affection in which it is held around the world, speaks for its power to connect mankind on what Tolstoy calls the religious level.

❖ ❖ ❖

Son of a coalminer and of a coalminer's daughter, Henry Moore was the seventh of eight children born in a little terraced house in the industrial town of Castleford in Yorkshire. His father was severe, intelligent, industrious and ambitious for his children. His mother was strong, direct, upright physically in her black dresses and morally in the unceasing care she provided, her love and her humour. Her fourth child, a boy, died in infancy; the eighth, a daughter, died when she was twelve and Henry was fifteen. The third, a son, disappeared to Canada in his late teens to escape the consequences of some misdemeanour. So there was death and sorrow as well as closeness. Father set and demonstrated standards. Self-taught in literature, music, mathematics and engineering, he improved his position as miner from working at the coalface to becoming pit deputy and then under-manager. He was strict with himself and strict with his children. Mother was 'feminine, womanly, motherly . . . She was to me the absolute stability, the whole thing in life that one knew was there for one's protection . . . So it's not surprising that the kind of women I've done in sculpture are mature women rather than young' [Berthoud 21].

Henry attended an infants' school nearby, then the junior section of the same school and Sunday school at the Congregational chapel. The Moore children were baptised into the Church of England but we get no sense of a religious household, rather of one making use of the facilities for social congress available in Castleford. Relatives came often, and then there was also the mutuality and cohesion of the local trade union in which Father was a prominent figure. A strike over wages lasted from October 1902 to January 1904, during which time he found ways of saving and earning money to feed the family. Life was neither easy nor especially varied, and the world had little to offer that was not hard-won. Yet there was warmth within that stringency, and comfort in the straitness of the two-bedroomed (from 1911 a three-bedroomed) house. Not far away was the wider world of hills, rocks and streams and the drama of the season's cycle.

In retrospect we note impulses towards art. One brother, Raymond, later a schoolteacher, had a talent for drawing and delighted little Henry with his sketches of animals. Shortly after Henry moved into Castleford Secondary School a new art teacher was appointed there, Alice Gostick, warm, encouraging and enthusiastic. She was half French and well informed of what was happening in modern art through magazines which she showed to interested pupils. Her teaching was open-ended rather than systematic and included pottery and other craft work. In 1913 Moore was asked to carve an oak notice board for the school, his first commission but presumably executed gratis. His talent and perhaps his reliability were already recognised. He certainly knew his own mind at sixteen: an art-school training should come next. His father persuaded him to make sure of a better chance of earning a living as a schoolteacher, like Raymond and like a sister, Mary, who became a headmistress. So teaching first, perhaps an art qualification

later. He had a short period as student teacher, then a full-time post at his old school. War brought him his second commission: he carved a panel as a Roll of Honour to record the names of former boys of the school who were marching off to France. Then war took him away. Moore fought at Cambrai, was gassed, came back to Britain for hospital treatment and convalescence, was trained as an army physical training instructor and then sent back to France though the fighting had ended. Soon he returned to Castleford and to teaching, but his war service had made him eligible for an education grant. He got one and enrolled in Yorkshire's major art school, in Leeds. He insisted that he wanted to study sculpture, and by what today seems a miraculous act of responsiveness a sculpture tutor was appointed and a sculpture department created to make this possible. That was in 1919. A year later another Yorkshire-born sculpture student arrived in the department: Barbara Hepworth. She came from a well-to-do family but Moore hinted at 'a little flirtation' with her none the less. Judging by prizes awarded by the school, Moore was the outstanding student but by no means the only one encouraged to look for further professional training. In 1921 he, Hepworth and four other Leeds art students moved down to London and the Royal College of Art.

That move was cardinal. The British art world is still focused on London despite attempts to decentralise it. In the 1920s it was even more so. Local movements and schools might arise and make their mark – Norwich, Glasgow, Newlyn – but London was where the art of the past and the present could be seen and argued over, where reputations were made, where conservatives and innovators confronted each other, where the dealers promoted and collectors gathered. To Moore London meant above all the Royal College where he spent two years as student and nine as instructor, and the British Museum where he went again and again to immerse himself in the art of the past untouched by Greek classicism: prehistoric, Mesopotamian and Egyptian, archaic Greek, Cycladic, pre-Columbian Mexican, African and so on. There were also the great collections of the Tate Gallery, the National Gallery and the Victoria and Albert Museum, as well as the Natural History and Geology Museums, the last three close to the Royal College. Trips to Paris and then a scholarship visit to Italy strengthened Moore's involvement in what must have seemed to him the great alternative tradition of art but then also challenged his rejection of the classical high road. He felt as 'a bitter struggle within' [Berthoud 62] the tension between the good art behaviour his instructors required which would lead on to qualifications and an assured career, and the 'desire to work freely at what appealed most to me in sculpture'. London also meant daily and growing contact with the whole sphere of artists. He made friends and allegiances, some of which were long-term, but he also learned how to exist in that world, when to comply and when to assert himself. He was ambitious, but it was not in him to take the perhaps easier, certainly smoother way of one who fits in with society's tastes and expectations. He seemed calm and steady, and he would not have been taken on as an instructor in the College had he not given that impression, but he felt in his bones that something had to be done in sculpture, said through sculpture, that only he could do and say. There was in him energy and a sort of stubbornness which made him search for its essence and test it in practice.

He was helped by the example of Henri Gaudier-Brzeska, killed in the war at the age of 23: Moore saw examples of Gaudier's often anti-naturalistic, primitivising sculptures of figures and animals, firmly abstracted to transmit rhythms. He read Ezra Pound's forceful book on the sculptor (1916), with its Gaudier quotations

reprinted from the Vorticist anthology and manifesto, the first *Blast* (1914): 'Sculptural energy is the mountain. / Sculptural feeling is the appreciation of masses in relation . . .' He saw Jacob Epstein's early carvings, some of them monstrously uncouth in the context of the time's taste; they were occasions for media scandal and for loud antagonism. Epstein became a friend and a supporter, buying some of Moore's sculptures and drawings and writing a firmly appreciative text for the catalogue of Moore's second show in 1931: 'For the future of sculpture in England, Henry Moore is vitally important'.

What had he brought south with him? In all basic respects his personality was formed. His family background had given him many strengths. He had learned a great deal. If the Leeds School of Art put most of its effort into teaching students how to paint, draw and sculpt in ways that official examiners would reward with scholarships, Moore himself knew that this was not the whole of art, not the inner life but only the surface manoeuvrings of art. Alice Gostick would have told him that, with her knowledge of French art from Impressionism on. Fry implied a linked endeavour across the ages that made key artists into collaborators rather than individuals in isolation: Masaccio and Cézanne, for instance, emerge as brothers and close kin to Giotto, 'Negro' sculpture as somehow parallel in its global contribution to what he called 'ancient American art'. In Leeds Moore had met Professor Michael Sadler, then Vice-Chancellor of Leeds University and a great collector of painting and sculpture including pieces by Van Gogh, Gauguin, Matisse, Kandinsky, and African carvings. (Later Sir Michael Sadler, then Master of University College in Oxford, was to buy early sculptures and drawings from Moore.) Moore had also given time to studying art history books; he was ready for the wider world of London and beyond. He was to spend the rest of his life living and working mostly or wholly in London and in country areas from which London could easily be reached. Yet in some ways he remained the Yorkshire working-class man, a little distanced from the smooth and generally middle-class world of English art. That too called for strength, and may lie behind Moore's ultimately supernational status. He always knew that greatness mattered. He recalled the story he had been told at Sunday school, about Michelangelo working on a carving and responding positively to advice from a passer-by; he never forgot Michelangelo's being referred to as 'the greatest sculptor who ever lived'. It stirred him deeply, that homage to one man's work continuing as generations succeed each other and the centuries pass, and spreading from Florence to the entire world. He was not thinking only of fame, though fame could be a spur. What stirred him was the intimation that what one man did could feed the world's spirit for ever.

The foundations for Moore's career in every sense – his life as man and sculptor, his thinking about art, his relationships in the art world and outside it – were well laid by the time he finished his studentship at the Royal College. This is not the place for a systematic account of that career. Our concern is with the character of his work, so well known now that there is a danger we might think we know it all and need no longer give it our attention. But there are a few more biographical points to be made before we leave that business to the chroniclers. Moore enjoyed London's cultural offerings, not only its art treasures. He went to the theatre, to plays and operas, he read, he discussed what he experienced with his friends. He went to Paris for the first time in 1922 or 1923, visited the museums and was especially excited by the Indian sculptures of the Musée Guimet, worked afternoons and evenings in two studio schools, and was awed by Pellerin's Cézanne *Bathers*, the famous painting now in Philadelphia. A scholarship took him to Italy in 1925. He wanted to spend time in Paris or Berlin

to study collections of primitive and exotic art, but it had to be Italy and once again fate was on his side. The young artist who had accepted, from Fry and others, the anti-classical and thus also anti-Renaissance stance of modernism, found himself deeply impressed by the early Renaissance from Giotto to Masaccio and by the last works of Michelangelo. He was still pulled in two directions, but in Giotto ('Giotto's painting is the finest sculpture I met in Italy' [Berthoud 78]) and in Masaccio he found some of the purposes of classicism combined with primitive strength, a sort of bluntness that echoed something in himself. Florence was followed by Rome and then by Venice, prescribed staging posts for the scholarship. He came home via Paris, rather earlier than had been expected. He said later that his three months in Italy, rather than a cheering, confirming experience, had brought him closer to a nervous breakdown than anything else in his life. Should we blame the 'bitter struggle' for that, or a *crise de coeur* in Florence and money worries in Venice? All of them perhaps, plus other things we can only guess at: the strain of being yet further away from his family, now living in Norfolk (he ran to them when he got back); Fascist blackshirts marching through the streets in Rome; possibly a deep urge to be at work making himself into the sculptor he felt within him, countered by his bewilderment at the conflicting messages he got from what he saw and what the world told him; the young man's commonplace but uniquely intense longing for confirming sexual experience and for lasting love. (He had prided himself on being able to recognise the girls at Castleford School by the shape of their legs.) In 1925 he wrote to a friend about his dream of living in a quiet country district in England and finding himself 'one of those richly formed, big-limbed, fresh faced, full blooded country wenches, built for breeding, honest, simple minded, practical, common sensed, healthily sexed . . .'

[Berthoud 83]. The obvious point has to be made that Moore's experience of woman is *fons et origo* of his art.

In 1929 he married, not a country wench but a delicate girl nine years younger than himself, elfin, *piquante* and of aristocratic Russian–Austrian–Polish origin. Irina Radetsky was a painting student at the Royal College. It was the look of her that attracted him first, then also her charming accent and perhaps her stories of life in Russia, followed by refugee existence in Paris and, in a well-to-do setting, in England. They married within a year of meeting. Irina was to devote her life to Henry and to their daughter, Mary, born in 1946 after repeated miscarriages. That plus the acquisition of the house Hoglands at Perry Green, some thirty miles north of London, in 1940, completed the basic Moore household. As the work grew in quantity, complexity and size the house was extended, studios and workshops were added and adjacent land was bought and used to display the larger pieces. Assistants came to work for Moore, occasionally at first, then regularly and persistently; a secretary arrived to stand between the sculptor and a world increasingly intent both on his productions and on involving him in activities that would get in the way of his producing them. The Yorkshire miner's son became a public figure as well as the world's most admired sculptor.

❖　　❖　　❖

Discussion of Moore's oeuvre must start from his enduring interest in two related themes which he said were his constant concern, Mother and Child and Reclining Woman. Many artists use their obsessions in their work. Such unforced concentration can be a source of great strength and fecundity. To explore a theme as idea means also exploring it as a formal problem, and for the gifted artist this is a spiritual and a technical adventure of great potency. Moore's work teaches us

that an announced theme is no finite thing but an area of interest within which many subjects await attention.

One wonders why he did not admit to a third theme. He has carved and modelled many vertical figures, some entire and usually modelled for casting in bronze, others half or three-quarter figures, mostly carved. Where gender is indicated they are female. At art school he had drawn and modelled many standing and seated figures; he had recourse to life drawing at several phases of his mature career. There were several vertical female figures among his earliest carvings in the 1920s. Greek and African sculpture provided encouragement, as did Renaissance sculpture and the modern example of, especially, Archipenko and Gaudier-Brzeska. On rare occasions these early figures can be in expressive action; some of the later cast ones, of 1950 and after, suggest anxiety even though they are almost abstract. Mostly they are at rest, though we are tempted to read additional meaning into the mien and poise of the face or the position of their arms and hands. What is striking in many instances is that they are girlish figures rather than the 'mature women' Moore claimed to prefer. Amongst his drawings and prints, too, there are many that express his pleasure in young, lithe bodies even if the maturer and weightier forms dominate.

Of the Mother and Child theme and the Reclining Woman theme he considered the former as representing 'the more fundamental obsession' [James 220]. This may be because of its universality and accessibility. We are all born of woman, we admit the special bond between mother and child which even the fondest father cannot match. The secular image familiar to us all is backed by religious images, not only in the Christian sphere. The theme of Moore's Reclining Women is less self-evident. It touches on common human experience but at a deeper level, requires a willingness to surrender one's imagination to the rise and fall of forms, to

hollows and holes as much as to protuberances, that make the sometimes boldly, sometimes only slightly abstracted body into a habitable world. It is usual to interpret them in terms of landscape, capable of enfolding us but just as capable of confronting us with dangerous escarpments and dizzying heights. David Sylvester has pointed out that 'their bearing, especially the set of head on shoulders, is more male than female' [Tate cat. 1968, 5]: the male river-gods of the classical tradition and the male Chacmool figures of pre-Columbian Mexican sculpture led Moore to think of his women as alert and energetic, not at all languid as often in eighteenth- and nineteenth-century art and its derivatives. We rarely feel that his Reclining Women are to be encountered as sexual partners: though this meaning is not excluded it is never, in Moore, the overriding subject. The body/landscape duality varies in intensity and according to which element is dominant in our reading of a particular piece, yet the body remains the theme, from the earliest semi-naturalistic representations to those involving radical dismemberment and transformation in the spirit of Picasso and Surrealism. Here too meaning is not remote.

Perhaps Moore did not include the vertical figure among his obsessional themes for lack of such thematic density. Formally the series is clear but the subject of each piece is less inherent in the theme, more dependent on treatment. When he produced his large carved **Three Standing Figures** (LH 268) for the Battersea Park Open-Air Sculpture Exhibition of 1948 he gave them 'a lifted gaze, for scanning distances' and a 'sense of release' [James 108]. This for once admits a separateness of meaning from form; usually Moore's work exhibits the opposite. His bronze **Double Standing Figure** (LH 291) of 1950 is almost purely linear and incorporates sharp triangles that come from outside his usual formal range. Study of these two groups shows by contrast how

readily even the most attenuated of Moore's Reclining Woman sculptures, such as that he made for the Festival of Britain exhibition in 1951 (here represented by cat. 70), retains the sense of a human presence.

Another theme Moore might have mentioned is that of the hollow form embodying a separate or quasi-separate form. This suggests an extension of the Mother and Child theme: we think of the mother's embrace, and of pregnancy. But the internal form can also be awesomely powerful, threatening to disrupt the carrier. The most dramatic instance of this is the elmwood **Reclining Figure** (LH 263) of 1945–46, which has in its breast space a helmeted head pressing into and through the Mother form. (This subject is announced in drawings of 1942, HMF 2043 and 2075, very similar to the finished sculpture except that the containing Mother is more alert, the inner being more dormant.) At other times, as in the upright carving **Internal and External Forms** 1953–54 (here represented in cat. 69), there is a suggestion of the lover's embrace, of the human faculty of comforting and sheltering, without any indication of gender in either form. It also speaks of death, of the dead Christ supported by his Mother, as in Michelangelo's *Rondanini Pietà* which Moore admired for its 'deeply human values' [James 183]. The origin of the Internal/ External theme is in fact to be found in Moore's series of lead and bronze Helmets (see cats. 41, 68), begun in 1939. That of course was war-time, and the theme relates easily to a society urgently bringing armed force to bear on a puissant enemy and concerned with protecting the unarmed. Yet there are other implications in the series, some of them pointed out by John Russell. 'It is uncertain . . . whether the internal figure is protected or imprisoned by the helmet itself: whether it has, in short, got into a situation which it can no longer control' [Russell 117–18]. Russell points out that Moore pursued this theme in his later work, and associates it with the sculptor's interest in 'envelopment'. We all sometimes feel imprisoned by that which shelters us, and it is remarkable how varied the internal forms in the series are – the first fluent and confident but others, as Russell says, 'angular, irregular, uneasy, often forked and frantic'. Certain other sculptures, and many drawings, suggest oppressive confinement and fear.

Yet it was precisely war, and especially the nightly danger and terror of the bombing of London, that elicited some of Moore's most accessible works. The well-known Shelter Drawings (cats. 44–49) together amount to an epic poem on the theme of humankind's response to aggression, fusing fear and the urge to hide with an equivalent sense of humanity's ability to join hands in order to survive. The anonymous but not wholly generalised figures lie there, in the bowels of the earth, at once vulnerable and timeless. They are not in extermination camps – Moore does not exaggerate their plight – yet if and when daylight comes they will come out of their holes to see what is left of their homes and their way of life. They are, mainly, women. The men are away in the armed forces or above ground, dealing with fires, injuries and deaths. Of course there were more men to be seen in the Underground shelters than Moore shows, and more children though many had been evacuated from the capital. Two years later he did a series of drawings of miners working the mines of Castleford (cats. 50, 51). The two series are complementary in some ways: men at work as against women asleep, with hollow underground spaces and a context of danger common to both. In both cases, sketches made underground were developed into chalk, pen and watercolour drawings in the studio. The miners series lacks the other's epic character. But Moore had not drawn male figures since he ceased being a student. The new experience was to be reflected in his sculptures of women as well as men.

The following year, 1943, he accepted a specifically religious commission, for a carved Madonna and Child to go into St Matthew's Church in Northampton (here represented in cat. 54). He seems to have had no difficulty developing his conception of the Mother and Child theme to this end: he knew it called for 'an austerity and a nobility, and some touch of grandeur (even hieratic aloofness)', and also a sense of permanence. The body of the Madonna is in the tradition of 'big-limbed, fresh faced, full blooded country wenches', yet her great hands and feet are linked by slow, mighty draperies that stop us noticing what a large and powerful creature she would be were she to stand up. The Child similarly: by finding the perfect balance of individuality and interdependence in the two figures, the ideal degree of generalisation and character and enough detail to take our eyes around these great masses, he made an entirely popular sculpture that is at the same time a major work of art. It is beholden to pre-Renaissance examples and echoes well their character of unaristocratic dignity; it also speaks of Picasso's peasant figures of the 1920s. Soon he would be making Family Groups (see cats. 56, 59), returning to the secular theme but not now excluding the male element; these two must be counted among his most successful, in the sense of most popular, themes. Though their forms are far from the realism popularity is thought to demand, especially in their torsos and even in their heads, other parts signal care and gentleness. In the 1950s his work became more austere again, as it had in the 1930s, and in the 1960s and after he moved often between abstracted figuration and wholly abstract pieces, some of the finest of them carvings, done in Italy in Italian marble.

❖ ❖ ❖

Moore's art refutes Ortega's account of modernism. It addresses itself to human concerns. Much of it offers ready access, but even the work that may be 'difficult', on grounds of abstraction or of sheer grandeur, in time persuades us of its involvement with us, of its pertinent communication. What he communicated is of general relevance and rich in spiritual content. He met Tolstoy's demands for an art expressing the religious conceptions of his time, though not of course in the way Tolstoy specified.

What are the subjects he opens to us? Because they are important they are familiar; what is surprising is their range. There is, clearly, love and desire, the sexual drive; there is even more clearly the love of mother and child, parents and children, the warmth and strength of family life, the need for protection and for social mutuality and intercourse. But it includes also fear and awe – fear of man's ability to destroy mankind, awe at the grandeur of human and of landscape forms, awe at life, fear of death. Rarely has sculpture dealt with these matters without running to anecdote and belittling detail. Moore's work focuses on them with a directness very rare in British art (one thinks of William Blake as perhaps his unique predecessor) and rare anywhere if we look for instances that still have the power to move us. The boy moved by mention of Michelangelo's greatness tacitly chose the task of turning our minds to the great issues of all times. This was made more arduous by his not being able, on all but one or two occasions, to have direct recourse to the time-honoured formulae of religious imagery. Moreover, he embarked on it at a time when even in Paris sculpture was more intent on following painting's stylistic adventures than on content. Paris's avant-garde sculpture rarely touched grave subjects. (Brancusi's dealt with them, but by occult means.) Moore informed himself of what was being done but had to distance himself from it, finding his spiritual path in the examples of archaic and primitive cultures and then also in the work of the sternest of

Renaissance artists. Later, after 1945, the world of modern sculpture became much more ambitious yet still refused to commit itself to major themes.

Moore showed that modern sculpture could address such themes without recourse to academic routines and that the results could reach a global public. He removed the curse of elitism. When we ask which other artists in modern times have devoted themselves so fully to great issues and similarly pressed them on their public, we have to turn to painters who have still not attained anything like popular success: Mondrian and Malevich in their maturity, at specific times Delaunay and Kandinsky. Significantly, these were abstract painters: in order to address their art to the religious conceptions of their time they set aside the long traditions whereby communication is made through the human image enacting this or that drama on a pictorial stage. This implies that sculpture, at any rate in Moore's hands, was able to renew figurative expression whereas painting was not. But there was one other modern artist who has to be considered in this context, and he is Picasso. Moore credited Picasso the sculptor with possessing the instinct for three-dimensional form which he himself saw as essential for sculpture [James 203], and recognised Picasso's ability to 'make poetry out of objects that everyone else had passed over' [James 198]. But it was Picasso the two-dimensional artist who was most important to him, the painter of massive female figures in the 1920s and in the 1930s the painter and designer of partly humorous, partly monstrous 'anatomies' – assemblages of natural and unnatural forms that offered themselves as strange yet irresistible metaphors for the human body. That transformational model invited Moore to explore the infinite world of non-figurative forms in order to return to the figure by means of it. Thus the human image becomes the measure and the reconciliation of all experience. The all important differ-

ence between Picasso and Moore in this matter is that Picasso leaves the unnatural character of his compilations dominant as though he wanted us to be aware of our imagination's strange, perhaps obsessive, power to accept even the most unlikely grouping of shapes as a human image, whereas Moore almost always returns us to the figure as the prime image, however distorted. His figures, we might say, are rich in metaphorical extensions; Picasso's are only on the brink of becoming figures. We ourselves are figures, and we respond to Moore's figures as images of humankind even when at first we notice only their metaphorical sub-texts. He knew the value of delaying recognition in order to hold our attention, thus enabling the wider meanings of his sculpture to reach our spirits. 'People should want to go on looking and thinking: it should never tell us about it immediately' [Seldis 197]. He may have learned that important lesson from Kandinsky. (It is striking that Moore, unlike Kandinsky after 1914, usually avoids the simple geometrical forms beloved of Neoclassicism, Suprematism and Bauhaus Elementarism. These are for him too immediately direct and knowable; the organic, irregular forms that were his normal language call for slower reading and rereading, and remain without a name.)

Is it possible to define the way Moore took, his alternative to realism? In many public places around the globe stand abstract and near-abstract sculptures that many would say are difficult to understand yet are regarded as positive presences in the environment, friends rather than enemies, pleasurable rather than offensive. Also, in spite of his stylistic breadth, we recognise a Moore by its forms and often by a plenitude that we sense as generosity. His way was, of course, unusually inclusive. From the first, he countered the essentially classical models put before him by his teachers with the primitive and archaic alternatives provided

by non-European and early Mediterranean cultures. Soon he drew also on the austerer end of Renaissance and pre-Renaissance art and the not-quite-abstract formal explorations of some modernists, notably Gaudier, Brancusi and Arp. We have noted Moore's admiration of Picasso, and of Cézanne's *Bathers*: he was to buy a small Cézanne *Bathers* study and to explore it by means of sculpture (cat. 106). He made use of formal ideas from many other modern artists and adopted as first principle the Surrealist method of associational transformation. This meant that he could follow his life-long interest in nature's forms – landscape, rocks, flints and pebbles, bones and shells – and enrol it as a major part of his working routine. And of course he refreshed his eye by means of drawing, principally life drawing, but also animals (notably the sheep that grazed near his house), the magnificent elephant's skull Julian Huxley gave him, as well as non-organic things such as the ancient monoliths of Stonehenge. Whereas other artists impress us – or distance themselves from us – through specialisation and narrowing explorations, Moore showed himself open to almost all the experiences the world could offer. He sought a 'common world language of form', perhaps unconsciously denying old barriers between the languages of art, and that meant both accepting his place in time, in the history of art and the history of mankind, whilst also insisting on the whole of history as his domain: 'Art is a universal activity with no separation between past and present'. This may seem to set him in opposition to the modernist call for 'being of one's time' and even pointing into the future, yet this universality in time as well as idiom recalls that of the Russian Futurists with their appetite for everything that would recharge words and forms with meaning. Khlebnikov could well have wanted to appoint him a Chairman of the World.

We should note also the range of Moore's communi-cation. Many of his subjects suggest care, comfort, love. His forms are frequently warm with life, inviting, re-assuring. His images can at times be playful, at others noble, occasionally awesome. But we must not blind ourselves to the discordant qualities of some pieces, the evidence of pain and protest in the face of experience. His distortions can tear at our spirits. Tensely drawn-out forms jangle our nerves, especially in the context of a human image; sharp edges can jar amid rounded forms, implying violence; an architectural element often found in the drawings, sometimes in sculptures, can suggest oppression. If some of the heads come close to caricature, others seem to deny humanity in their concentration on action or expression, even their elision to non-existence. As in Rodin, truncations can speak of calamity but need not: they also remind us of ancient sculptures and thus of survival. Some of Moore's subjects, such as the **Atom Piece**, represented here by the maquette (cat. 92), and of course the Helmet series, refer us to the danger of mutual and self-destruction.

This leads us to challenge Ortega at another level. Can art, seriously pursued, truly be dehumanised? It can of course attend more and less obviously to human concerns, but all of it reveals human attachments. Terence's 'Homo sum; humani nil a me alienum puto' (I am a man and think nothing human alien to me) should be our guide in this. Art is a natural human product. Moore's humanity is exceptional among modern artists because, whilst encompassing so much, he directed his discoveries back to the human image as his principal enquiry and proposition.

Why was it in Moore to do this, and not in X or Y? We can only describe his origins and suggest the answers lie there and in the personality they formed. But note one of the consequences of his ambitious pursuit: the young man who began work conscious of a conflict between the demands of academic tradition as

the didactic form of classicism and the dramatic potency of pre-classical and non-European primitivism, reconciled them to evolve a formal language capable of bearing his communication. Two events symbolise this aptly. One was his embrace of the marble quarries of Carrara as a second spiritual home after Yorkshire: Michelangelo's only landscape – his only woman, one is tempted to say. From the mid-1960s until 1982 Moore spent part of most years near the Carrara mountains. The other is the exhibition that in 1972 crowned his career by bringing his work to Michelangelo's city in an indoor and outdoor display that seemed to make the whole of Florence its host. Tradition at its most elevated and modern primitivism came together both in Moore's work and in the world's reception of it.

NOTES (TEXT AND CATALOGUE)

BERTHOUD: Roger Berthoud, *The Life of Henry Moore*, London, Faber & Faber, 1987

CLARK: Kenneth Clark, *Henry Moore Drawings*, London, Thames and Hudson, 1974

COMPTON: Susan Compton, *Henry Moore*, exhibition catalogue, London, Royal Academy of Arts, 1988

DARRACOTT: Joseph Darracott, *Henry Moore War Drawings*, exhibition leaflet published by the Imperial War Museum, London, 1975

HEDGECOE: John Hedgecoe, *Henry Moore*, London, Ebury Press, 1986

JAMES: Philip James, *Henry Moore on Sculpture*, London, Macdonald, 1966

RUSSELL: John Russell, *Henry Moore*, Harmondsworth, Penguin Books, 1973

SELDIS: Henry J. Seldis, *Henry Moore in America*, London, Phaidon Press, 1973

TATE CAT.: David Sylvester, *Henry Moore*, London, Arts Council of Great Britain, 1968

WILKINSON: Alan G. Wilkinson, *The Drawings of Henry Moore*, New York and London, Garland Publishing Inc., 1984

CATALOGUE

LH numbers for the sculptures refer to the Lund Humphries catalogue raisonné; HMF numbers for the drawings refer to the Henry Moore Foundation archive.

Notes for the captions may be found on page 30.

I

Head of a Girl 1922
H 24.1 cm wood
City Art Gallery, Manchester
LH 4

These two very early sculptures (cats. 1 and 2) reveal the young Moore's difficult position between tradition, representing the models and methods proposed to him by his teachers, and the modernist urge to formal innovation for the sake of new or deeper meaning. He spoke of the tension inherent in this position. His work suggests that it was a positive, creative tension, far removed from the rebellious convention wished on modern artists by art journalism whereby they are supposed to reject all traditions.

 Head of a Girl reflects Moore's study of African tribal art. It is carved in wood and we see the marks of the chisel. The form of the whole suggests that he started with a cylindrical piece of wood, perhaps one with a bend in it, and then removed only as much as was essential in order to present the girl's head and neck as two linked masses. There is enough detail to inform us about the subject but not so much that we forget the material or the process of carving. The girl's features are both modest and exaggerated; the bulging fleshy eyes, together with that high leaning forehead, give the work a particular character and expression. Shocking at the time and against all rules of taste or style, the sculpture now strikes us as gentle and harmonious. To Moore himself, making this piece away from the Royal College of Art must have seemed an adventure, a challenging complement to his student activities.

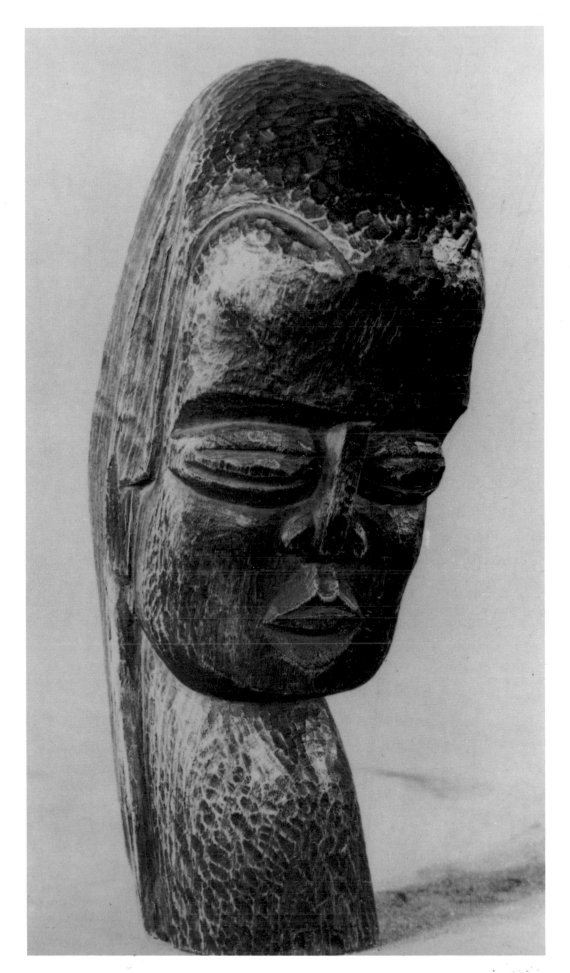

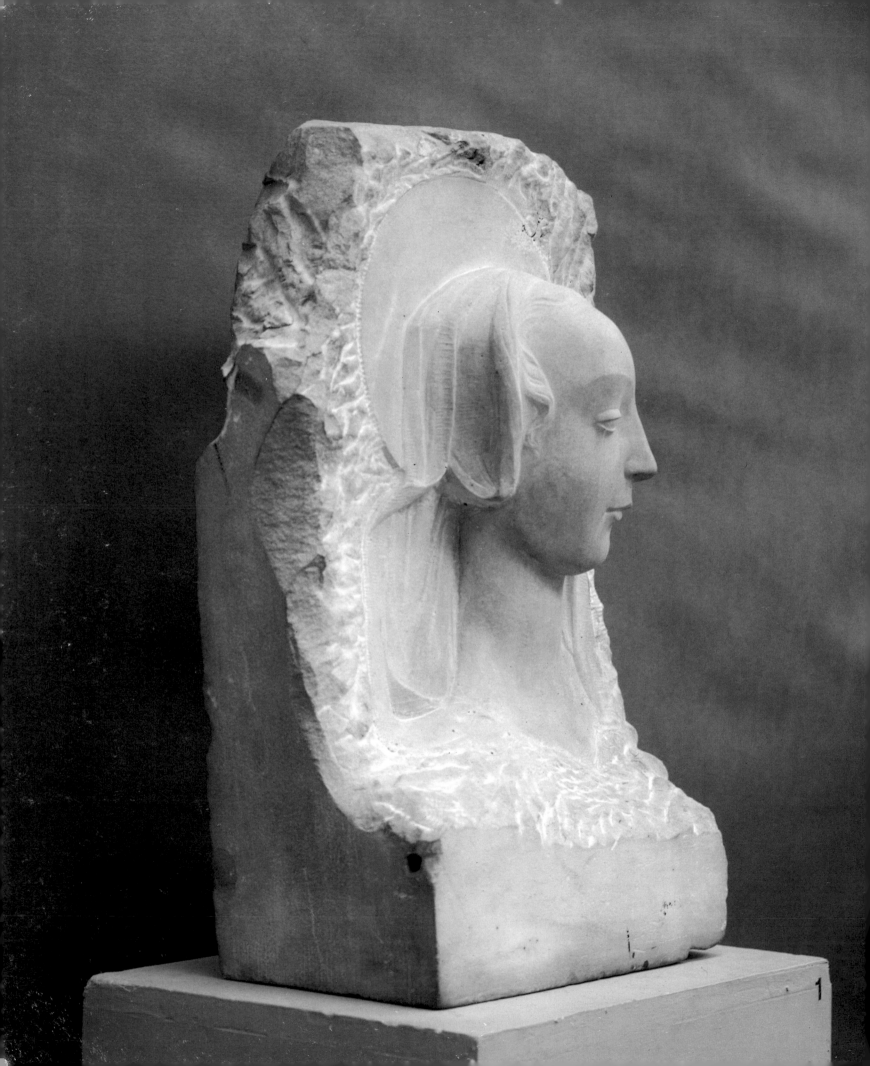

2 (left)
Head of the Virgin 1922
H 53.2 cm marble
The Henry Moore Foundation
LH 6

A task set Moore at the Royal College was to copy the head of a Madonna in the Victoria and Albert Museum, the central element in a relief by the fifteenth-century Florentine, Domenico Rosselli, representing the Madonna and Child with cherubs' heads. Moore obviously worked hard at his version and took satisfaction in it. As tradition and this example demanded, he carved and smoothed the marble to render the subject – skin, hair, drapery – according to the idealised naturalism honoured in the Renaissance, proving his skill and care in the academic manner. But he also exaggerated the three-dimensionality of the head and surrounded it with rough chiselling which contradicts that approved hiding of labour and material. The piece speaks of self-confidence as well as of respect for the original.

3
Head of a Girl 1923
H 17.5 cm terracotta
The Henry Moore Foundation
LH 15

When Moore was a student, carving was less attended to in art schools than was modelling – and that meant primarily modelling heads from the life or from imagination. We cannot be certain whether this tiny head was done at the Royal College or in the privacy of the artist's home. It is at once primitive and classical; one wonders whether Moore knew he was here close to bridging the problematic opposition between Western tradition and exotic primitivism. Some African heads

exhibit exactly this formal purity, but this head also recalls the geometrical clarity found in the paintings of Piero della Francesca, available to Moore in the National Gallery and soon to be admired by him in Italy. If painting was his chief inspiration here, we must acknowledge also the head's emphatic three-dimensionality as a cylinder supporting an egg form little disturbed by the detailed forms of face, ears and hair.

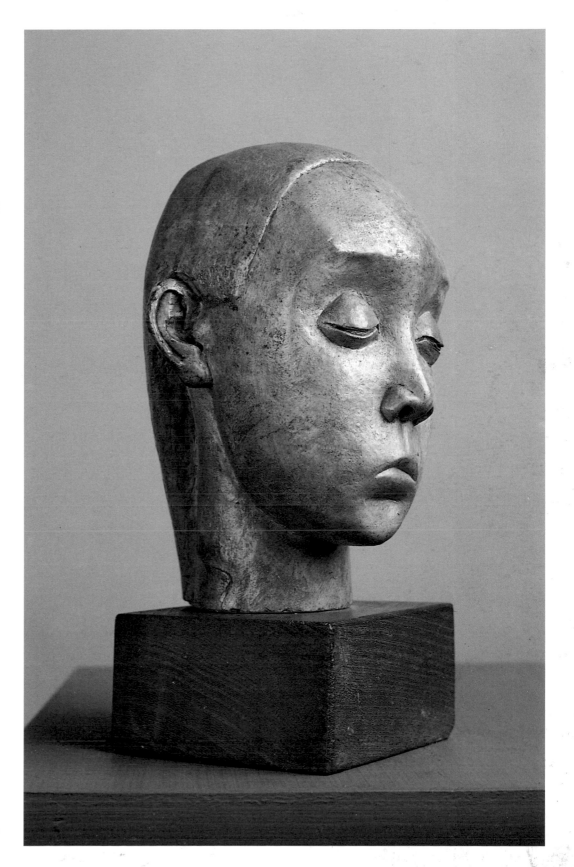

4
Reclining Nude 1923
black and red chalk
269 x 411 mm
The Henry Moore Foundation
HMF 339

This drawing is probably also a student exercise. It is stylish and rather charming though by no means weak. Moore enjoyed the softness of the chalks as much as that of the forms he was looking at, following the flow of the model's back rather than testing the physical nature of flesh and bones, weight as well as surface. Significantly, the left arm, supporting the figurc, is not allowed to do so in the drawing.

Moore welcomed the emphasis on life drawing he found at the Royal College, and later stressed the value of life drawing to the sculptor. He returned to the practice throughout his life, enjoying contact with the living model. The activity of seeing and noting refreshed and challenged him, bringing him back from the generalising activity of his sculpture to the particularities of drawing a living being in a here-and-now context. 'Drawing', he said later, 'keeps one fit like physical exercises . . . and it lessens the danger of repeating oneself and getting into a formula' [Clark 78–83].

5
Standing Woman 1924
black chalk
476 x 226 mm
The Henry Moore Foundation
HMF 251

In this drawing, possibly too a student work,
Moore uses the chalk freely both to capture
the rounded volumes of the model and in
sharper strokes, especially on the legs, to carve
away excess form. The result is rich and warm
and owes more to new modes of expressive
life drawing to be found in Paris than to the
usually more timid traditions of drawing,
dominated by line and thoughts of
correctness, upheld in England.

6
Seated Figure 1924
H 25.4 cm Hopton Wood stone
The Henry Moore Foundation
LH 19

The forms of this little carving assert the nature of the block of stone more than the particular character of a seated figure and suggest a sculptural sketch rather than a finished work. It is a fragment and its surface finish is discontinuous. Moore is likely to have made it at home, under the influence of archaic sculptures seen in the British Museum and perhaps also of certain works by Gaudier-Brzeska and Epstein.

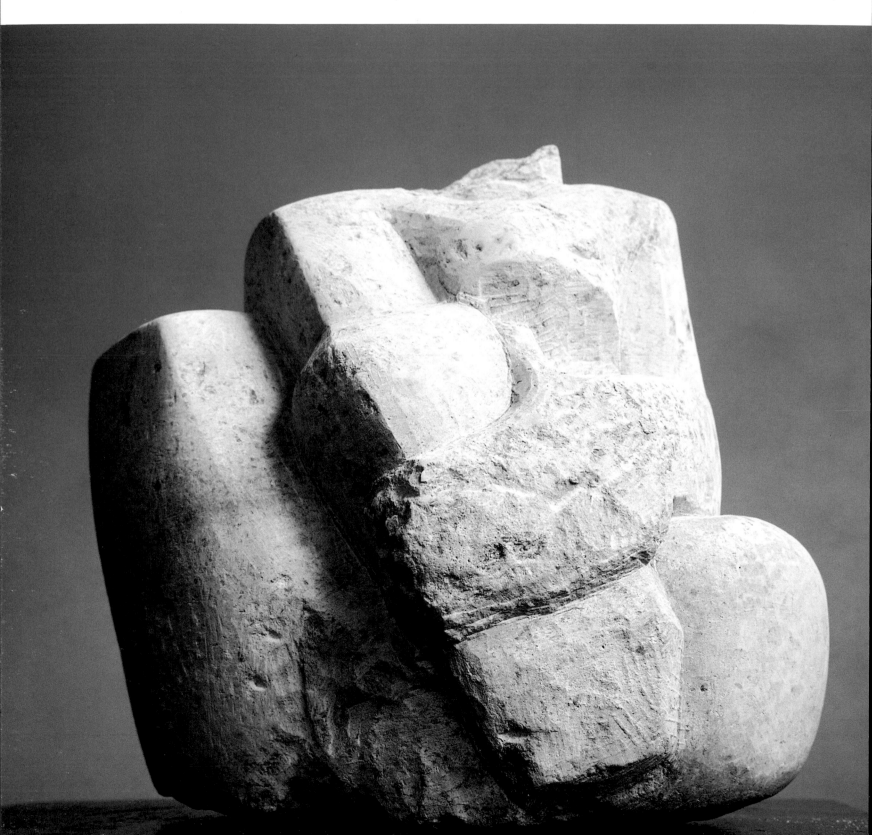

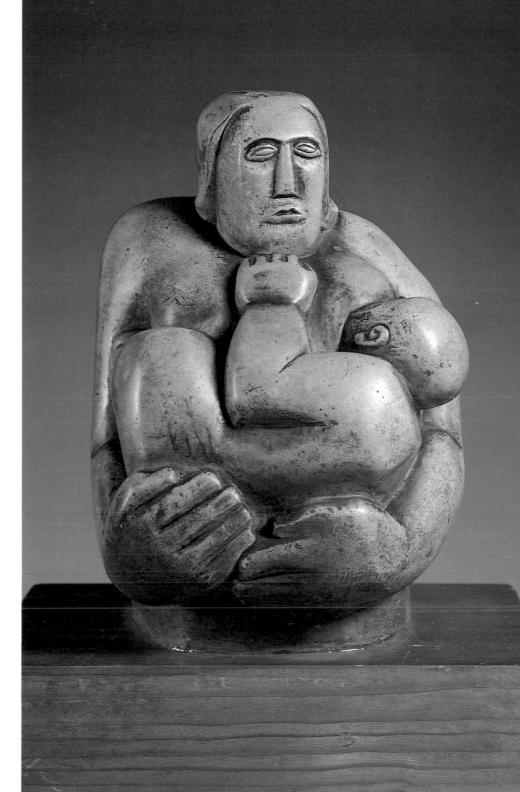

7
Maternity 1924
H 23 cm Hopton Wood stone
Leeds City Art Gallery
LH 22

The modest size of this sculpture almost, but
not quite, denies the monumentality given it
by the photographer. Gaudier had associated
'sculptural energy' with the mountain.
Moore's piece is mountainous as well as
small, a thing of superhuman masses
composed to present an archetypal Mother
and Child image. The woman's grave and
summary face echoes the so-called barbarian
carvings of Europe from the British Isles to
Russia; the fullness of her body, though not
its lumpishness, remind us of Moore's early
passion for Indian figures seen in London and
Paris. Its frontality and concision give this
sculpture the character of an icon.

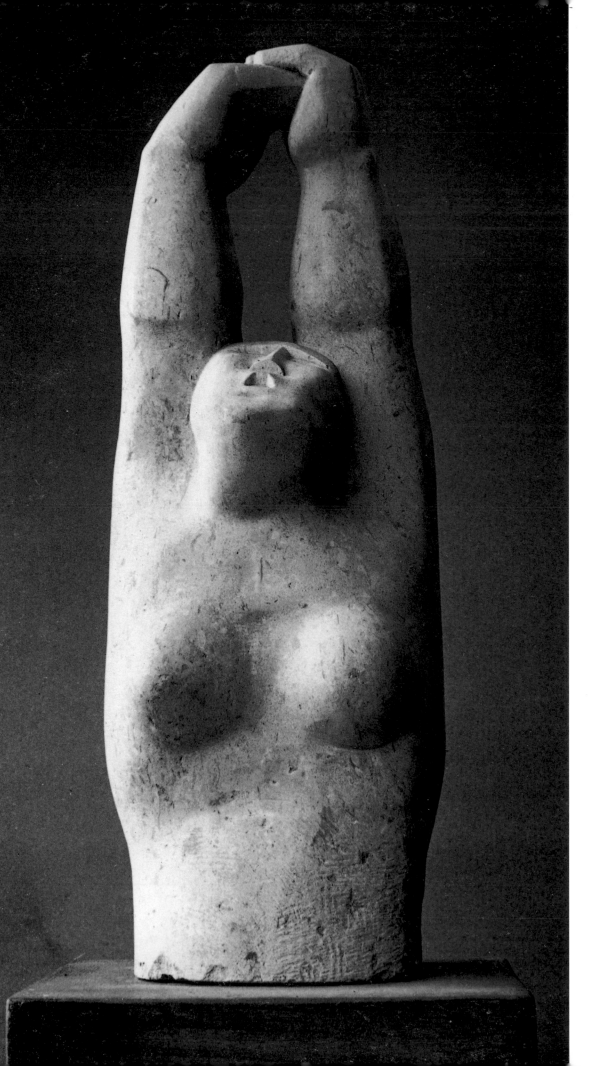

8
Woman with Upraised Arms 1924–25
H 42.2 cm Hopton Wood stone
The Henry Moore Foundation
LH 23

This sculpture suggests Rodin in its gesture, Gaudier in the formal interaction of the raised arms, and the agonised, much simplified face of Eve in Masaccio's Brancacci Chapel frescoes. Moore visited these last repeatedly while in Florence. They confirmed for him what Piero's paintings had already suggested, that the sculpturally powerful forms he knew from primitive cultures could be found also within the range of Renaissance and pre-Renaissance art. Few of Moore's sculptures represent movement or even strong gestures. Like Matisse, he thought of sculpture as primarily a vehicle for static subjects and forms, and this distanced him from Rodin, the most famous sculptor of recent times, except in such pieces as this and the **Fallen Warrior** (see cat. 74).

9
Mother and Child 1924
H 57.2 cm Hornton stone
City Art Gallery, Manchester
LH 26

This is a larger treatment of the Mother and
Child theme than cat. 7 but it offers
interesting points of comparison. Again, we
confront monumentality and sense the
mountain. But the stark frontality of the
earlier piece yields here to the limited but
highly effective play of diverse axes, with
elbows, the left breast, the child's knee and
shoulders and, above all, the two faces
pointing in different directions, bringing
rhythm into the sculpture in spite of its
massiveness. This mountain lives and
breathes; the faces, though far from sweet,
invite our interest.

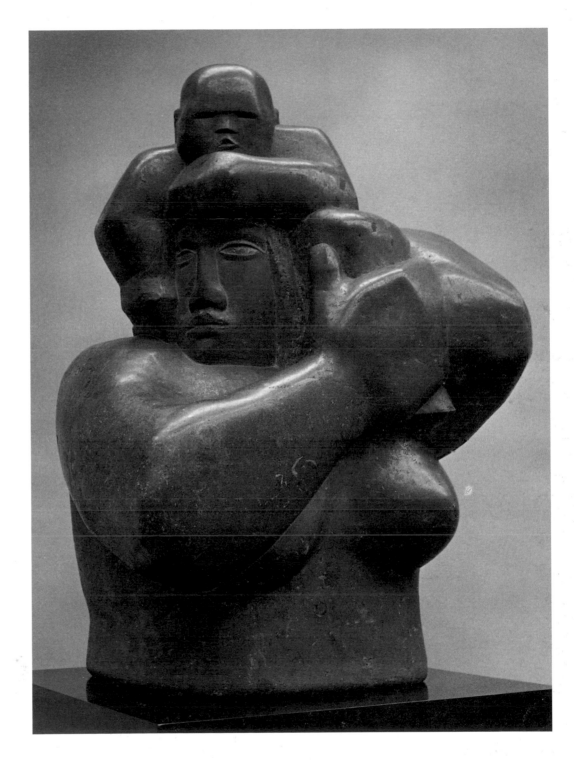

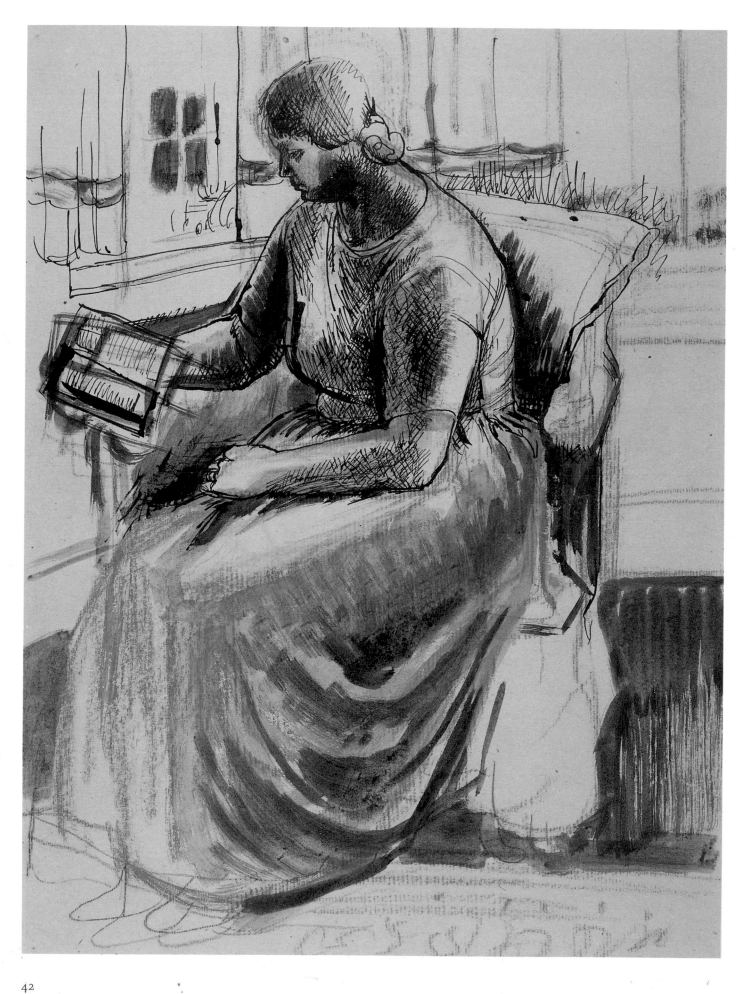

10 (left)
Woman Seated Reading (The Artist's Sister)
1925
ink, wash, watercolour, chalk
445 × 335 mm
The British Council, London
HMF 470

This is one of a few drawings Moore did of his
sister Mary in the middle or late 1920s; a
summary ink and wash drawing of a seated
woman, dated 1928 by him, may well be
another [Wilkinson plate 36, as **Seated
Woman**]. Line, soft in chalk, sharp in ink, and
broad washes establish a physical presence
that is at once particular, presenting a portrait,
and general in stressing the sculptural
strength of the subject. Its charm does not
deny the fact that here too is a mountainous
form, compact but generously proportioned.
Notice how the tops of the sitter's thighs, the
drapery hanging cliff-like from her knees, and
especially the near face of her leg and dress,
smoothed by brushmarks, have a
blockishness that reminds us of Moore's
assertion of his blocks of stone. The
shoulders, arms and breast are mighty; the
head is small and neat. The whole image,
including the setting, is altogether
harmonious. The artist's willingness not to
detail every part leaves it fresh as well as
warm.

11

Seated Figure 1927
charcoal, watercolour wash, pen and Indian
ink
440 × 304 mm
The Henry Moore Foundation
HMF 519

Graceful though this drawing is, it is the
opposite of stylish: observation of a specific
person here reigns over pictorial effect. Moore
plays fine lines, done with the pen to catch the
face and hands and to outline other parts,
against broad rubbings and washes in
charcoal and watercolour. This duality is
characteristic of some of the best of modern
English drawings, and can be found also in
the two-dimensional work of Ben Nicholson
and Barbara Hepworth.

12

Seated Nude 1927
chalk and pastel with wash
425 x 341 mm
The Henry Moore Foundation
HMF 507

The stylishness of this drawing belongs to
Paris, though the three-dimensionality of the
presentation, especially from the model's
waist down, speaks of Moore the sculptor.

13

Studies for Reclining Figure with Child 1928
pen and Indian ink, rubbed or washed
327 x 424 mm
The Henry Moore Foundation
HMF 682

Drawing 'as a means of generating ideas for sculpture' was all-important for Moore [Wilkinson 248]. He drew in order to generate ideas and then also to find variations on them, test them from different angles, and develop them on paper before turning to stone and chisel. It was a way of noting a host of possibilities; it also provided a means of thinking further about any of them. Thus he accepted a working method honoured especially in the Renaissance: there is no essential difference between his drawing and redrawing of the child's head and the woman's left arm coming forward to hold it and, for example, the many adjustments Raphael made in his drawings for Madonna and Child paintings. We could argue that Moore was holding back from modernist practices in this. Rodin drew often and learned a great deal from his drawings, but rarely used drawing as a way of planning a sculpture. Brancusi, who drew relatively rarely, gave priority to finding the forms of his sculptures in the process of carving or modelling. Moore used drawings, but also left himself free to rethink what he was doing when working in three dimensions. His sculptures never came directly from his drawings. Here, the female figure as drawn is close to Moore's cast and carved Reclining Figures of the late 1920s – when he produced his first masterpieces – whereas the subject of the Reclining Mother and Child does not show in his sculptures until decades later (see cats. 99, 113).

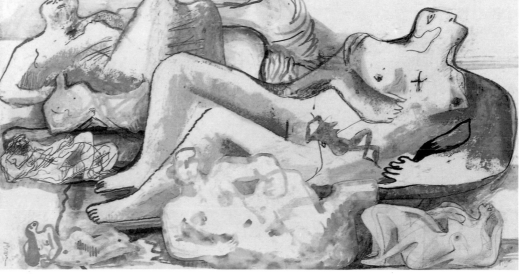

14

Montage of Reclining Figures c.1928
collage, pencil, black chalk, watercolour wash, brush and ink, green oil paint
303 x 567 mm
The Henry Moore Foundation
HMF 689

Gathering figures together by mounting them on one sheet, as Moore did on a number of occasions, was a way of making a fine presentation drawing but also brought with it consequences that must have interested him. (According to Wilkinson, Irina Moore at times cut out some of her husband's small drawings, 'usually reclining figures or mother and child studies', to collage them on one sheet, presumably with his approval. Wilkinson 268) Scale and space become illogical, almost Surrealist; in this sense we are left with separate images. In spite of that the whole image suggests a group and thus the possibility of a dramatic meaning, not least because of the heads looking up into the sky, alertly and perhaps in alarm. The result is at once ancient or classical and modern: we can identify with these anxieties. The way Moore has placed a tiny reclining woman on the belly of the largest of them suggests the caveman or cavewoman's way of painting one beast over another in prehistoric times.

45

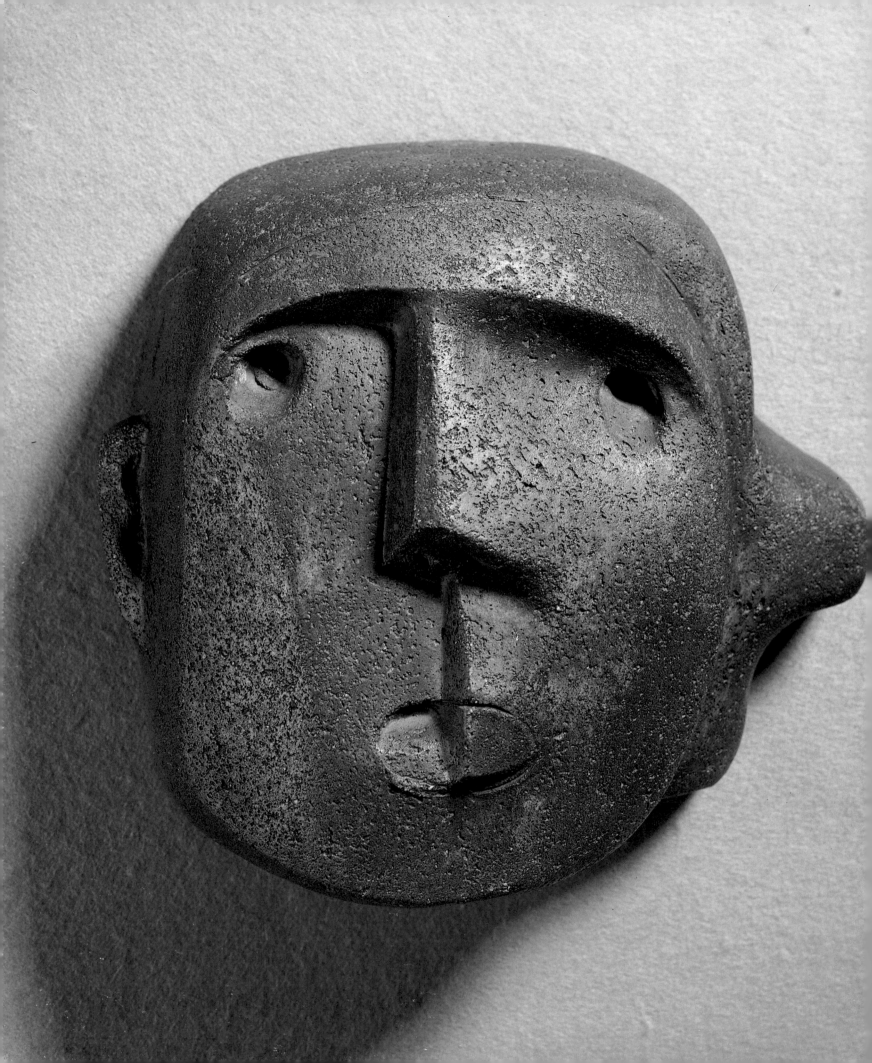

15 (left)
Mask 1929
H 21 cm cast concrete
Leeds City Art Gallery
LH 62

Moore made a number of sculptures in cast concrete in the 1920s. He modelled them in clay and then cast them, and their surfaces retain the natural pock-marked and grainy look of concrete. (He also at times carved concrete.) Some of these sculptures are gentle and pleasing, but it seems the process of modelling sometimes tempted him into more testing explorations of form or expression than carving. This mask exhibits his response to Mexican stone carvings he had seen in the British Museum and in books; he made a series of such abstracted heads in relief form at about this time. There is an echo of Cubism in the way he hints at a profile imposed on a frontal face.

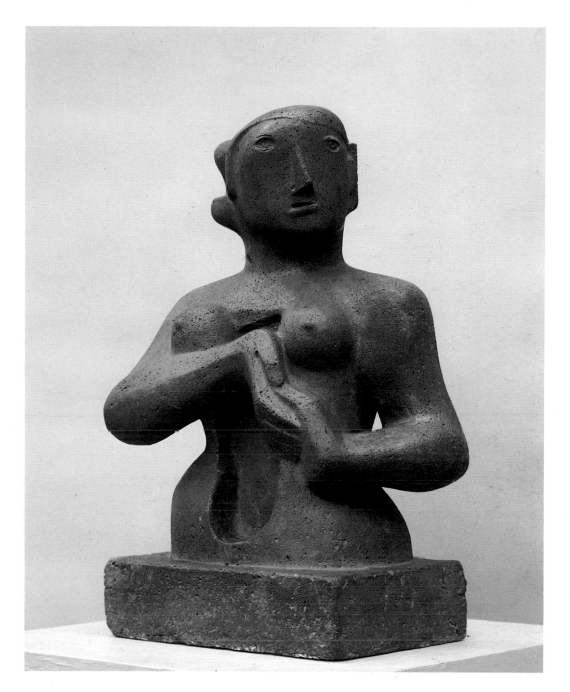

16
Half Figure 1929
H 36.8 cm cast concrete
The British Council, London
LH 67

This too is a modelled work, and here too we find new elements of anti-naturalism. At first glance this female half-figure is not so different from its predecessors; it is less massive than some of them and thus more graceful, and this is underlined by the poise of the arms and hands, held in what one thinks of as a singer's style. The turn of the head may also suggest a singer, but its forms are not unlike that of cat. 15. Most surprising is the large, key-hole shaped recess in the middle of the torso, foreshadowing Moore's famous holes but here suggesting a niche, a space that might contain another object, perhaps a child. Could the whole figure symbolise a would-be mother's loss of a child? The face and the tensed arm might suggest pain. The niche recalls that notorious avant garde sculpture *The Rock Drill*, modelled and constructed by Epstein in 1913 and subsequently reworked by him as a bronze half-figure, with a similar niche in the same place sheltering its foetal progeny.

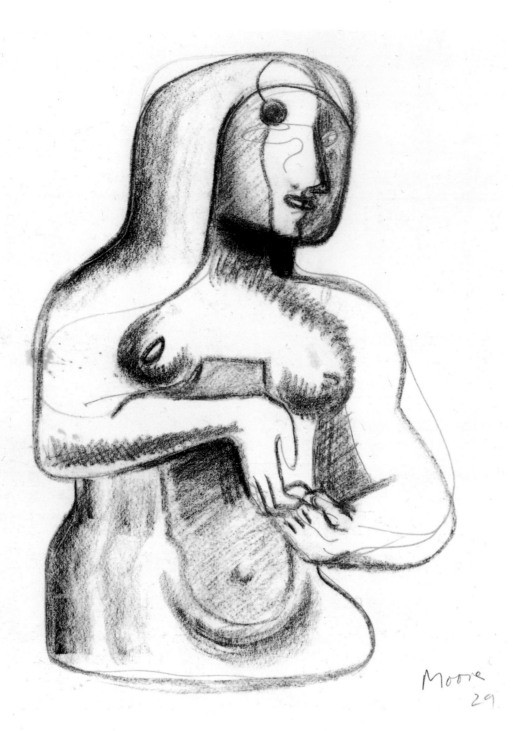

Moore
29

Seated Nude 1930
charcoal and wash
426 x 340 mm
The Henry Moore Foundation
HMF 771

As a modernist, Moore had an urge to develop
a style of drawing that would represent him
uniquely and also exhibit his sculptural
priorities. This drawing, which may have been
done from imagination, seems to speak with
two voices. A more or less naturalistically
described seated nude, full bodied and
inherently classical, has been partly worked
over to bring out the body's mass – note for
instance the lines that run like contour lines
around the right leg – and to add stylistic
detail, notably in the face. The two halves of
the face are treated differently and the
straightforward account of the woman's hair
is enhanced by rectangular forms that
resemble those of cat. 16. But it is also
unusual to find Moore providing so full a
setting for the figure when it is not a portrait.
In later drawings, and some sculptures, he
was to make dramatic use of this device.

17
Drawing for Figure in Concrete 1929
charcoal, black crayon and pencil
313 x 241 mm
Arts Council of Great Britain, London
HMF 724

Wilkinson mentions and illustrates three
drawings that relate to half-figures of 1928-9,
and refers to this drawing as a study for the
sculpture cat. 16 [Wilkinson 266–7]. I believe
this is a drawing after, rather than for, the
sculpture: its swift and certain lines suggest
Moore was drawing something in front of
him (though he seems to have hesitated over
the thumb of the left hand).

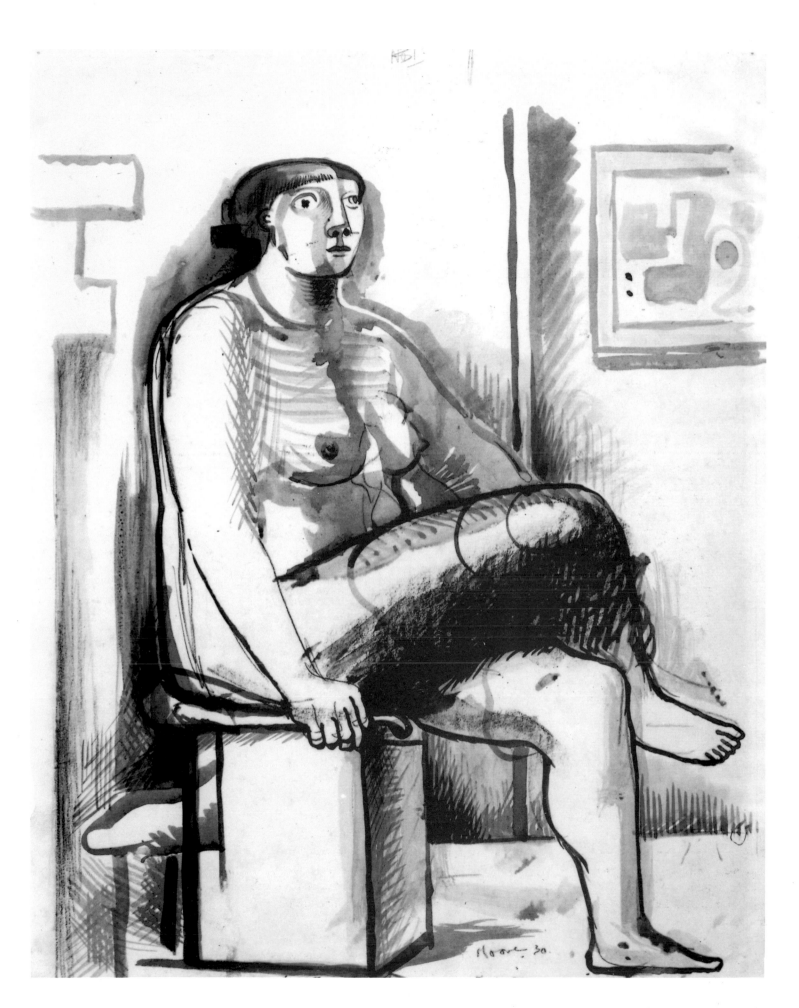

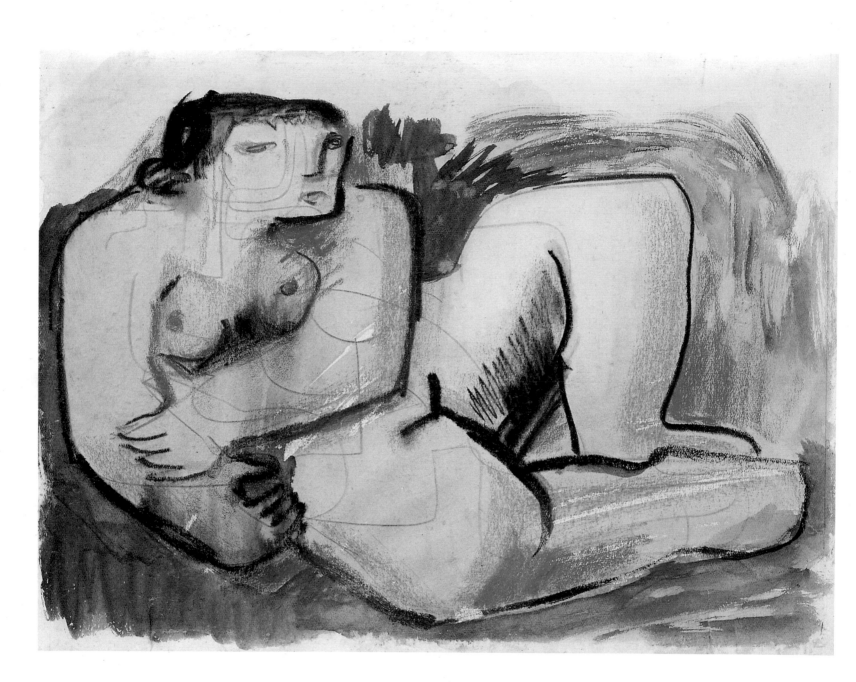

19
Study of Reclining Nude I 1930
pencil, ink, chalk, wash
151 x 222 mm
The British Council, London
HMF 786

20

Study of Reclining Nude II 1930
ink, chalk, wash
130 x 216 mm
The British Council, London
HMF 787

In the late 1920s the female Reclining Figure
became Moore's principal theme for
sculpture. Three drawings of 1930 relating to
it suggest how wide a theme it was for him at
that stage, and of course the rest of his career
shows Moore finding ever new forms and
meaning for and in it. Cat. 19 is close in form
and spirit to the milestone carving in brown
Hornton stone in Leeds City Art Gallery LH
59, as suggested by the emphasis on the mass
and angularity of the legs and the structural
role of the right arm; the chief differences are
that here the carved head looks along the line
of her right shoulder and her left arm is
raised, the hand touching the back of her
head. The openness of her belly (not having
the arm crossing it) and the turn and
alertness of the head link the Leeds carving to
cat. 20, altogether a gruffer, more summary
representation.

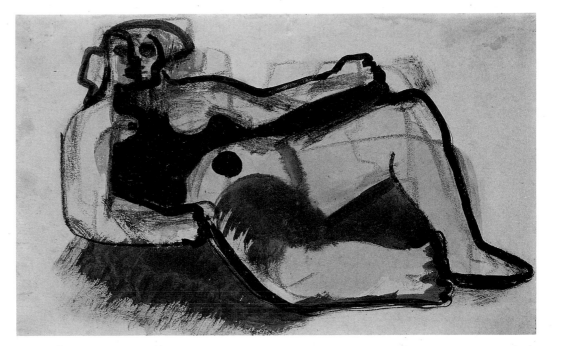

21

Study of Reclining Nude III 1930
ink, chalk, wash
150 x 222 mm
The British Council, London
HMF 788

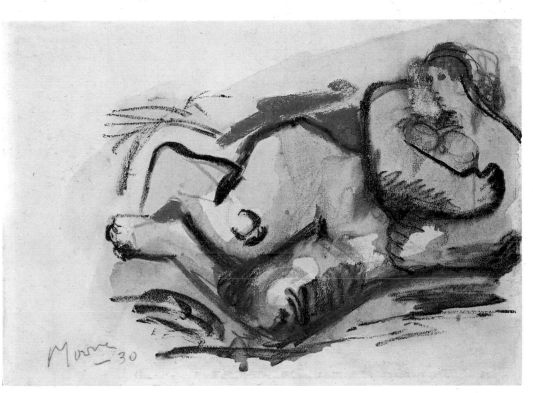

For all its formal similarities to both the
previous studies, this is utterly different in
spirit. The opposed orientation, with the head
of the figure to the right of the drawing,
allows less prominence to her legs and
abdomen, and here the legs are closed. The
body is massive, the head tiny in comparison,
and the whole figure is experienced more as
softness and fluency than as a thing of weight
and structure. It is possible that Moore was
here reflecting some influence from painters'
nudes, notably those of Matthew Smith who
painted and exhibited a series of nudes in the
1920s, often generous in form and rich in
colour. Smith had studied under Matisse and
lived and worked partly in England, partly in
Paris.

22

Reclining Figure 1930
H 17.1 cm bronze edition of 2
The Henry Moore Foundation
LH 85

This is a bronze version of a figure Moore carved in ironstone. It is tiny, and perhaps for this reason alone is quite different in feeling from the Leeds sculpture (LH 59, see cat. 19) and from other large figures sculpted by Moore in the 1920s. It is an object in the nature of an amulet and its composition gives it almost a relief character. Rhythmic curves outline it; gentle swellings and recessions deliver the anatomical detail. Yet it has little of the sensual appeal of the curvilinear nude in cat 21.

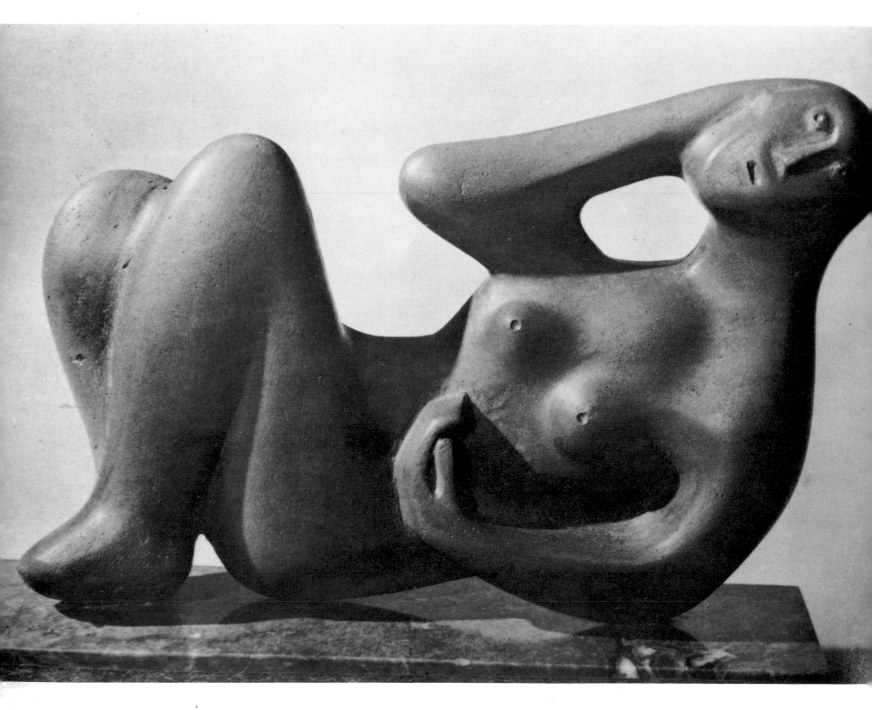

Reclining Figure 1930

23
Reclining Figure 1931, cast 1963
L 43.2 cm bronze edition of 6
The Henry Moore Foundation
LH 101

Moore modelled this figure in 1931 and himself cast it in lead. Lead, with its relatively low melting point, can be cast quite simply by the lost-wax process. In modelling the figure Moore seems to have had lead in mind. Its surface has the slippery character of lead, and he modelled stretched lines, limbs, curves and edges that work well in the material. The result is one his more discordant figures, almost satirical in its treatment of the head and limbs, its displacement of the breasts and exaggeration of the pubic mound. Especially disquieting is the barred hollow which is her chest. Those bars pre-echo the stringed sculptures of which cats. 35–7 are good examples, but here they speak of imprisonment and exclusion, and trigger anxiety. In 1963 the sculpture was cast in bronze, as here.

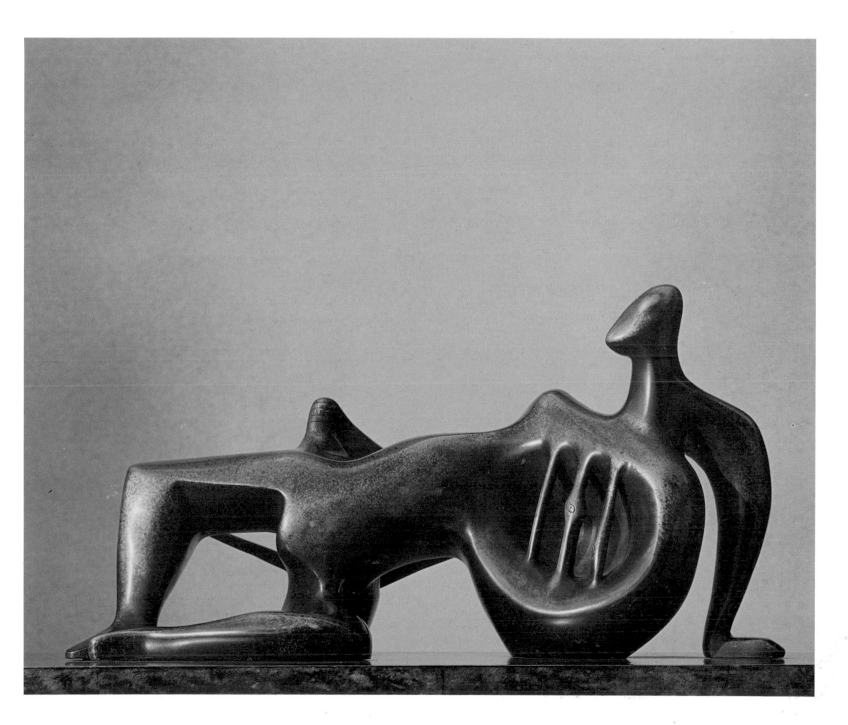

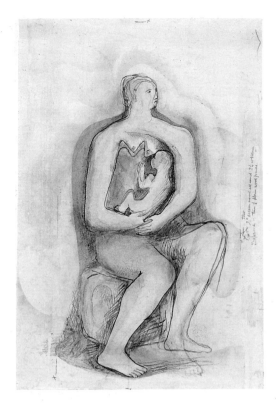

24 (left)
Seated Mother and Child 1933
charcoal, washed pastel, pen and black ink,
brush and black ink
556 x 374 mm
The Henry Moore Foundation
HMF 1001

These two contrasting representations of
seated women, done at about the same time,
show Moore's continuing investigation into
languages of representation and the meanings
they bear. The gentle, linear image of Mother
and Child develops the theme of breasts as
almost independent and expressive features
though the context is unusually naturalistic.
Naturalistic too is the child sketchily shown in
the woman's arms, yet the way this part of the
drawing is developed makes a shrine of the
woman's body.

The play of protuberance against
hollowness is implied in the much more
abstracted, quasi-Surrealistic seated women of
cat. 25. The treatment of the breasts and
sternum of the woman on the right heralds
Moore's dramatic development of the breasts
and stomach in cat. 81. The anti-naturalistic
treatment of the two figures, combined with
the nightmarish quality of their faces – one of
which suggests a clock face – lends them an
awesome character as threatening presences.
(See also cat. 116, a tapestry based on a
drawing of 1943.) Moore was not to attempt
such dramatics in sculpture until much later,
though in the early 1930s he did venture more
closely than ever to complete abstraction.

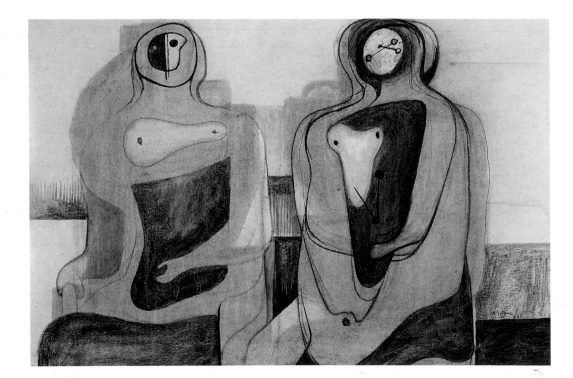

25 (above)
Two Seated Women c.1934
charcoal (rubbed and washed), watercolour
wash, pen and Indian ink, black crayon
370 x 553 mm
The Henry Moore Foundation
HMF 1077

26 (right)
Composition 1931
L 41.5 cm Cumberland alabaster
The Henry Moore Foundation
LH 102

In **Composition** the forms are again
exaggerated or grievously diminished, yet the
sculpture is much more harmonious than cat.
23. The head is severely simplified, though
without losing its alertness; it seems that
Moore wanted to avoid characterising his
figures by giving them faces in which we
would be able to read this or that expression.
The shoulders, arms and fists can be read as
aggressive and are certainly strong, but the
breasts are tender and the meaning of the
whole seems to have more to do with
motherhood and protection than with attack.

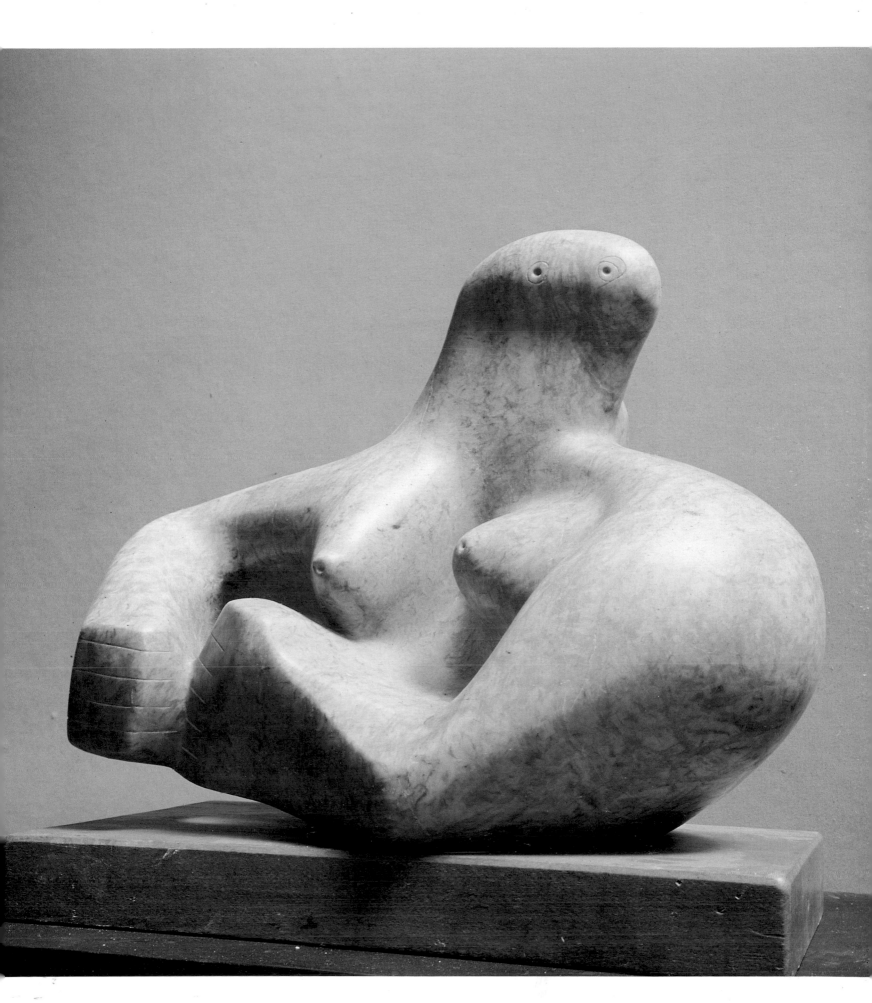

Carving 1934
H 9.8 cm African wonderstone
The Henry Moore Foundation
LH 142

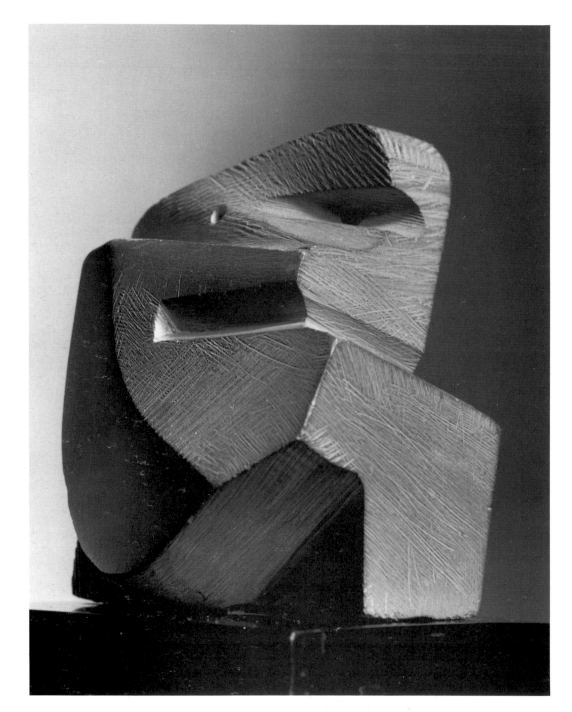

It is likely that this carving was conceived as an abstract work, without reference to anything outside itself, a thing of forms related only to each other. The urge to give identity even to something considered abstract is strong, however, and it is possible that no form is conceivable that does not also incorporate some significant memory. So we note recesses drilled into the upper part of the sculpture, call them eyes and instantly read that upper part as a sort of head – of a reptile, perhaps. Other readings are possible; what is difficult, if not impossible, is to encounter the piece without attributing some meaning to it. It is likely that this carving owes some impulse to Giacometti's contemporary sculptures.

Page from Sketchbook
Simple Shapes 1935
pencil 273 x 181 mm
The Henry Moore Foundation
HMF 1182

Page from Sketchbook
Ideas for Sculpture 1935
pencil 272 x 183 mm
The Henry Moore Foundation
HMF 1187

Page from Sketchbook
Ideas for Sculpture 1935
pencil 272 x 183 mm
The Henry Moore Foundation
HMF 1188

'Try to get out of simple shape the effect of power and human intensity'. As Moore worked on the quick sketches shown in a 1935 sketchbook, he talked to himself with words as well as formal ideas. There was no thought of these words becoming public, but we cannot ignore them. What did he mean by 'simple shape[s]'?

The upper half of cat. 28 was used up mainly by vertical three-quarter figures in varying degrees of metamorphosis from natural appearances. Then the instruction to himself, and, close by it, a relatively 'simple shape', an idea for a rounded carving with, it seems, a hole cut right through it. In 1932–3 he had for the first time pierced through his carvings and had found doing this 'a revelation', leaving us to ponder the implications of penetrating matter, linking near side to far, letting light and air come through, and so on. Such holes are indicated in other drawings on this sheet, but the most striking fact about this group of sketches,

probably done in quick succession, is that some might be called abstract, others are certainly figurative, whilst they all belong more or less to one family. Abstract and figurative are not opposites here but neighbours with no frontier between them, in theory or in visual fact.

The same can be said of cat. 29 with its standing and reclining figures, its heads and, among them, what must be a half-figure image of Mother and Child (lower centre).

Cat. 30 includes a sketch for one of the seated women in cat. 25 among what are mostly very swiftly noted ideas for figures.

different succession, from the solid head-like carvings of the early 1930s, as in cat. 27, to the rock-like two- and three-piece bronzes of the 1960s and occasional squarish pieces such as the four elements making up the **Time-Life Screen** 1952–53 LH 344. Moore's progress was marked by two or three main pursuits, at any one time flanked by any number of excursions. Little was investigated that did not bear fruit at some time. The black images here tell of monumental carvings hinting at Reclining Figures whilst not moving far from the originating block of stone. The drawing is not unique in this period; it represents an idea persisting in Moore's mind and demanding exploration.

32 (right)
Carving *c.*1936
H 45.7 cm Travertine marble
The Henry Moore Foundation
LH 164

Moore carved a number of Square Form sculptures, beginning in 1934: succinct shapes that speak of the block from which they are carved but take on a quality of life through the sculptor's action on them. Some of them recall pre-Columbian Mexican sculpture. This piece, which is related to the series, bears on its upper plane a composition of raised and recessed geometrical forms that recalls the reliefs carved by Moore's friend Ben Nicholson at this time. (Nicholson's reliefs were hand-carved into hard wood.) They were considered Constructivist art in the 1930s but are neither Constructivist in principle nor far removed from Nicholson's still-life paintings in spirit. That Moore's version is not even rectangular in format but rounded and more or less symmetrical about its long axis gives his composition the character of an abstracted face and the whole sculpture the suggestion of a head, its face upturned to the heavens.

31
Square Form Reclining Figure 1936
black chalk, black ink wash
555 x 392 mm
The Henry Moore Foundation
HMF 1242

The 1930s saw the sculptor opening up the figure more and more, dividing it into Four-Piece Compositions in 1934 and having it flow as one linear structure in space with minimal mass in 1936 and 1938. But Moore never pursued only one idea or one technique. The Reclining Figure ideas he brought together in this drawing belong to a quite

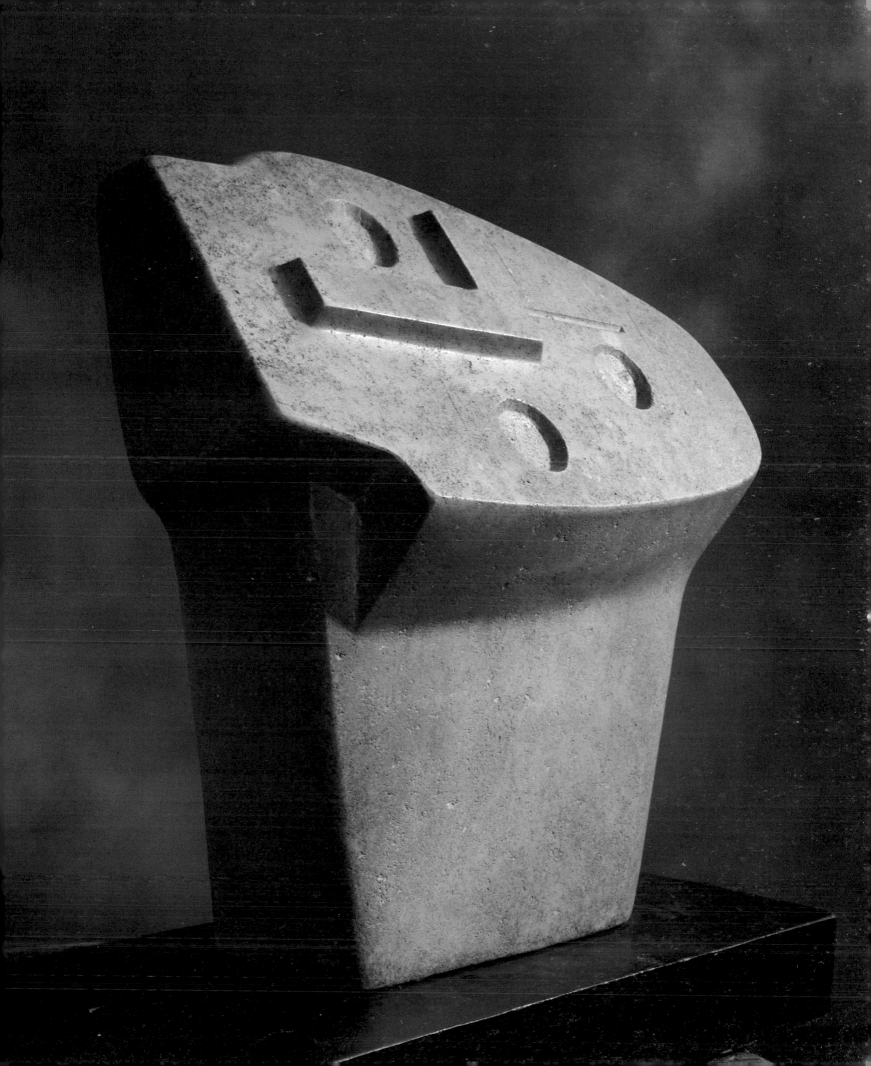

33
Five Metal Forms 1937
chalk, crayon
387 x 559 mm
City Art Gallery, Wakefield
HMF 1317

From 1937 Moore made a number of developed drawings of ideas for sculpture lined up on a pictorial stage as though on parade. Sometimes these imagined sculptures are drawn so elaborately, with full modelling, that one is tempted to think that the sculptures exist and the drawings were done from them, but this is not generally so. In some of these drawings we do find ideas for sculptures made subsequently and representations of sculptures made recently, but mostly these were, and remained, ideas.

The impulse to this kind of drawing, in which the artist gives enhanced reality to his imaginings, came from French Surrealism and from Picasso's invented *Anatomies*. The Picassos encouraged Moore to test all sorts of formal groupings for their power to suggest figures, and then also to place them side by side; Surrealism showed the dramatic force of representing imaginary objects by graphic means that make them seem real. In this instance, as in some others, Moore associated his drawn forms with metal. He did not

specify whether he meant construction in sheet metal and rods or sculptures cast in metal; it seems likely that he did not want thus to restrain the play of his imagination.

34
Drawing for Sculpture 1937
chalk, watercolour, gouache
483 x 546 mm
The Henry Moore Foundation
HMF 1325

Like cat. 25, this drawing suggests two seated
figures. They seem far removed from
realisation as sculpture; we receive them as
purely graphic inventions of marked
expressive force.

35
Stringed Mother and Child 1938
L 12.1 cm bronze and string
The Henry Moore Foundation
LH 186f

Moore, like the Paris Surrealists, was interested in mathematical models as a source for art alternative to nature. In the Science Museum in London he could study and draw models that used string or wire to show lines in space. He was also aware of Naum Gabo's use of line to form dematerialised planes; the Russian sculptor was resident in England during 1935–44 and was well known to Britain's avant-garde artists. This said, it is of course striking that Moore should use this novel process, with links both to Surrealism and Constructivism, as a means of refreshing his development of the Mother and Child theme.

In cats. 35 and 37 the lines of string are psychological ties made visible; in cat. 36 they recall the strings of a musical instrument, adding a notion of sound to an otherwise strikingly mute head.

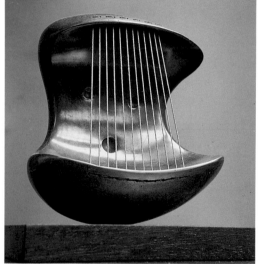

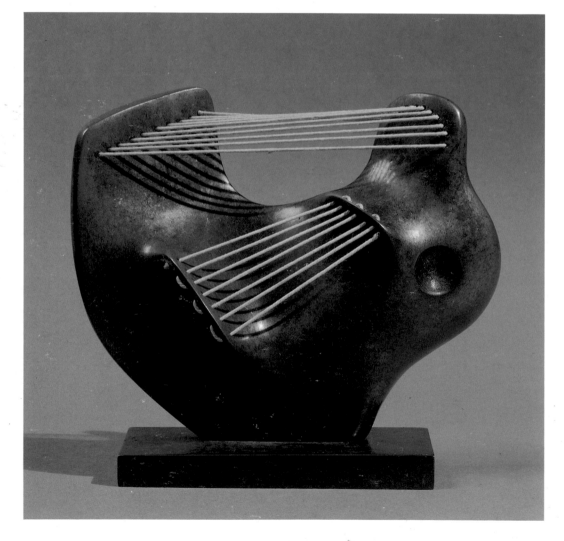

36 (above)
Head 1939
H 13.7 cm bronze and string edition of 6
The Henry Moore Foundation
LH 195

37
Mother and Child 1939
L 19 cm bronze and string edition of 7
The Henry Moore Foundation
LH 201

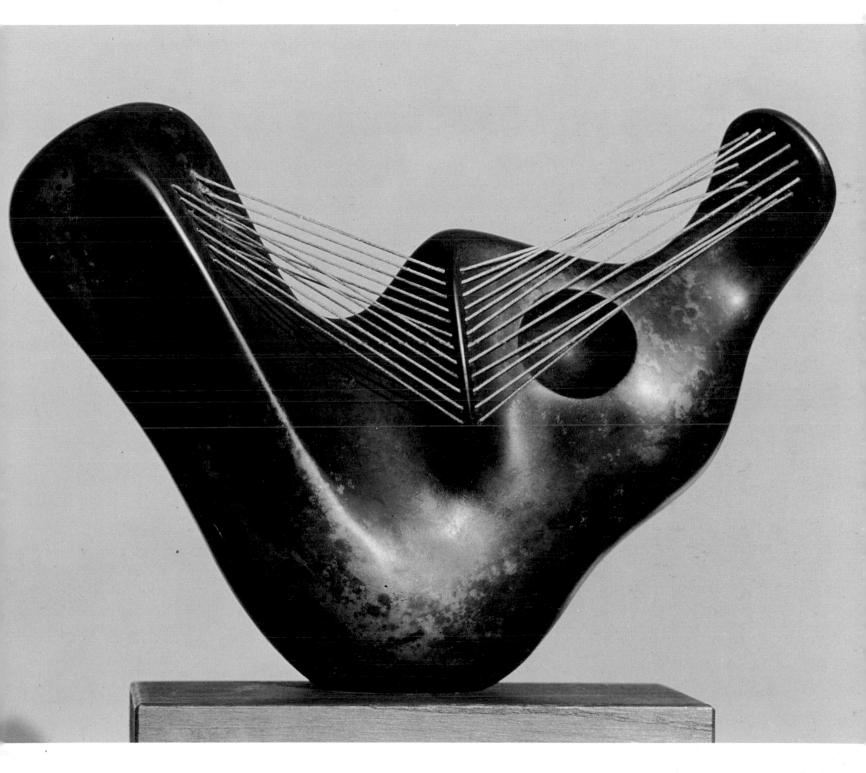

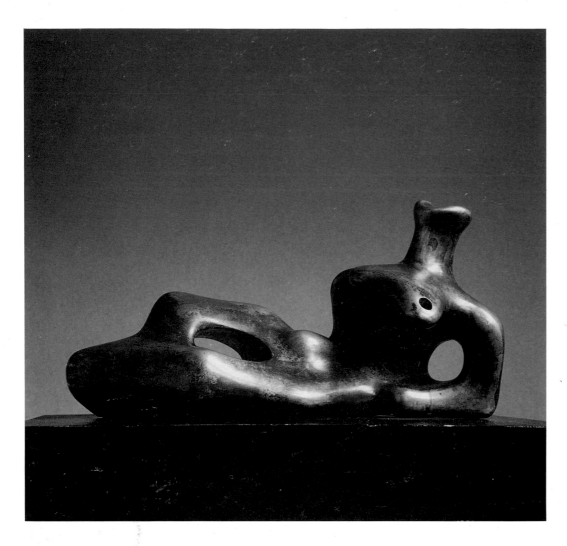

38
Reclining Figure 1939
L 27.9 cm bronze edition of 3
The Henry Moore Foundation
LH 202

Encouraged by Picasso and Surrealism, Moore continued his investigation into what one may describe as the almost infinite suggestibility of the imagination, ever ready to endow forms with human meaning. It is always with us, and in exploiting it the Surrealist artists had found a rich vein for visual exploration, matching the poets' work in the labyrinthine mines of words and verbal associations. It may be significant that the German Surrealist, Max Ernst, then working in Paris, had visited Moore in 1938, but it must also be stressed that Moore chose not to declare himself a Surrealist or as belonging to the opposite camp of the Constructivists: both, in his view, were valid.

The two bronze maquettes shown here, both of 1939, may suggest contradictory modes of expression. Cat. 38 is mellifluous and, considering how far it is removed from what we consider woman's normal appearance, rich in hints of femininity and sensuality. Cat. 39 is less inviting, tenser, though here too a sense of femininity is preserved. Cat. 38 implies thoughts of carving; cat. 39 must have been done as a maquette for a modelled figure to be cast in bronze and thus able to sustain those attenuated, nervous forms.

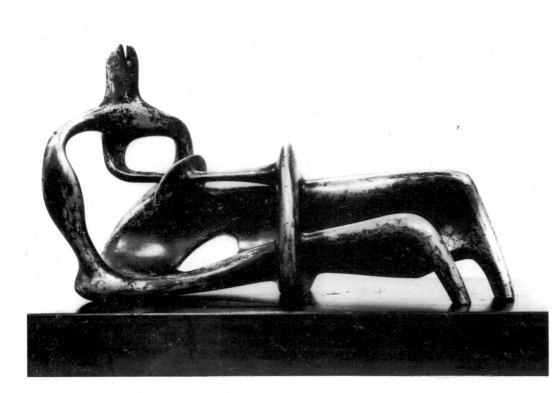

39
Reclining Figure 1939
L 33 cm bronze edition of 9
The Trustees of the Tate Gallery, London
LH 208

40

Studies for Sculpture in Various Materials

1939

pencil, white wax crayon, yellow crayon,
watercolour, pen and Indian ink, black crayon

254 x 432 mm

The Henry Moore Foundation

HMF 1435

This dense crowd of figurative ideas, not a
parade here so much as a dream or a Last
Judgement, has been developed by Moore to
make an exceptionally rich and persuasive
pictorial image. The studies float in space and
overlap, some clear, some scarcely legible. We
can distinguish seated and reclining figures,
some Mother and Child ideas including a
stringed sculpture, but mostly they are
discrete figures and upright. Generally the
forms are organic, echoing the shapes of
bones, shells and pebbles which the sculptor
explored with growing attention from the
early 1930s on. But there are echoes also of
Picasso's *Anatomies*, and in the centre there
appears to be the winged horse of inspiration,
Pegasus, which could also have been
suggested by Picasso.

41
The Helmet 1939–40
H 29.2 cm bronze
The Henry Moore Foundation
LH 212

This first Helmet was originally cast in lead, hence the smooth shell of the external form and the fluent lines of the standing figure inside. We associate helmets with warriors and warriors with men so that, for the first time in this selection, and almost for the first time in Moore's sculpture, we meet a masculine image. It embraces a female form, and thus might be interpreted as an image of man's preoccupation with woman. But this sculpture was made in the first months of the Second World War, and so it is likely to mark the artist's response to the dreadful uneventfulness of that period when England daily awaited air-raids of unknown ferocity. The Helmet was developed in subsequent sculptures; the idea of pairing an external and an internal form, hinted at in earlier works such as cat. 24, was later to become one of Moore's most powerful themes.

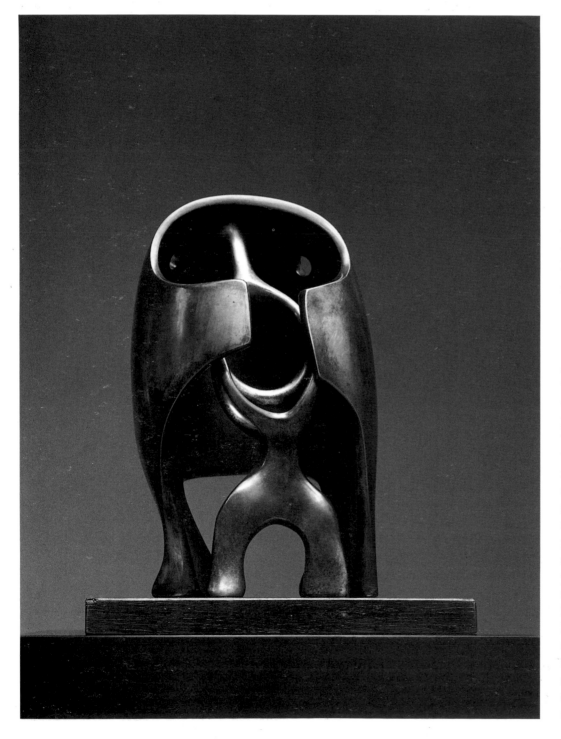

42 (right)
Artist and Model 1940
pencil, watercolour, black ink and crayon
368 x 280 mm
Whitworth Art Gallery, University of Manchester
HMF 1504

Artist and Model is a subject rare in Moore's work, though of course we may argue that every drawing or sculpture implies the artist's presence and then also our own. For Picasso the subject was an obsession, a means of testing as well as describing and often mocking his activity as artist and also his sexual urges. Moore offers us a strong, almost monumental treatment of the theme, iconic rather than narrative. Its mood is grave – perhaps because of the war, though it is striking also that the model avoids eye contact with the artist and that the two almost symmetrical figures are divided rather than linked by the panel on which he is working. His face is not detailed and gives no hint of expression; hers seems grim. The proportions of the figures – small heads and thin arms against expanded torsos and, especially in her case, mighty thighs – would reappear in his sculptures of the 1940s.

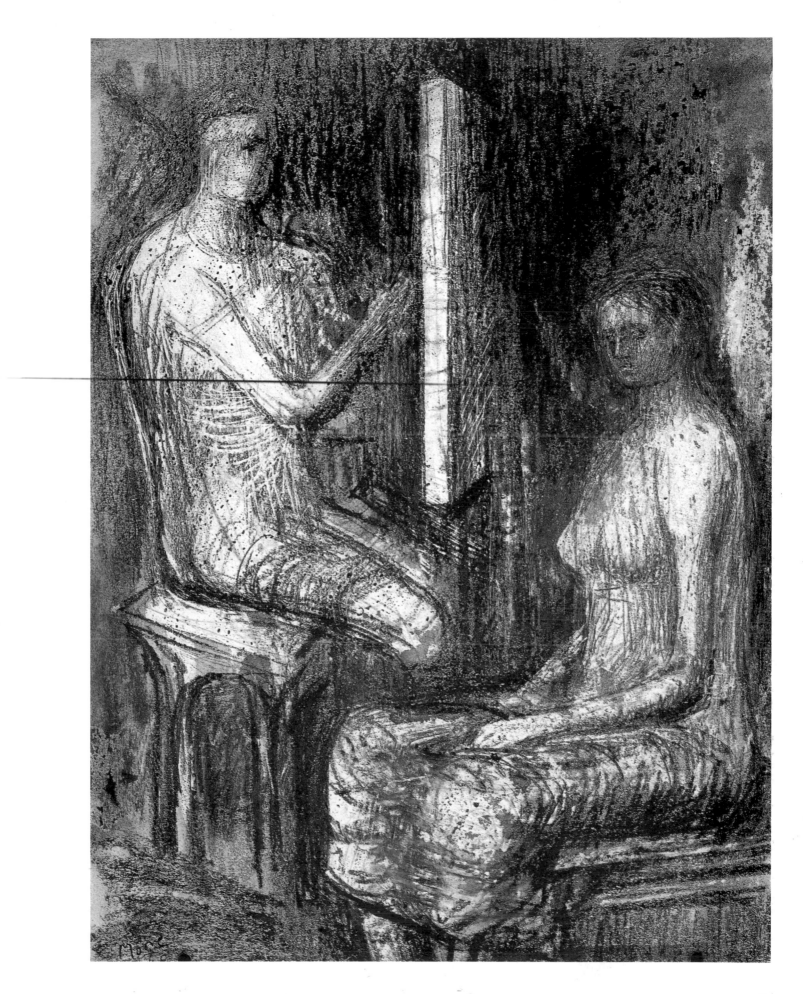

43
Studies of Reclining Figures 1940
pencil, white wax crayon (scraped in places),
pastel, watercolour wash, coloured wax
crayon, gouache, pen and Indian ink
380 x 556/560 mm
The Henry Moore Foundation
HMF 1478

This dreamlike image again hints at the world
of Surrealism, but the main figures in this
drawing belong to the sequence of benign,
generously curved and spatial stone and wood
carvings that Moore produced in the late
1930s, some large, others quite small (see
cats. 38 and 39).

44
Shelterers in the Tube 1941
pen and ink, chalk, crayon, watercolour
381 x 559 mm
The Trustees of the Tate Gallery, London
HMF 1797

'I saw hundreds of Henry Moore Reclining Figures stretched along the platforms. I was fascinated, visually' [Darracott]. Moore's own words make an all-important point about his Shelter Drawings. They made him popular: the mad modernist artist of the cartoons, who obviously did not know what shapes women had in real life or merely sought notoriety by abusing them, was suddenly seen to be moved by common human sympathies and capable of making images that many could appreciate. Yet the fact is that Moore's visiting the Underground shelters was a sort of homecoming; perhaps several sorts of homecoming. It was as though reality had moved to meet him. We are told that it was the people of London who turned the platforms and unused tunnels of the Underground system into nightly shelters.

Officialdom had been against it, wishing to keep these stations and ancillary spaces clear for 'troop movements and essential services' [Darracott]. The sheltering people turned themselves into Henry Moores. 'Hundreds of Reclining Figures': that says much of it. His favourite motif and theme.

There are in the drawings many echoes of his previous work, seated women and reclining ones, Mother and Child as well as single figures. He made notes to himself on the sketches: '3 or 4 people under one blanket – uncomfortable positions, distorted twistings . . . Two figures in sleeping embrace. Masses of sleeping figures fading to perspective point of tunnel. Groups of people sleeping, disorganised angles of arms and legs, covered here and there with blankets'. The experience, he said, 'humanised everything I had been

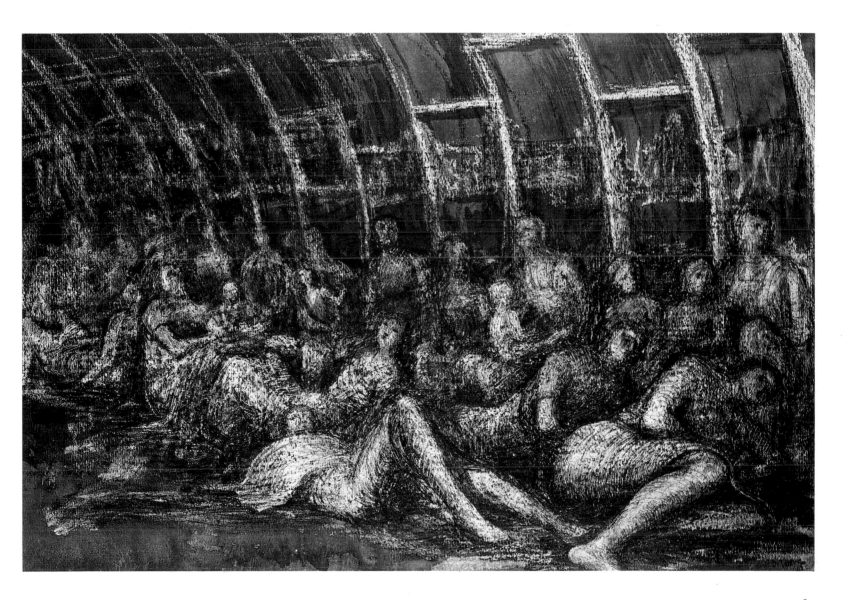

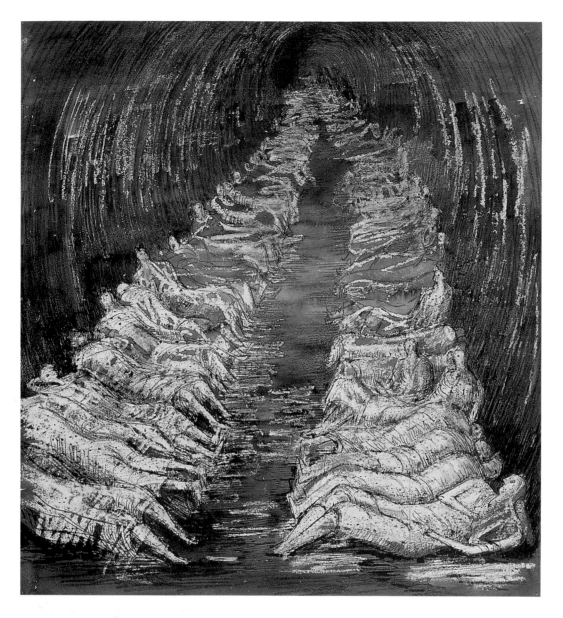

45
**Tube Shelter Perspective, The Liverpool
Street Extension** 1941
pen and ink, chalk, crayon, watercolour
477 x 432 mm
The Trustees of the Tate Gallery, London
HMF 1801

doing' [Darracott]: notice the past tense, not 'I
was to do from now on'.

It was not only the German onslaught that
made this such a major event: common
danger produced common sympathy, even
intimacy, in a land not noted for its social
warmth. The British may be said to have
found themselves amid this extremity;
Londoners certainly did. But what moved
Moore was not merely national and local. He
said, for example, that 'the only thing at all
like those shelters that I could think of was
the hold of a slave-ship on its way from Africa
to America, full of hundreds and hundreds of
people who were having things done to them
that they were quite powerless to resist'
[Darracott]. But no doubt he sensed in what
he saw and in the images he made elements
of Dante, of Michelangelo's Ancestors of
Christ in the lunettes below the Sistine
Ceiling, and of many other Renaissance
painters from Giotto to at least Piero. It is
possible that recollections of Cézanne's
Bathers were fed into some of the developed
drawings; I believe that prints by the German
sculptor Barlach contributed. The artistic
hinterland is infinite.

What is new about these drawings for
Moore's art is the central motif of people in
quantity, of people forced by circumstances
into unwonted togetherness, of mass society
as a physical presence. His warm, perhaps
grateful, response may bear in it memories of
the Moore family crowded into a little
Castleford house, but it may also prove a
conversion in Moore's view of the world. In
spite of his family background and the
support and encouragement which the young
Moore had received from them in becoming
an artist, one senses that, for all his friendly
social ways, the adult Moore was inclined to
solitude. He was not one for crowds, or even
for groups (which may have contributed to his
staying clear of Surrealist and Constructivist
circles). His sculpture had been of single
figures or of the tight unit we call Mother and
Child. In his recent drawings, however, he
had repeatedly turned to groupings and even,
on occasion, to something like a crowd, as
though, unconsciously no doubt, he were
reaching out through his art towards a wider
involvement in mankind (see particularly cat.
40). Single figures would continue to
dominate the work to come, but it is ➤ 72

46
Shelter Scene: Bunks and Sleepers 1941
pen and ink, wax crayon, watercolour, gouache
482 x 432 mm
The Trustees of the Tate Gallery, London
HMF 1789

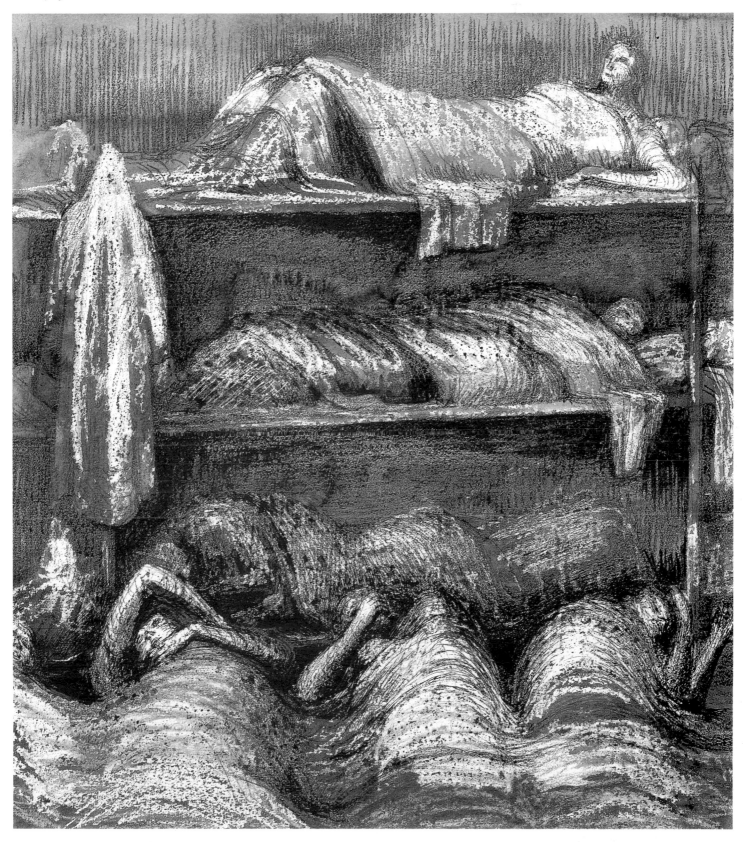

47

Group of Draped Figures in a Shelter 1941
pen and ink, chalk, crayon, watercolour
and white gouache
324 x 586 mm
The Henry Moore Foundation
HMF 1807

striking that after the war he was to be admired for his Family Group sculptures (he had proposed doing one shortly before the war when he was invited to make a sculpture for a new school, designed by Gropius).

The technique Moore used for these drawings was also new. He had happened by accident on the combination of wax crayons and watercolour, and found it an effective means of showing light figures in a dark setting. It enabled him to parallel the dimness of the shelters, not well lit before the war and now, with total darkness required at the stations' entrances and all possible economy with electricity and equipment demanded below ground, thoroughly gloomy places. He had been invited to make these drawings by the War Artists' Advisory Committee, chaired by Sir Kenneth Clark. Moore had in any case decided not to attempt any major sculpture at this time; he guessed that war would interrupt any large undertaking. So the commission was timely as well as psychologically apt. He had in fact begun to sketch in the shelters

before the commission came, so it is almost certain that the idea came from him and was brought to the Committee by Clark. A book of reproductions of some of them was published with great success in 1944.

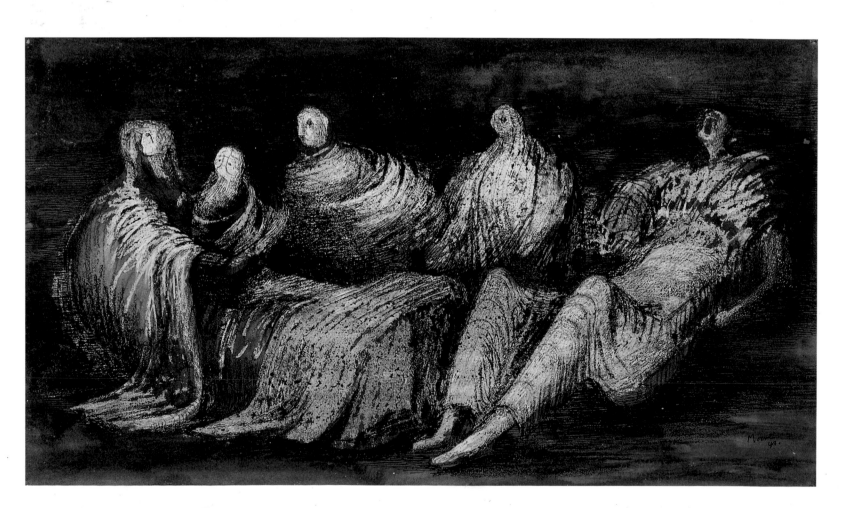

48
Shelter Drawing: Sleeping Figures 1941
pencil, watercolour wash, black crayon, pen and ink
303 x 308 mm
The Henry Moore Foundation
HMF 1816

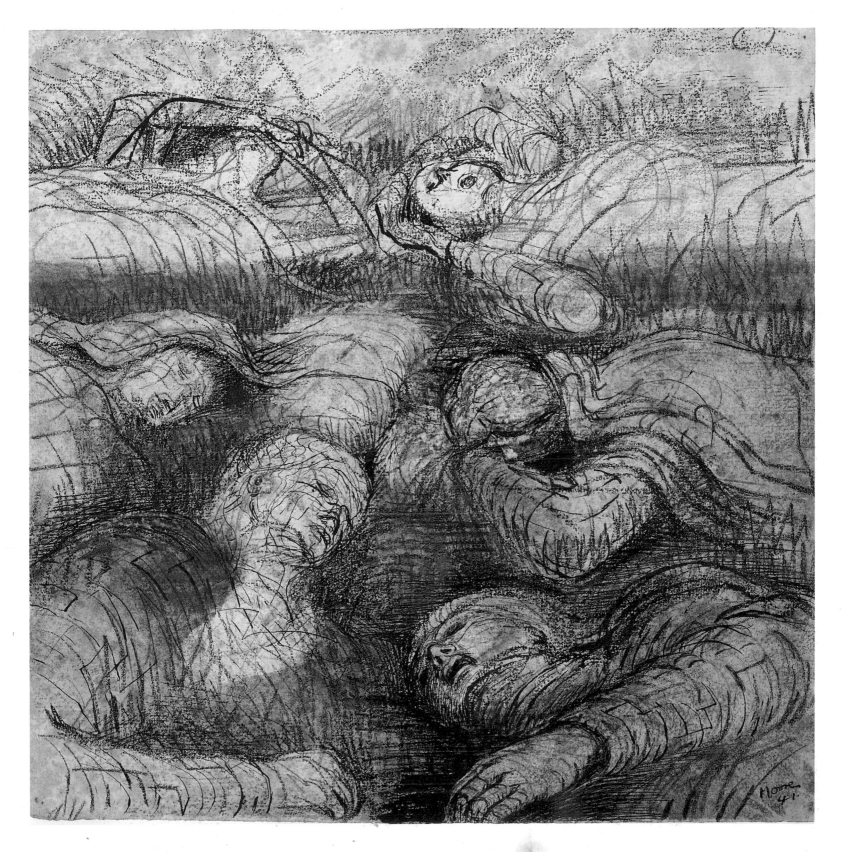

49
Mother and Child among Underground Sleepers 1941
pencil, wax crayon, watercolour, pen and Indian ink, gouache
485 x 439 mm
The Henry Moore Foundation
HMF 1798

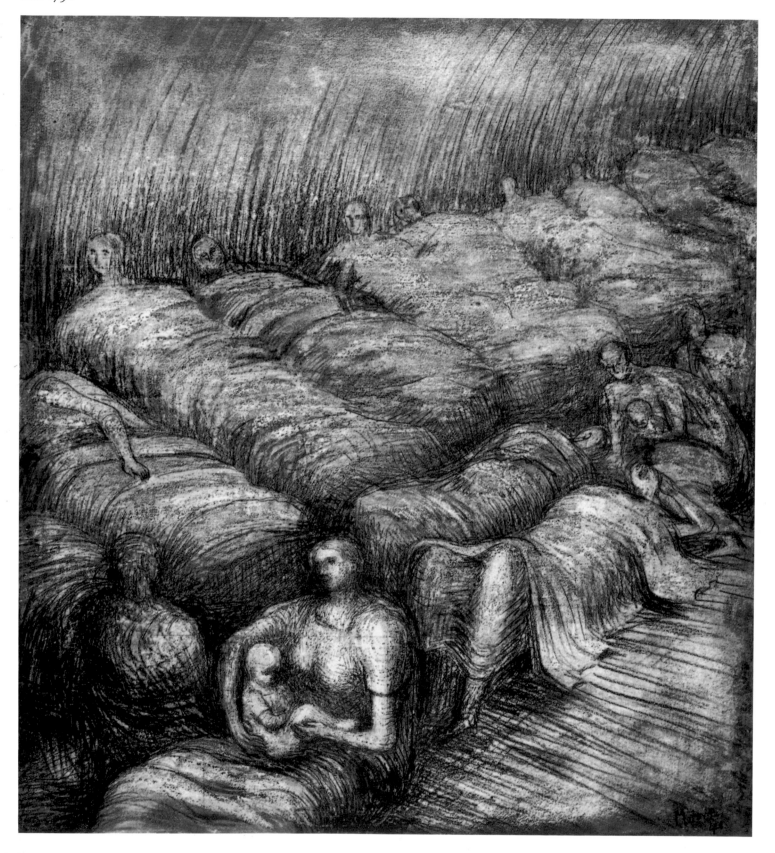

50
At the Coalface 1942
pen and ink, chalk, crayon, wash, watercolour
348 x 562 mm
Leeds City Art Gallery
HMF 1996

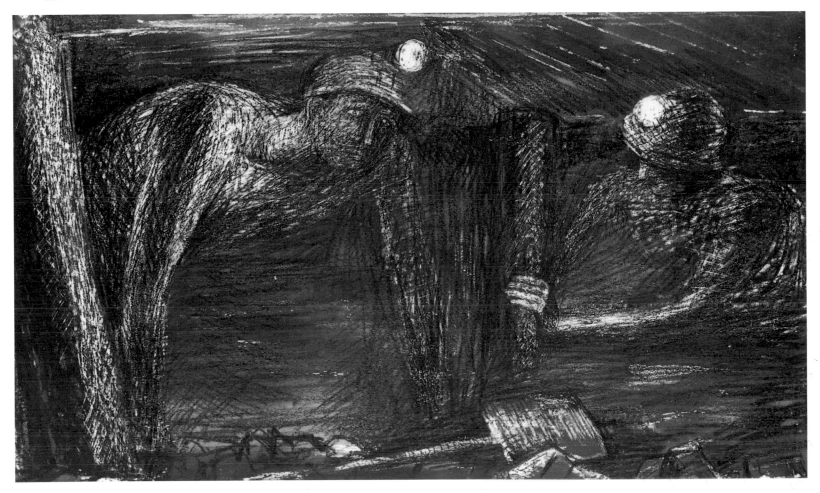

The idea that the War Artists' Advisory Committee should invite Moore to draw coalminers at their work came from Herbert Read, the poet and critic, a Yorkshireman like Moore. This too must have seemed a kind of homecoming, a return to Castleford and the world of mining Moore knew so well from his father, maternal grandfather and other relatives and friends: the working class of Castleford naturally turned to mining. Yet he spoke of it as a commission 'coldly approached' [Clark 155]. Did he now feel estranged from Castleford and perhaps embarrassed to return there from so different a world? His family had left long ago. Did he who had been so determined not to join his schoolmates down the mines feel that visiting them there was like entering a trap? He spent a lot of hours down in those claustrophobic tunnels deep underground, more than he need have done had it been a matter merely of ordinary fear. It may well be that he was not at home, or at home now, in the company of working men: it was women he had worked with and on ever since he left art school.

Moore gained something from the adventure. 'I had never willingly drawn male figures before – only as a student in college. Everything I had willingly drawn was female. But here, through these coalmine drawings, I discovered the male figure and the qualities of the figure in action. As a sculptor I had previously only believed in static forms, that is, forms in repose' [Darracott]. Subsequently he included male figures in his range as sculptor, in his Family Groups and the **King and Queen** (cat. 71), and then also alone in a sequence of Warrior sculptures. The drawings he made in the mines certainly yielded him transcriptions of the male body that he could use in sculpture: notice especially the broad, shell-like back of the miner in cat. 51. The experience also sharpened his sense of figures in a dramatic setting and of black itself as a dramatic agent.

51
Miner at Work 1942
ink, chalk
492 x 495 mm
The Trustees of the Imperial War Museum, London
HMF 1987

76

Madonna and Child 1943
H 18.4 cm bronze edition of 7
Private collection, New York
LH 222

Moore was not the only British artist to adopt
a more popular – in some cases, a more
obviously British – idiom at the onset of war.
That certainly was a time for taking strength
from Britain's physical separation from the
Continent. Some cut all links with the
modern art they had acquired from across the
Channel and which had recently gained
energy here from the presence in London of
Gabo, Mondrian, Moholy-Nagy and other
foreign artists. Others made their work less
wholeheartedly modernistic. Moore's work
certainly moved closer to naturalism. Since he
had not adhered to any of the 'isms' promoted
around him, this did not involve a change of
position or allegiance. We could say he moved
closer to the relatively naturalistic work he
had sometimes done in the 1920s (see cats. 3,
5, 9, 10). During 1933–35 he had drawn some
exceptionally fine and altogether classical
nude studies of his wife. So he was not
abandoning his own terrain. He was,
however, abandoning the harsher temptations
of Surrealism, its invitation to transform the
known and loved into its threatening,
monstrous opposite. Later he would return to
this threshold of the psyche; for the present,
he needed calmer seas and broader horizons
for himself, and in this he echoed the needs
of his fellow creatures.

The success of the Shelter Drawings
brought Moore the commission to carve a
Madonna and Child for the parish church of
St Matthew's in Northampton. Of course the
idea attracted an artist who so often thought
of and worked at images of the Mother and
Child. He knew that the religious context
called for a more formal, more permanent
embodiment, something more hieratic. The
three maquettes exhibited here show some of
the steps in the process.

Cat. 54 is very close to the carving itself: a
strong but essentially classical statement,
given elements of rhythm and movement by
the heavy lines of drapery across the legs. Cat.
53 is more the naturalistic Mother and Child,
any young woman with any child: they are in-
turned, psychologically excluding us. Cat. 52

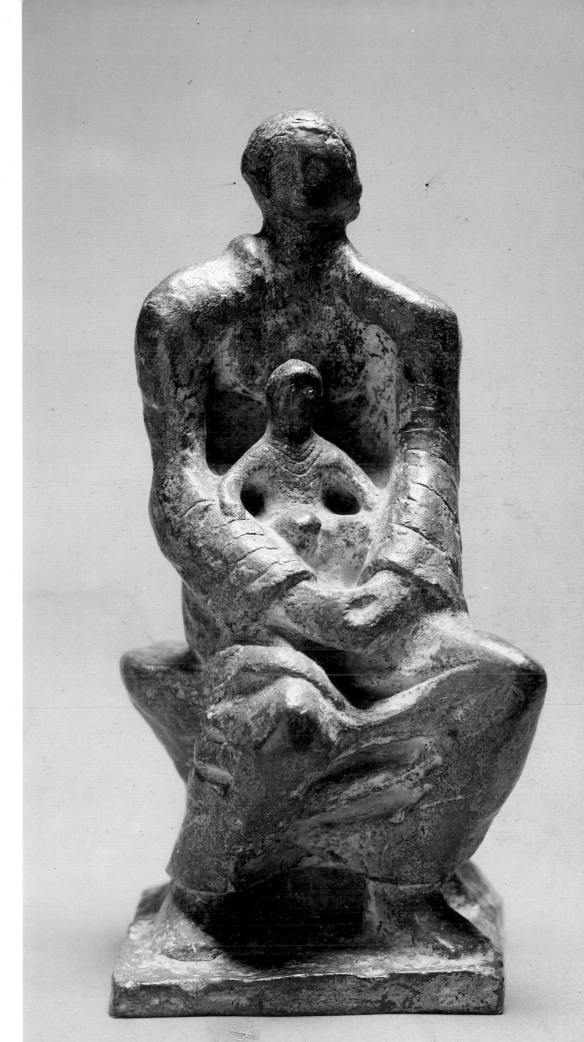

53
Madonna and Child 1943
H 14 cm bronze edition of 7
The Henry Moore Foundation
LH 216

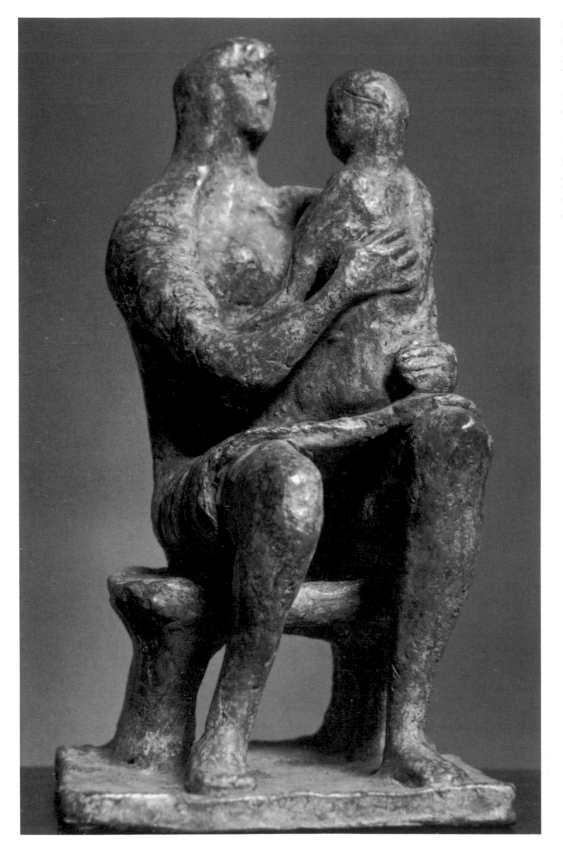

is the most formal, almost a Byzantine icon in sculptural form in the frontality of Mother and Child and in the enshrining of the child by his mother's arms. Cat. 54 retains something of that formality yet is also less courtly.

It has to be added that the carved Madonna, now one of Moore's best loved works, met with fierce criticism from parishioners and others who felt that their church, their faith and art itself had been desecrated by it.

54
Madonna and Child 1943
H 15.2 cm bronze edition of 7
The British Council, London
LH 224

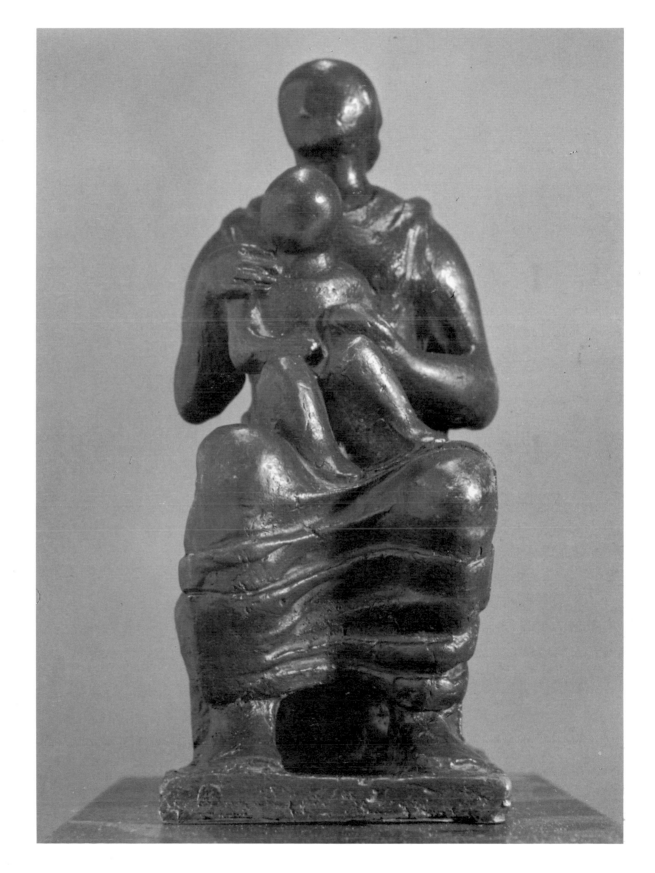

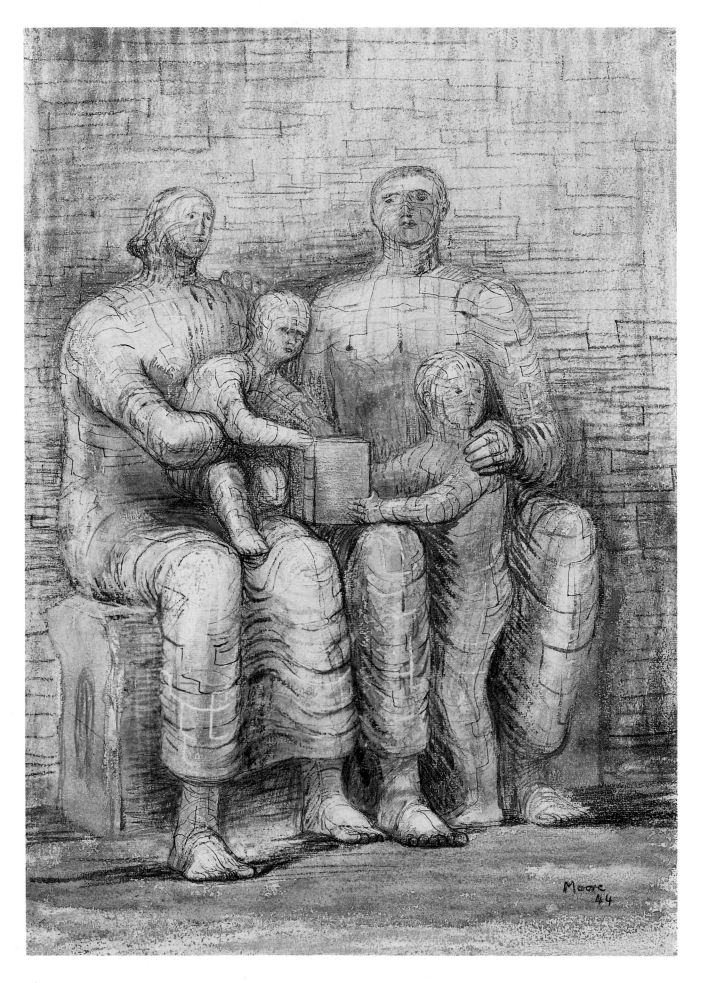

55 (left)

Family Group 1944
pencil, coloured crayon, pastel, watercolour
wash, pen and Indian ink
549 x 892 mm
Private collection, New York
HMF 2237

Mention has been made of the emerging of
the Family Group theme in Moore's work (see
cat. 44 etc.). He drew a number of such
groups in 1944, in some of them, as here,
emphasising the three-dimensionality of the
forms yet setting the group against a wall.
Using the crayon plus watercolour technique
he had used in the Shelter Drawings, Moore
here asserts the volume of every part. His
lines follow the volumes horizontally and
divide them vertically so each mass seems to
be shown as blocks, almost as though the
drawing had been done to instruct a
stonemason. Having recently given much
thought to Madonna images, he cannot have
been unaware of the religious overtones
carried by Family Groups. When there are two
children, the older one suggests St John the
Baptist, often included in Renaissance
treatments of the Madonna and Child.

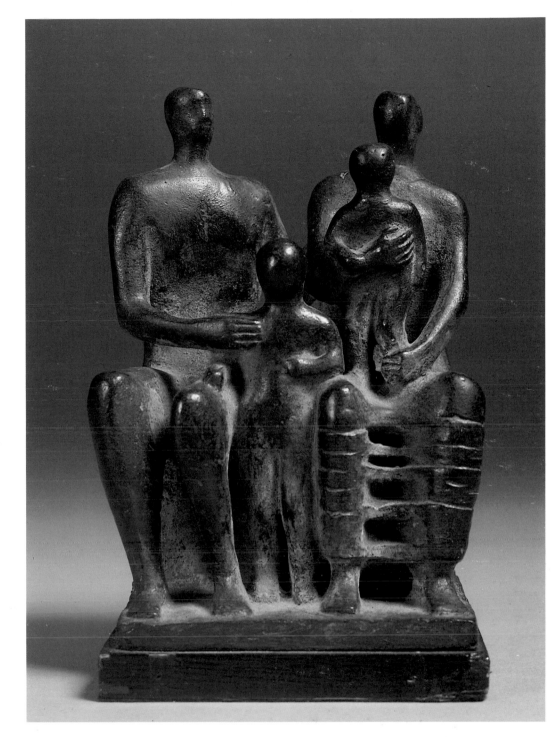

56

Family Group 1944
H 16.2 cm bronze edition of 9
Hirshhorn Museum and Sculpture Garden,
Washington DC
LH 232

Of the Family Groups here presented (cats.
56, 57, 59 and 60) cat. 56 is in several ways
the most relaxed: the forms of the figures are
strong and harmonious, and they are set in an
easy and natural spatial relationship.

Cat. 57 is much more stylised. The two
women sit almost side by side – perhaps
echoing the formal male–female groups of
Egyptian sculpture and Renaissance paintings
of the Madonna and Child with St Anne.
Their smooth and rounded forms echo across

the sculpture; they stress, most noticeably in
the cloth that turns the adult laps into a kind
of altar, unity of mood and action.

In cat. 59 this stylisation becomes almost
humorous. The broad and shell-like torsos of
the parents promise shelter; their limbs flow
into the children and the children into each
other.

Cat. 60 is the sculpture Moore made for a
school in Stevenage. It shows many of the
positive qualities of the maquettes as well as

some new ones: the sheltering form of the
parents' torsos, their joint action in lifting the
child above their knees, the man's protective
hand on the woman's shoulder.

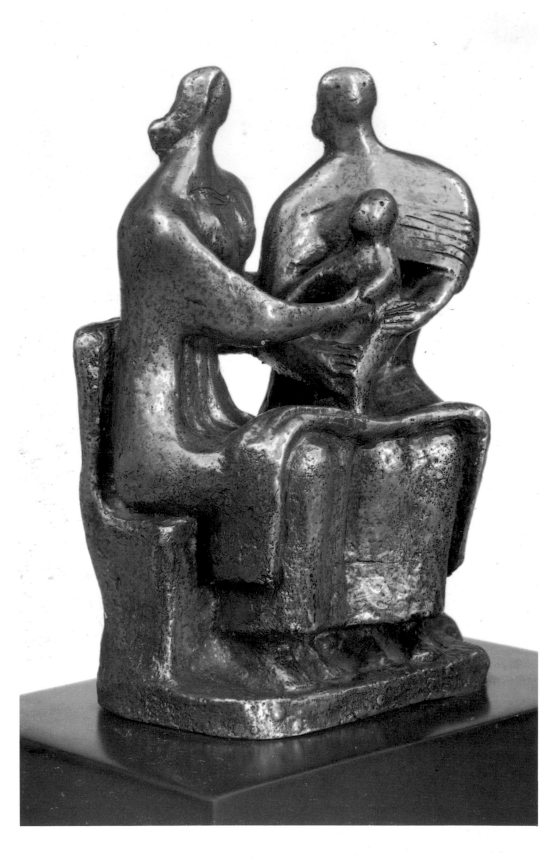

57
Two Seated Women and a Child 1945
H 17.1 cm bronze edition of 7
Hirshhorn Museum and Sculpture Garden, Washington DC
LH 241

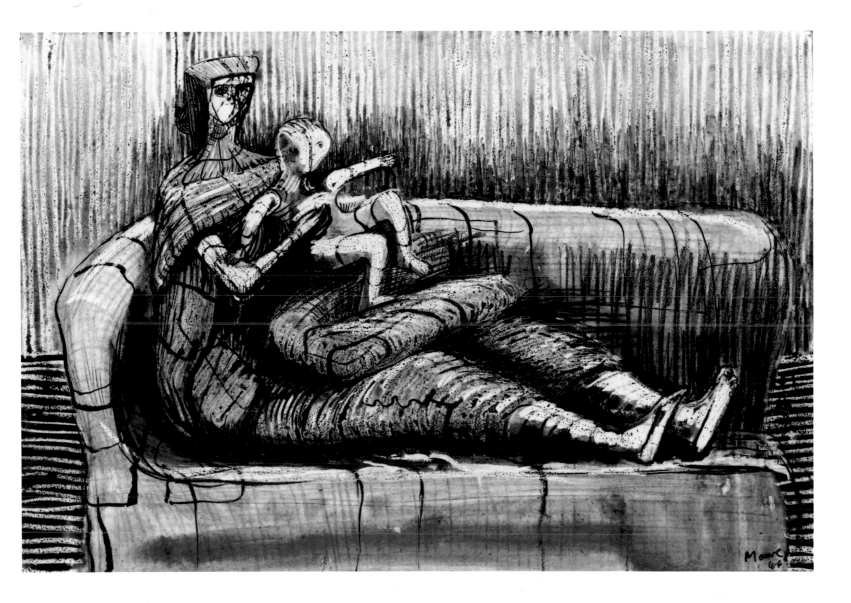

58

Mother and Child on a Sofa 1946
pen and ink, chalk, crayon, watercolour
378 x 555 mm
The British Council, London
HMF 2387

Henry and Irina Moore's only child, Mary, was born in March 1946 after many miscarriages. If this drawing was done late that year it may well show Irina and Mary, happy mother and energetic baby, on a sofa, a cushion on Irina's lap for Mary to bounce on. Moore here too uses lines that emphasise the volumes of the forms, but he does not insist on them and in the end they become part of the linear action of the drawing as a whole, from the vertical and horizontal lines on the wall to the parallel lines that turn Irina's hair into a courtly head-dress.

59
Family Group 1947
H 40 cm bronze edition of 7
Private collection, New York
LH 267

60 (right)
Family Group 1948–49
H 152 cm bronze edition of 5
The Henry Moore Foundation
LH 269

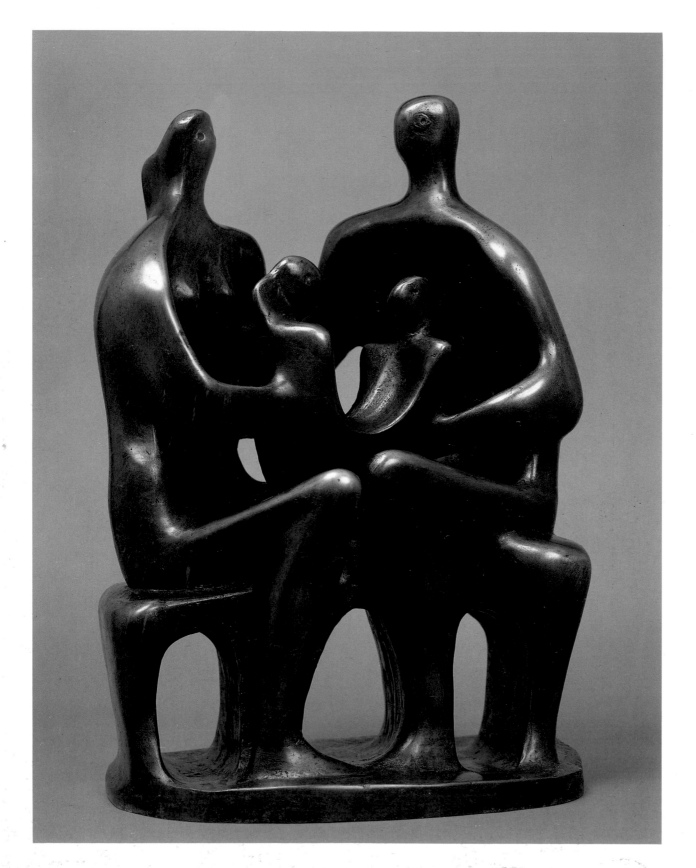

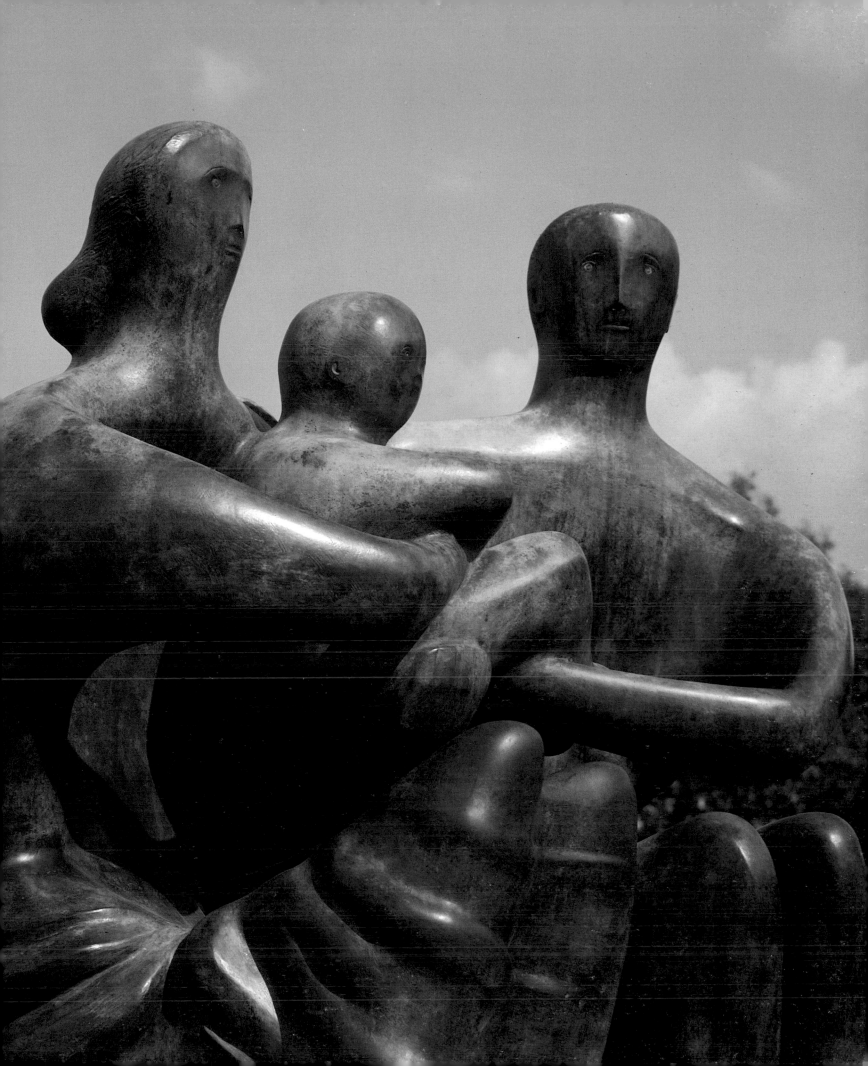

61 (left)
Two Seated Figures 1948
ink, chalk, crayon, watercolour
542 x 568 mm
The British Council, London
HMF 2492

62
The Rocking Chair 1948
pencil, wax crayon, watercolour, gouache
521 x 708 mm
City Museum and Art Gallery, Birmingham
HMF 2516

These two seated figures, isolated but related by closeness and by style, take us back into the awe- or doom-laden realm of cat. 25, and even of the somewhat calmer collage, cat. 14, with its anxious upturned faces. Looking with apprehension into a night sky had taken on additional meaning thanks to the war; what is striking here is the additional tension created by the attenuation of the arms and legs. Long, weightless bodies and limbs show in a drawing of the early 1920s, **Homage to El Greco** [Wilkinson, plate 128], but the increased emphasis in Moore's production on modelling for casting in bronze had led to thinner, stretched forms (see, for example, cat. 39).

In 1950 Moore was to make a series of rocking-chair sculptures as toys for his daughter. The idea is seen surfacing here, perhaps out of his consideration of Family Groups and other subjects that show the interaction of adults and young children. No doubt there was a rocking chair to which Irina Moore took Mary for a stationary ride from time to time. The larger images here suggest a stone sculpture rather than the little bronzes Moore made two years later (cat. 64).

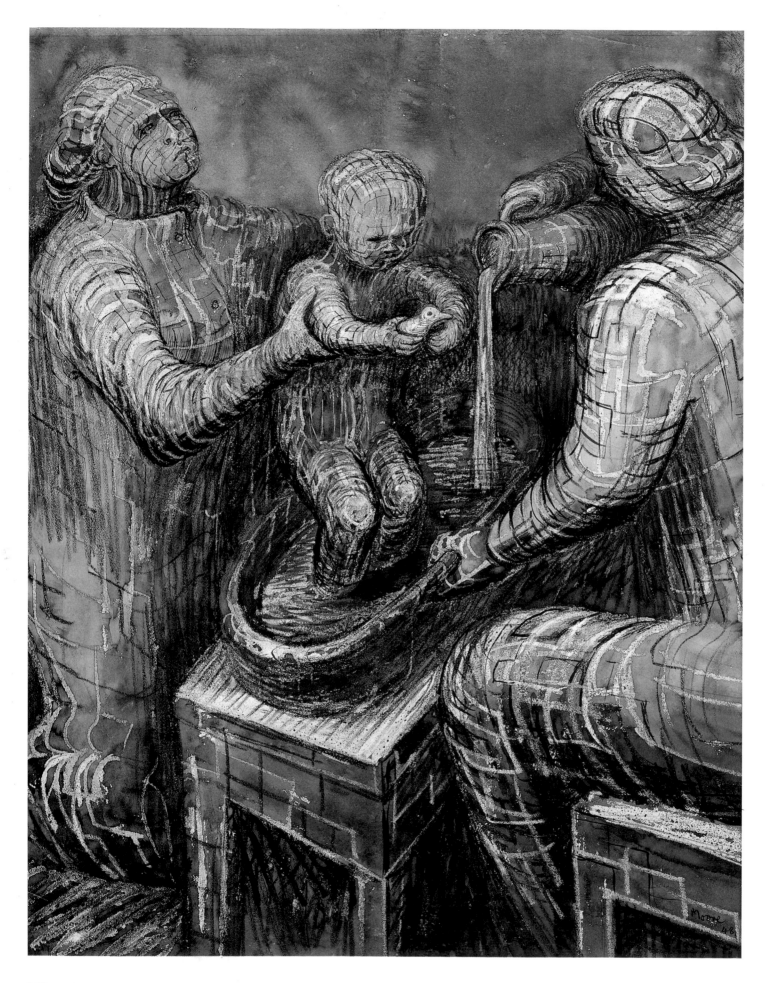

63 (left)
Two Women Bathing a Child 1948
pencil, crayon, watercolour wash, pen and ink,
gouache
727 x 582 mm
Private collection, New York
HMF 2501

This drawing offers a complete contrast to cat.
61. The child is too big to represent his baby
Mary, but it was probably the father's
experience of domestic life that suggested the
subject. At the same time, it carries religious
overtones, echoes from scenes of the washing
of the Christ child in *quattrocento* frescoes;
from the Renaissance too may have come the
idea of having the child hold a bird. The
solemnity signalled in the drawing – in the
faces, the mighty forms, the formal, almost
symmetrical presentation (as against, say, the
informality of cat. 58) – gives it a wider
meaning.

64
Rocking Chair No.2 1950
H 28 cm bronze edition of 6
Private collection, New York
LH 275

There is something archaic about the forms of
this little sculpture, most obviously the
mother's face, perhaps also the chair itself. In
any case, the interaction of mother and child,
the small legs pressing down so convincingly
on adult knees, the strong union of the two
pairs of hands, all make for a representation
that belongs to all ages.

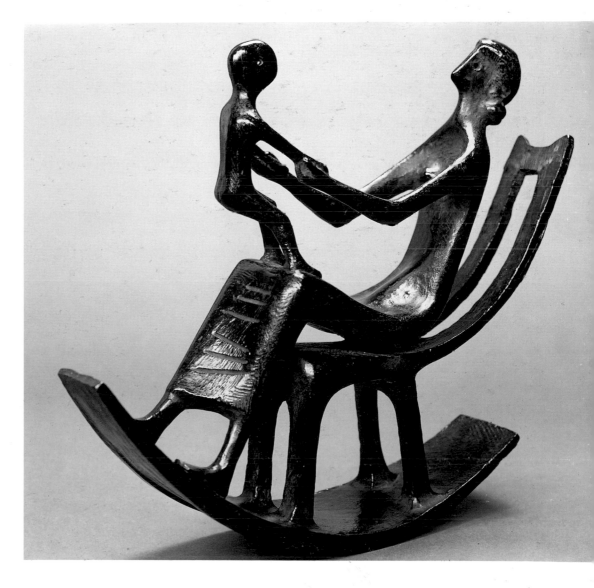

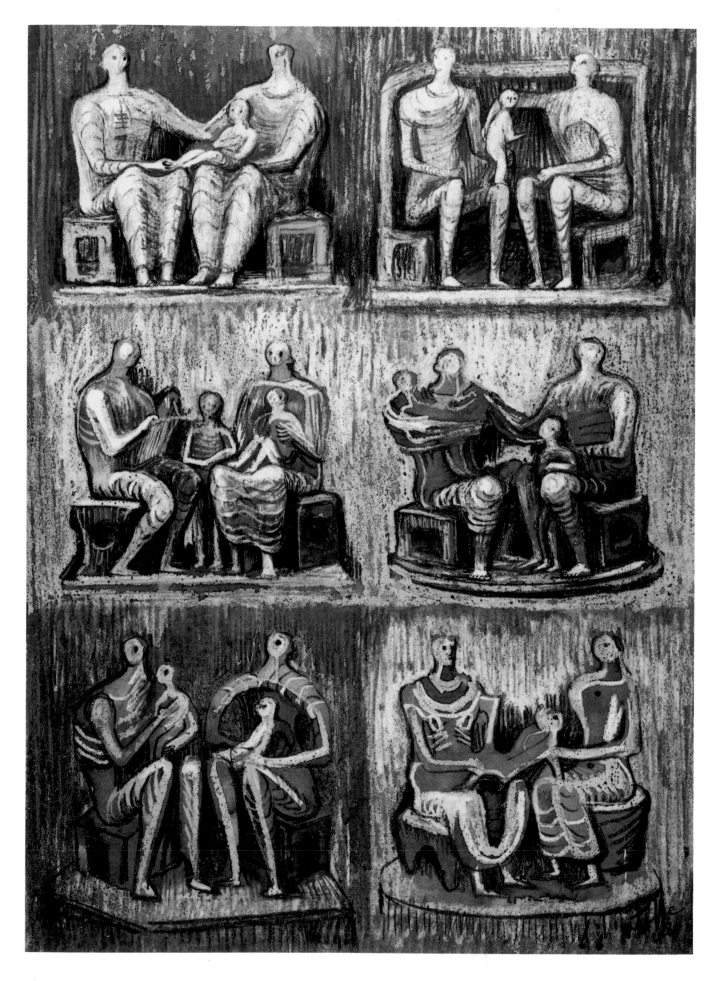

65 (left)
Six Studies for Family Group 1948
pencil, white wax crayon, coloured crayon,
grey watercolour wash, pen and Indian ink
525 x 384 mm
The Henry Moore Foundation
HMF 2501a

This cluster of Family Group studies is given
pictorial coherence by relating the angle of
view for each group to one eye-level, that of
the feet of the two groups at the top.

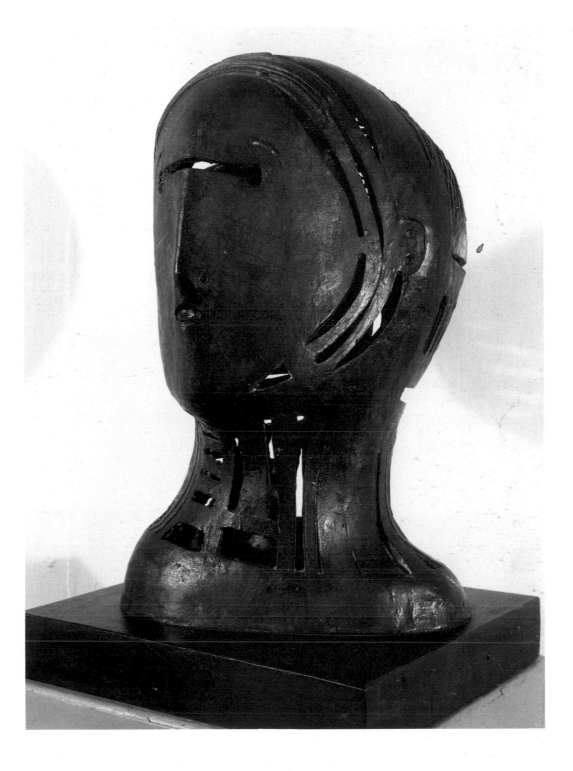

66
Openwork Head No.2 1950
H 40 cm bronze unique cast
City Art Gallery, Wakefield
LH 289

Ten or so years after the **Helmet** of 1939–40
(cat. 41), Moore picked up the theme again
(see also cat. 68). The war was over but the
world was tense with fear of a greater,
terminal war.

Cat. 66 is a head worked in the manner of
a visor. We are invited to read the sculpture as
a head, only to find that it is transparent and
empty.

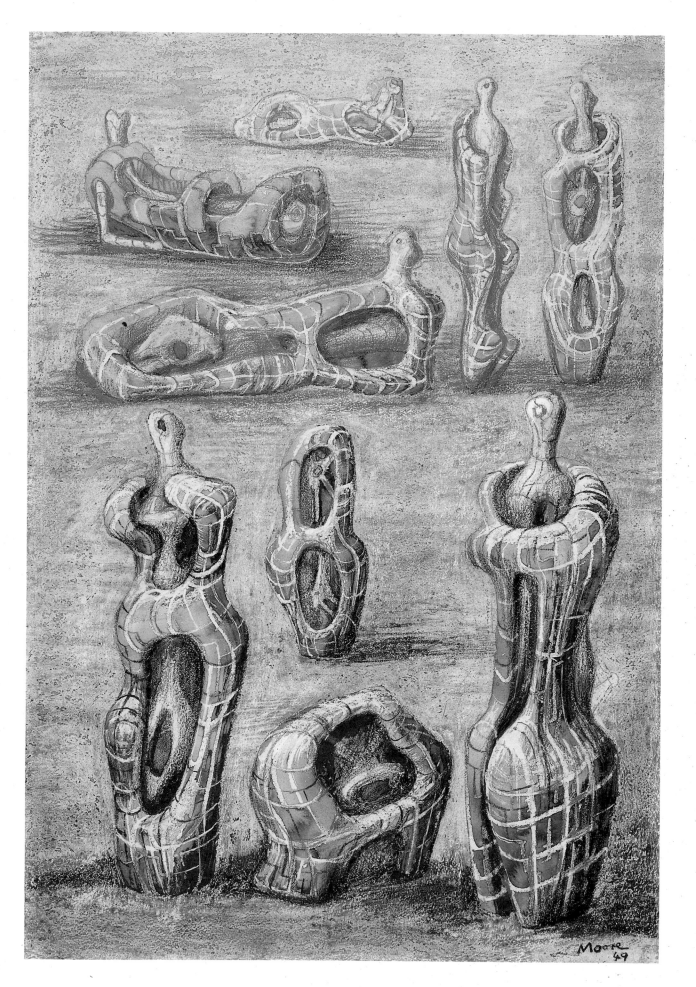

67 (left)
**Studies for Sculpture: Ideas for Internal
External Forms** 1949
pencil, white and coloured wax crayon, chalk,
watercolour, gouache, black ink
584 x 398 mm
The Henry Moore Foundation
HMF 2540a

In this drawing one of Moore's most
impressive inventions is brought towards
maturity; it reached that stage two years later
in a plaster made as a step towards a large
wood carving, of which cat. 69 is a bronze
cast.

There are many meanings to be attached to
the theme of an external form containing,
perhaps sustaining, an inner form. It was pre-
echoed in cat. 41, but here we are led to
consider a mother and child, womb and
embryo, as well as more purely psychological
levels of containing and being contained.

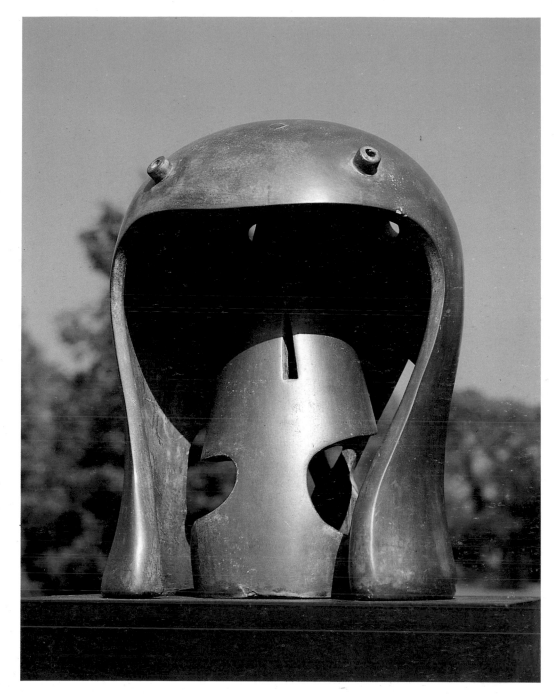

68
Helmet Head No.1 1950
H 34 cm lead
The Henry Moore Foundation
LH 279

The internal element is much less a figure
than in cat. 41, and suggests rather the
internal personage of which the helmet itself
is merely the external image. Like cat. 66, it is
guarded, fearful, warlike.

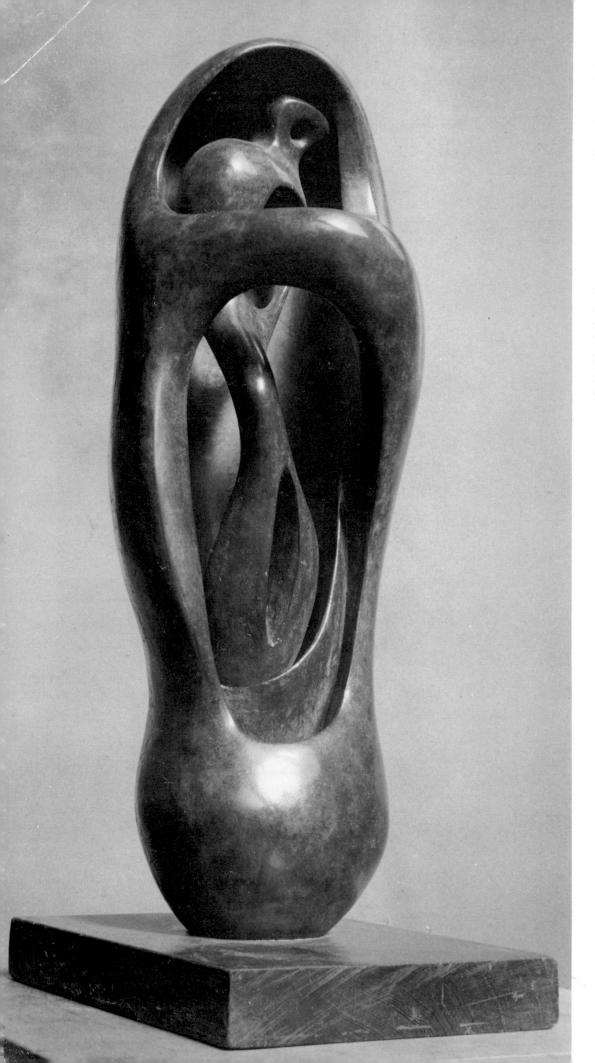

69
**Working Model for Upright Internal/External
Form** 1951
H 63.2 cm bronze edition of 7
The Henry Moore Foundation
LH 295

The contrast between this piece, cast from the plaster working model for a sculpture to be carved in wood at perhaps five times the height, and cat. 70 is in part the contrast between Moore's thinking in terms of bronze and in terms of wood. Here the forms are rounded and generous. Even though there is little to suggest the human image, we accept the composition as showing a kind of figure held within an outer form that also has human, or at least organic, connotations. The meaning of this work has already been touched on (see cat. 67).

70
Working Model for Reclining Figure: Festival
1950
L 43 cm bronze edition of 7
The Henry Moore Foundation
LH 292

This is a cast from the plaster working model for the sculpture Moore was commissioned to make for the Festival of Britain exhibition on the South Bank in London in 1951 (LH 293). The Festival was organised to raise British spirits after the war; it was a national event, even though it marked the centenary of the great international exhibition put on in London in 1851. Several paintings and sculptures were commissioned for it, mostly of a more or less traditional sort. Moore's large **Reclining Figure** seemed harsh at that time and in that context, and shocked many who thought the artist had abandoned his modernism for ever. On a small scale it is a

less disturbing work; there is something satisfying about the sculpture's swift movement from the left arm on which it rests to the legs swooping down into the base. On the large scale the disruptions of the figure are more dominant: the split head, the barrel chest, the absent lower torso.

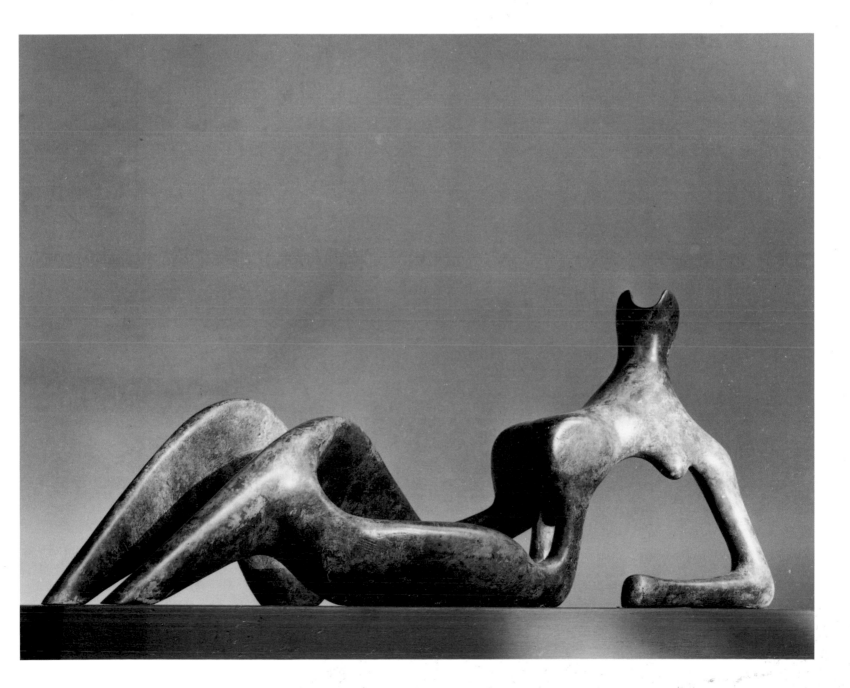

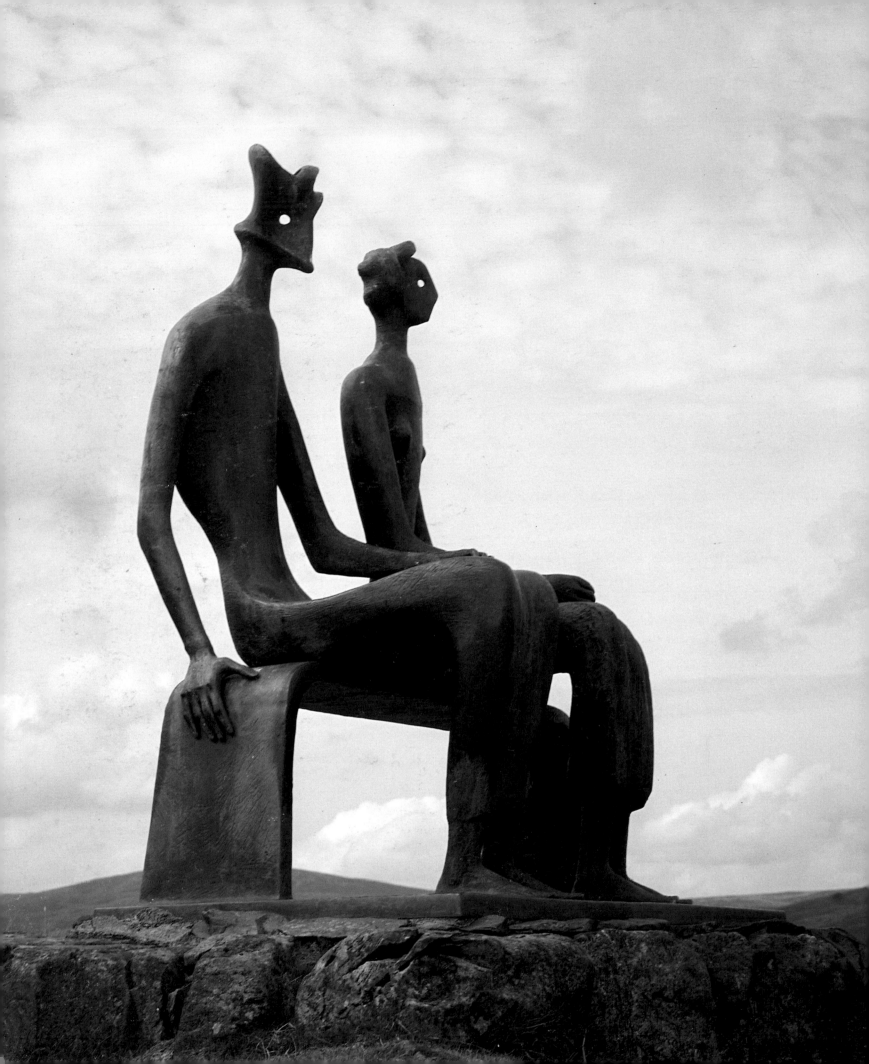

71 (left)
King and Queen 1952–53
H 164 cm bronze edition of 5
The Henry Moore Foundation
LH 350

72
Mother and Child on Ladderback Chair 1952
H 40.5 cm bronze edition of 7
Private collection, New York
LH 313

Moore sometimes said that it was the duty of sculpture to reveal itself slowly, holding the viewer's interest by a variety of means long enough for the multiplicity of meanings and references to become apparent. (It is an idea he may have found set out in Kandinsky's first theoretical treatise, *On the Spiritual in Art*, 1912, of which he will have heard in Leeds.) The notion of making a sculpture of a King and Queen may have come to Moore by way of the stories he read to his daughter. It may also have been triggered by the death in 1952 of the much-loved King George VI. He made a head that turned out to wear a sort of crown; then he made this sculpture. It was, he said, one of his favourites.

The most surprising aspect of it is the combination of naturalistic, even elegant hands and feet with boldly abstracted torsos and strange, even frightening heads. The general pose is known to us from Egyptian sculpture. The broad and shallow backs recall Moore's drawings of miners (cats. 50 and 51). The Queen's head may remind us of the archaic head of cat. 64 but that of the King is a new conception, linked to the Helmet series but in detail closer to the head of a famous work of Italian Futurism, Boccioni's *Unique Forms of Continuity in Space*. Moore said the King's head had something animal about it, as well as regal.

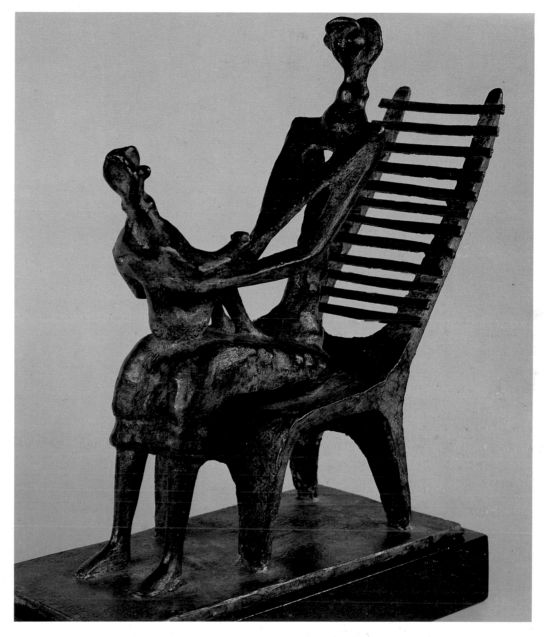

Again, as in cat. 64, we have a domestic scene of a mother with a young child in her lap, as though in conversation or play. But here the chair is static and monumental and the figures are immobile. The slightly macabre heads face each other silently and the triangular plate that descends from the mother's shoulders, both screening her breast and standing in for it, adds to a sense of tension that counteracts the stillness of the ensemble.

73
Seated Torso 1954
L 49.5 cm bronze edition of 9
The Henry Moore Foundation
LH 362

At first glance an elegant, even seductive image of a woman, this gradually reveals itself as thoroughly disconcerting. Looking at something we accept as a human image, we identify with it, whatever its gender, and receive any distortion or fragmentation as a personal injury. This woman has a long neck but appears to be headless; her lower legs end in stumps. This matters more where the idiom of the sculpture seems at first to be naturalistic, less when the whole announces itself as far removed from normality as in cat. 70.

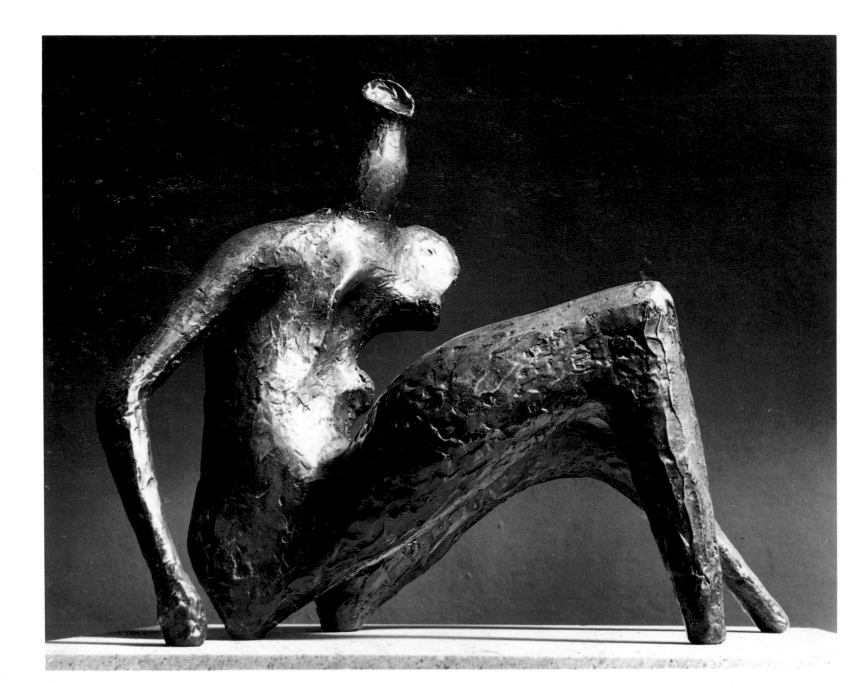

74
Maquette for Fallen Warrior 1956
L 26.4 cm bronze edition of 10
The British Council
LH 404

In the 1950s Moore made a series of Warrior
sculptures, taking his theme from Greek and
Roman examples. Strictly, this piece
represents a falling, not a fallen, warrior, and
thus also one of the rare instances when
Moore uses sculpture to show a figure in
movement. His warrior is a man of no
particular place or date; only the shield gives
any sense of period, and that a very wide one
though it excludes modern times.

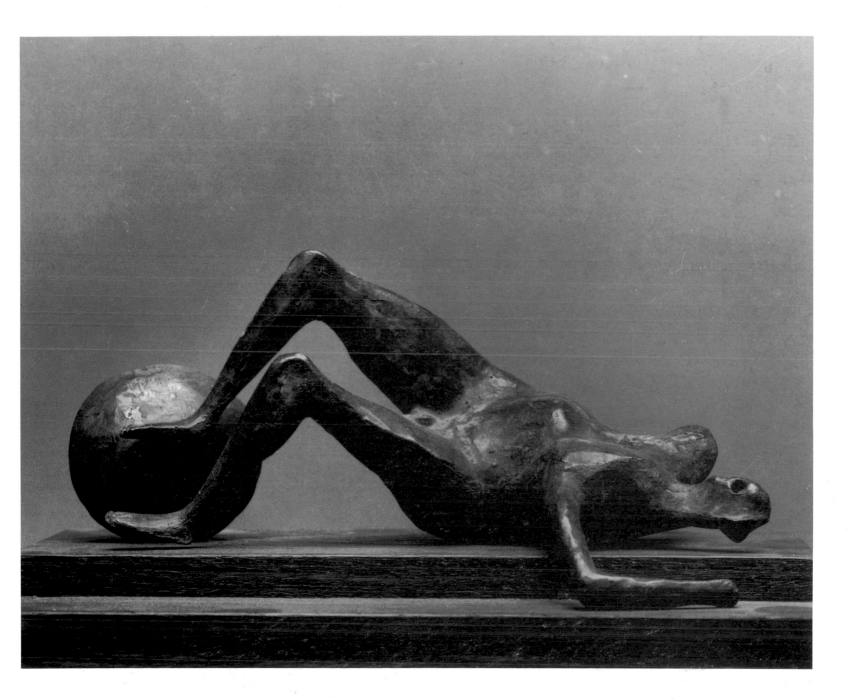

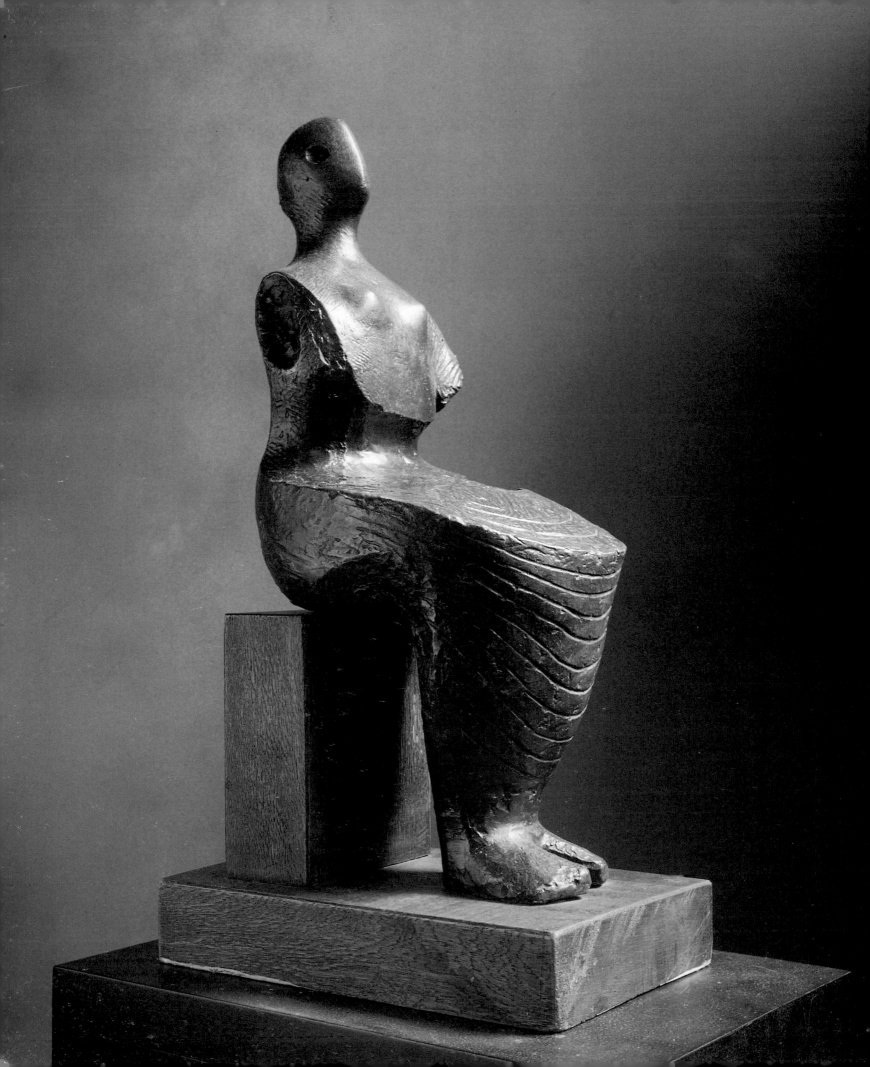

75 (left)
Seated Figure: Armless 1955
H 44.5 cm bronze edition of 10
Hirshhorn Museum and Sculpture Garden,
Washington DC
LH 398

The absence of limbs is here less disturbing
than the distortions noted in cat. 73. This
hieratic piece seems to belong to the earliest
days of Mediterranean culture and could well
have lost its arms and much of its surface
detail from the depredations of time.

76
Maquette for Unesco Reclining Figure 1956
L 22 cm bronze edition of 6
The Henry Moore Foundation
LH 414

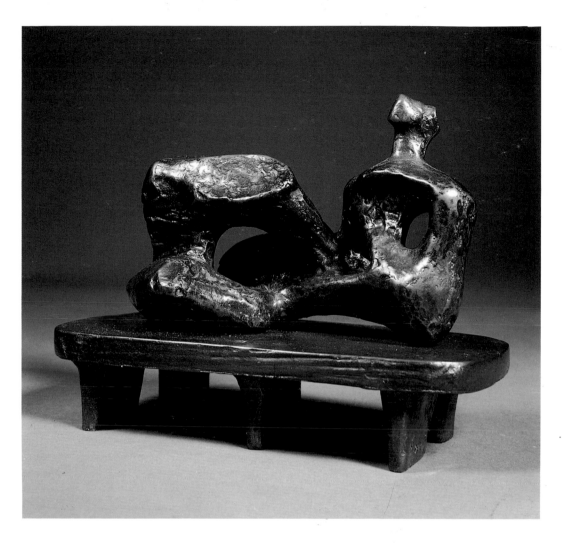

The commission for which Moore created this
maquette was an unusually difficult one and
involved major reconsiderations and revisions
before it was finished. The work itself was
completed in 1958 in the form of a 5-metre-
long version of this maquette, carved in
Roman Travertine marble, set up outside the
boring and scaleless façade of the
headquarters of the United Nations
Educational, Scientific and Cultural
Organisation in Paris.

Moore had first thought of a bronze
sculpture, a seated woman backed by some
sort of wall that would show up against the
restless architectural detail, such as cats.
78–80. In the end he opted for this beautiful
white marble and for massive forms capable
of standing up against the building. And he
opted for yet another Reclining Figure.

He wanted to avoid anything that could
seem openly symbolic. In so far as his figure
would be rocky and powerful it would remind
spectators, unconsciously or otherwise, of
nature's energies amid their bureaucratic

doings and urban traffic. In so far as it could
be seen as an archetypal but not pronouncedly
sexual woman, it would suggest something
ancient and general, an earth goddess. Its
forms would be a counter-statement to the
architecture; the matt and grainy marble, used
for the base as well as the figure, would
refresh the eye after exposure to all that
mechanically repeated detail.

Moore always expressed pleasure with this
piece. At the time many commentators felt he
had retreated into the safety of his habitual
theme in the face of this challenge. Today,
most people would say that the sculpture has
stood the test of time.

It is worth noting that the carving, about
24 times as large as the maquette, is in several
respects a simplified version of it. Moore gave
the maquette a lot of surface detail because of
the character of the stone he was about to use,
and indeed Travertine does in itself offer a
very interesting surface. But the forms
themselves are more continuous in the large
figure than in the small.

77
Reclining Figure: Goujon 1956
L 24 cm bronze edition of 9
The Henry Moore Foundation
LH 411a

As in the case of cat. 73, we acknowledge this sculpture, this woman, as an elegant and seductive thing. A small head with a hint of a stylish coiffure, long limbs openly displayed for us, unusually prominent breasts (fitting the starlet taste of the 1950s). Her timeless pose says, Look at me, I am pretty, I am desirable. But she is also deformed, she is the pin-up formula pushed to the point of ridicule . . . and of course the finger of ridicule points even more at the male viewer/voyeur who responds to such signals than at the women who send them.

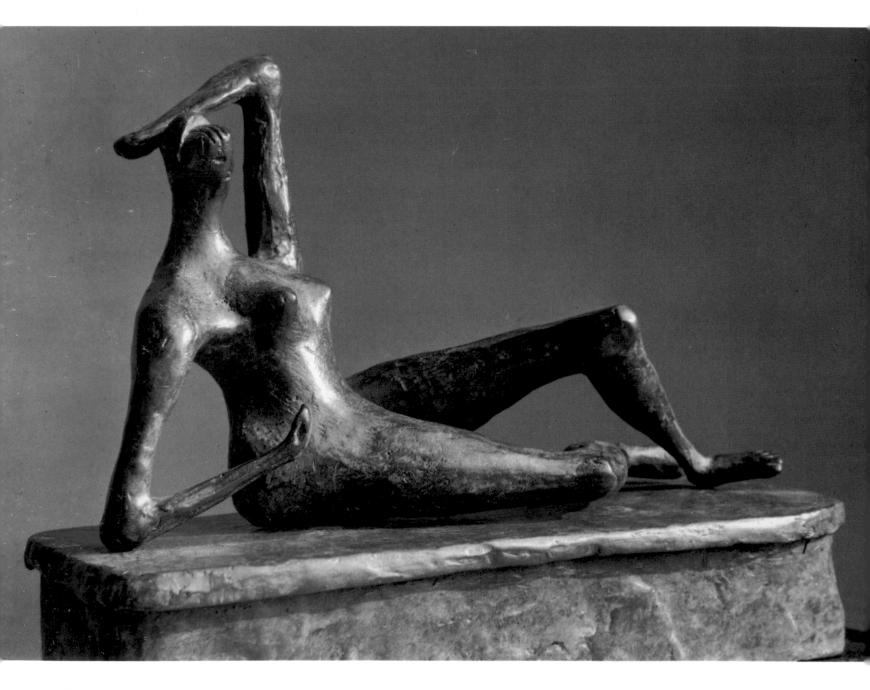

78

Mother and Child against Open Wall 1956
H 20.5 cm bronze edition of 12
Hirshhorn Museum and Sculpture Garden,
Washington DC
LH 418

These maquettes (cats. 78–80) represent some of Moore's ideas for the Unesco sculpture. They show him investigating something that had, perhaps inevitably, come up in his drawings: the matter of a figure, or figures, against a background or in a setting which is part of the sculpture. He did not approve the modern habit of calling in an artist after a building was done and asking him or her to provide some sort of ornament for it or distraction from it. At the same time, he normally wanted his sculpture to be visible from all sides, not to be set against a surface that would screen parts of it from the viewer. To incorporate some sort of architectural element in the sculpture itself was an apt response, and we see him thinking first of enlarging the seat itself or seating the figure against a low wall.

In cat. 78 the interaction of the two figures and the arched openings in the back of the seat make for an intimate and comfortable image, one perhaps lacking in monumentality. More arresting is the single figure seated before a curved wall in cat. 79; her slender limbs would not be suited to stone carving. The rectangular wall in cat. 80, interrupted only by small recesses, seems an oppressive setting for the figure seated in front of it, as though the one short length of wall indicated a prison cell. It is clear that Moore was following up ideas, even though they might not lead to an image suited to the Unesco commission.

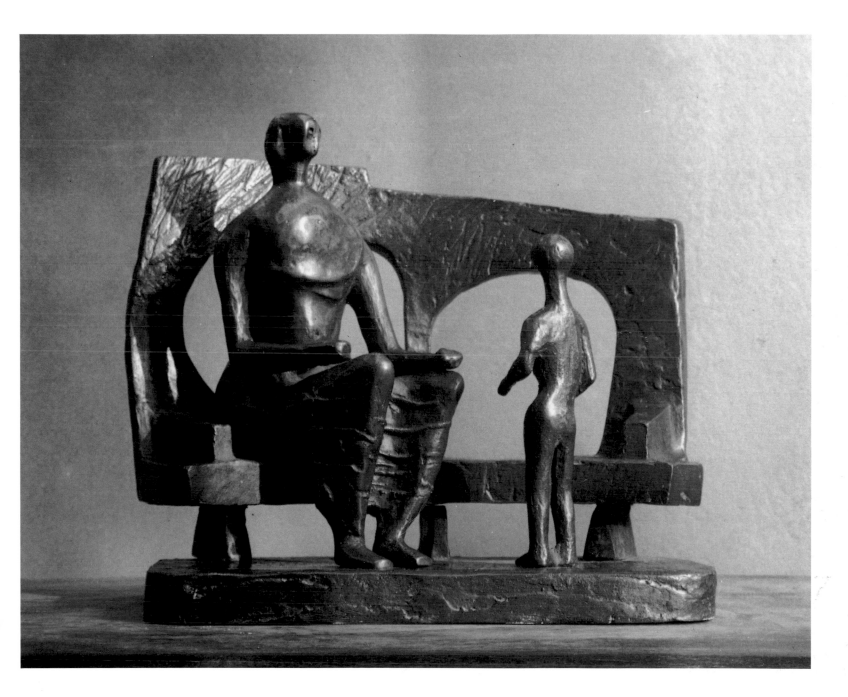

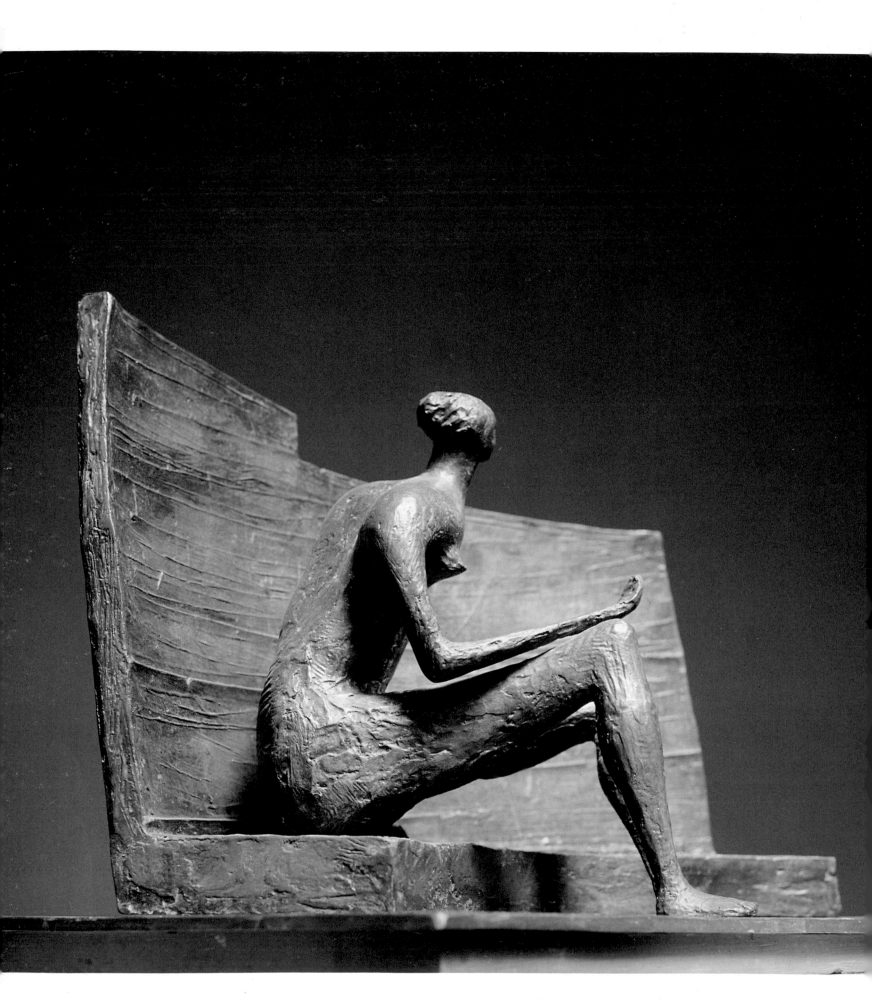

79 (left)
Seated Figure against Curved Wall 1955
L 81.5 cm bronze edition of 12
Arts Council of Great Britain, London
LH 422

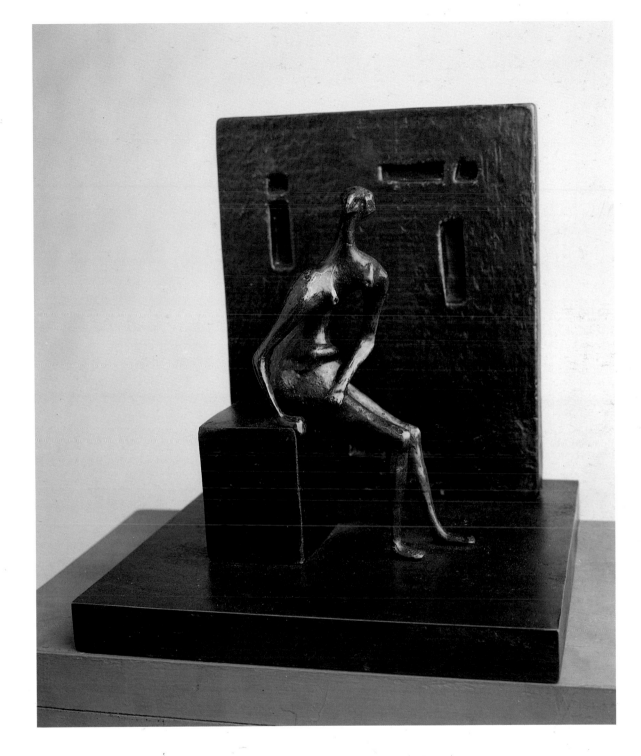

80
Maquette for Girl Seated against Square Wall 1957
H 24 cm bronze edition of 12
The Henry Moore Foundation
LH 424

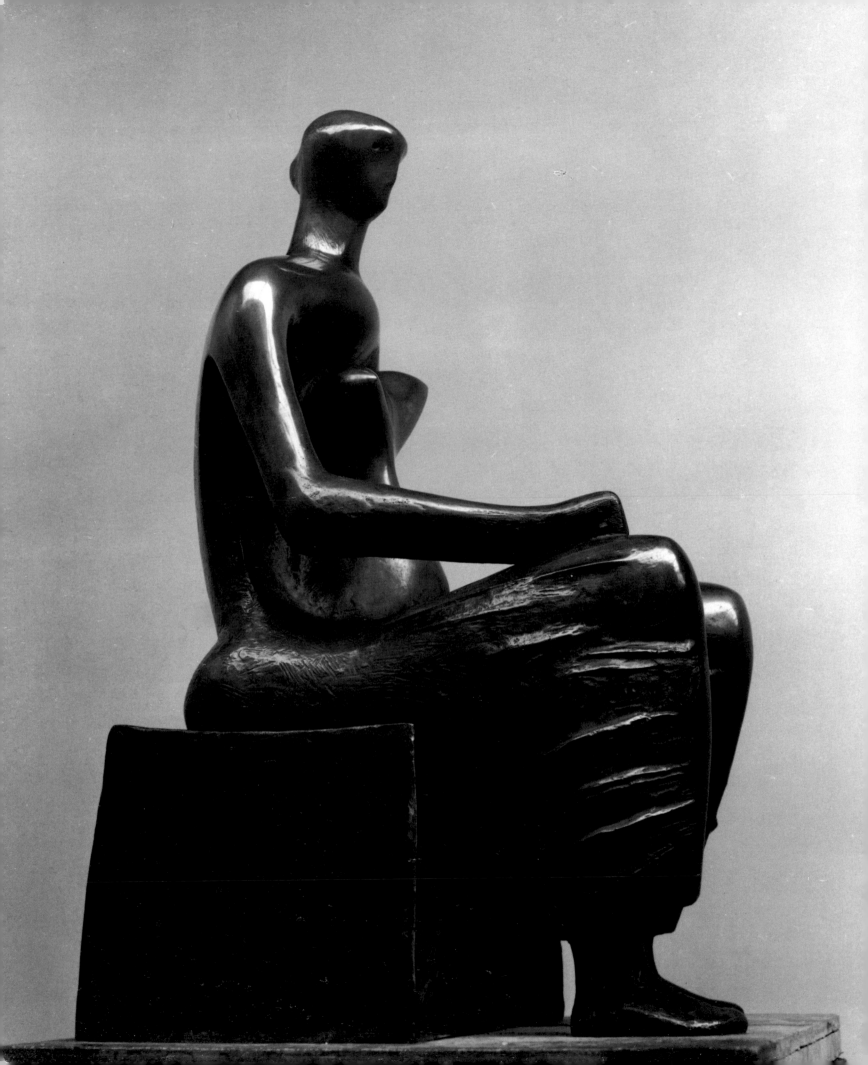

81 (left)
Working Model for Seated Woman 1980
H 76 cm bronze edition of 9
The Henry Moore Foundation
LH 433b

So separate do this woman's breasts and
stomach appear from the broad totality of her
torso that for a moment one could mistake
the sculpture for a seated woman with a child
on her lap. Perhaps we should see this piece
as a step towards the two- and three-piece
women of the 1960s; it was pre-echoed to
some degree in the drawing cat. 25. The
severe frontality and near-symmetry of the
sculpture recall Moore's preparatory work for
the Northampton **Madonna and Child** LH
226, especially cat. 52.

82
Seated Figure on Square Steps 1957
L 23.5 cm bronze edition of 11
The Henry Moore Foundation
LH 436

Steps are another way of giving a sculptured
figure its own physical setting and
psychological space: see the comments on
cats. 78–80.

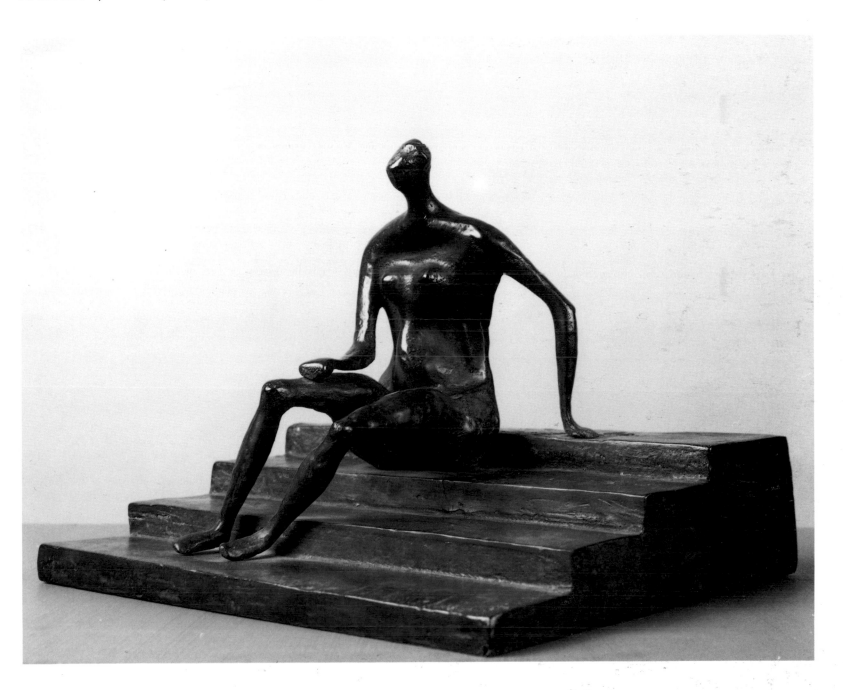

83
Page from Sketchbook: Head 1958
wax crayon, watercolour wash, ink
289 x 249 mm
The Henry Moore Foundation
HMF 2979

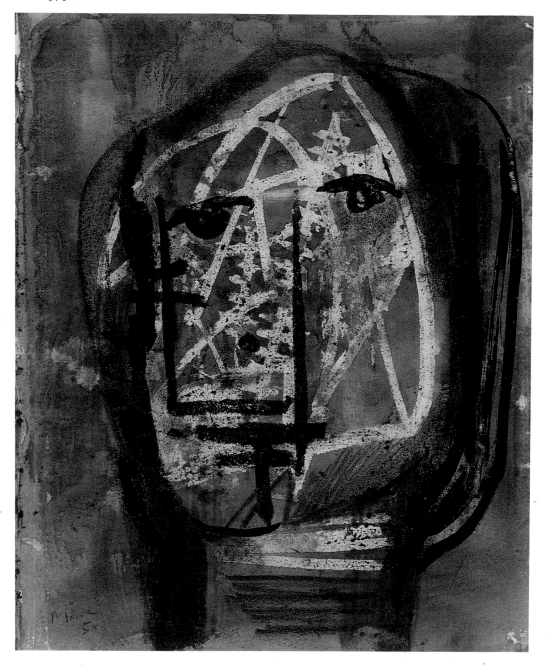

Moore's heads repay careful study. Heads must be a problem for every artist, since so much of our understanding of each other, and thus of ourselves, stems from close reading of the character and passing mood of people's faces. In this we are all experts, practising the skill from birth.

Much of Moore's work deals with generalities, with large and important issues to do with life and death and our place on this earth, and thus cannot accommodate particular physiognomies and expressions. He drew some fine portraits where the face is treated in detail; but most of his portraits, as in cat. 10, give only a broad account of the face. His sculptures do without facial particulars from the mid-1920s on, and his drawings, not only those thought of as studies for sculptures, rarely show faces bearing much identity. (Notice, for example, the way he avoids showing facial character, even indications of age, in the Shelter Drawings, see cats. 44–49.)

The head in this drawing may be female but in its general form suggests Moore's Helmet series. He seems to be seeking in it some balance of generalisation and abstraction against a hint of individuality.

84
Maquette for Reclining Figure 1960
L 21 cm bronze edition of 9
The Henry Moore Foundation
LH 464

In the dislocation of the leg portion of this Reclining Figure we may catch an echo of the two-part Reclining Figures Moore began to make at about this time. The massiveness of the forms as a whole, the absence of openings within the torso and space between it and her limbs, also indicate this new phase.

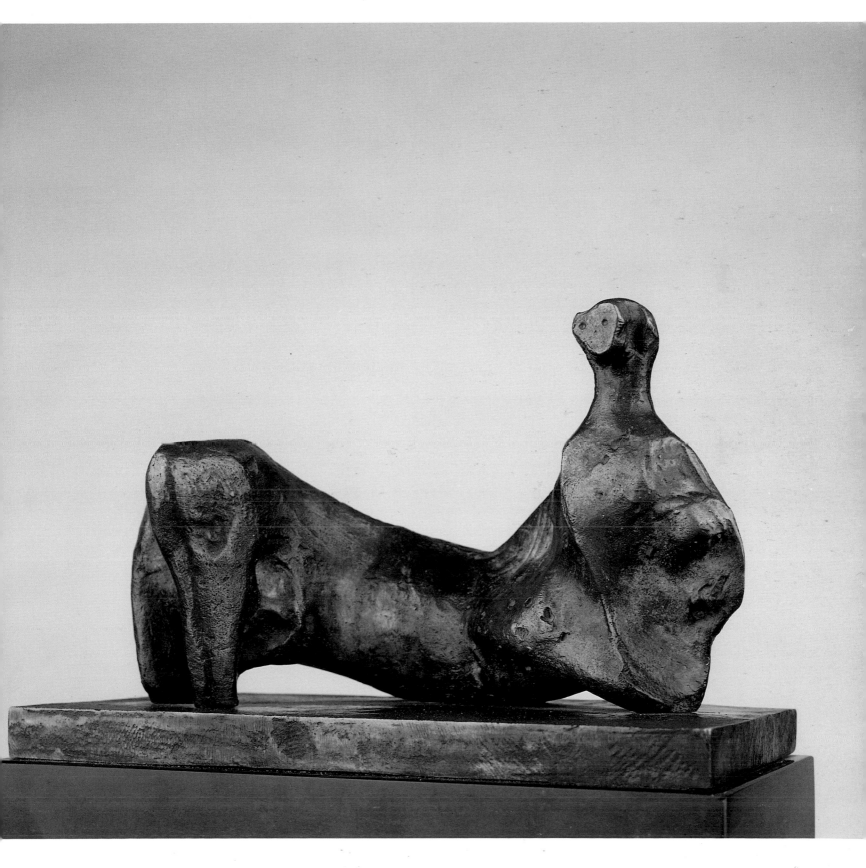

85
Two Torsos 1960
L 20.5 cm bronze edition of 9
The Henry Moore Foundation
LH 462

It is rare to find Moore (as opposed to, say, Barbara Hepworth whose work he knew well) making a sculpture of two discrete figures; we have seen him juxtaposing figures in his drawings. The two fragmentary torsos set up here are rich in classical echoes, and though their truncation is extreme they are not without charm. There is no sort of dialogue between them; in this, and perhaps also in the form of the one that has its back to the other and appears to be departing, we may catch a hint of Cézanne's paintings of Bathers (see also cat. 106).

86 (right)
Helmet Head No.3 1960
H 29.5 cm bronze edition of 14
Arts Council of Great Britain
LH 467

With its suggestion of eyes in the internal form, this Helmet Head asserts its human meaning, yet on closer inspection the internal form reveals itself as architectural, fortress-like, rather than organic, giving the whole piece a powerfully defensive quality.

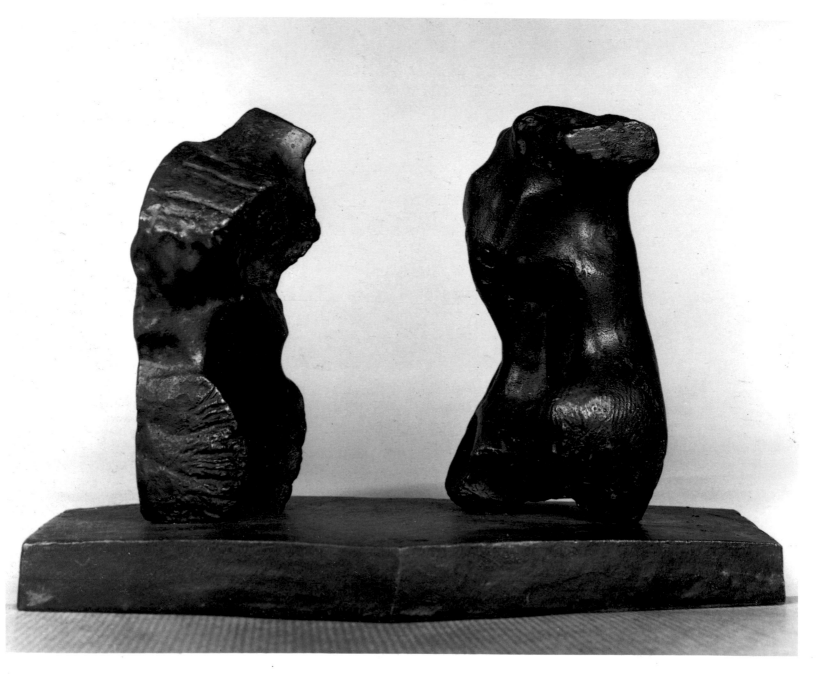

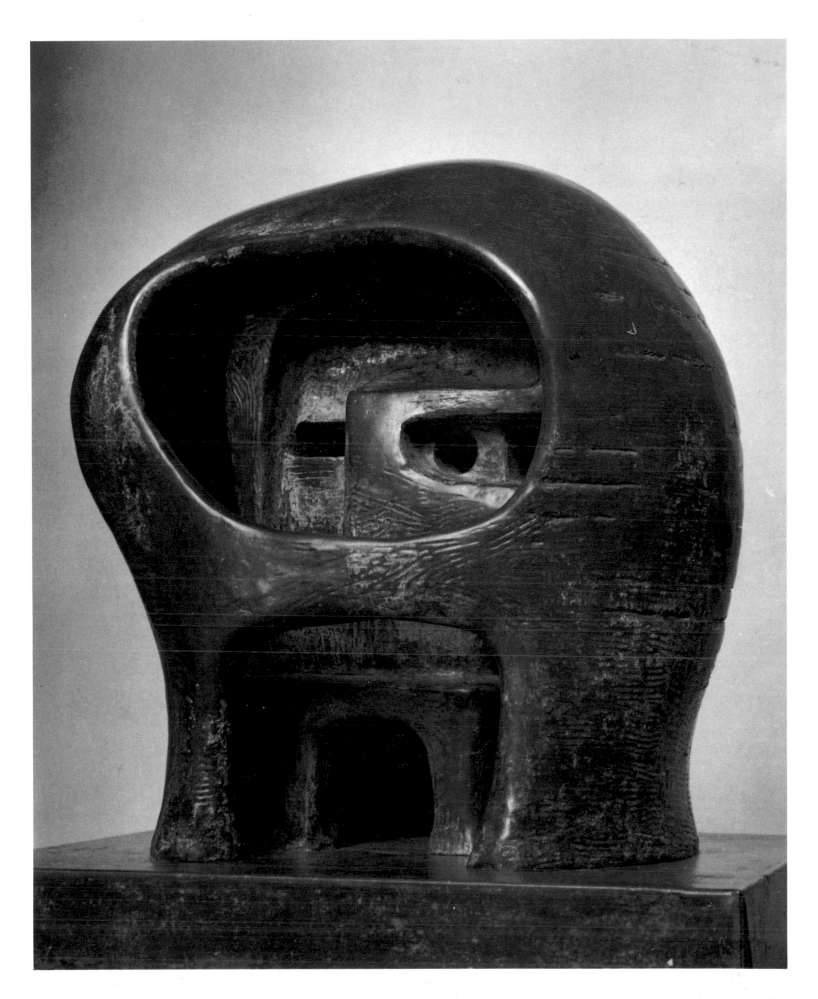

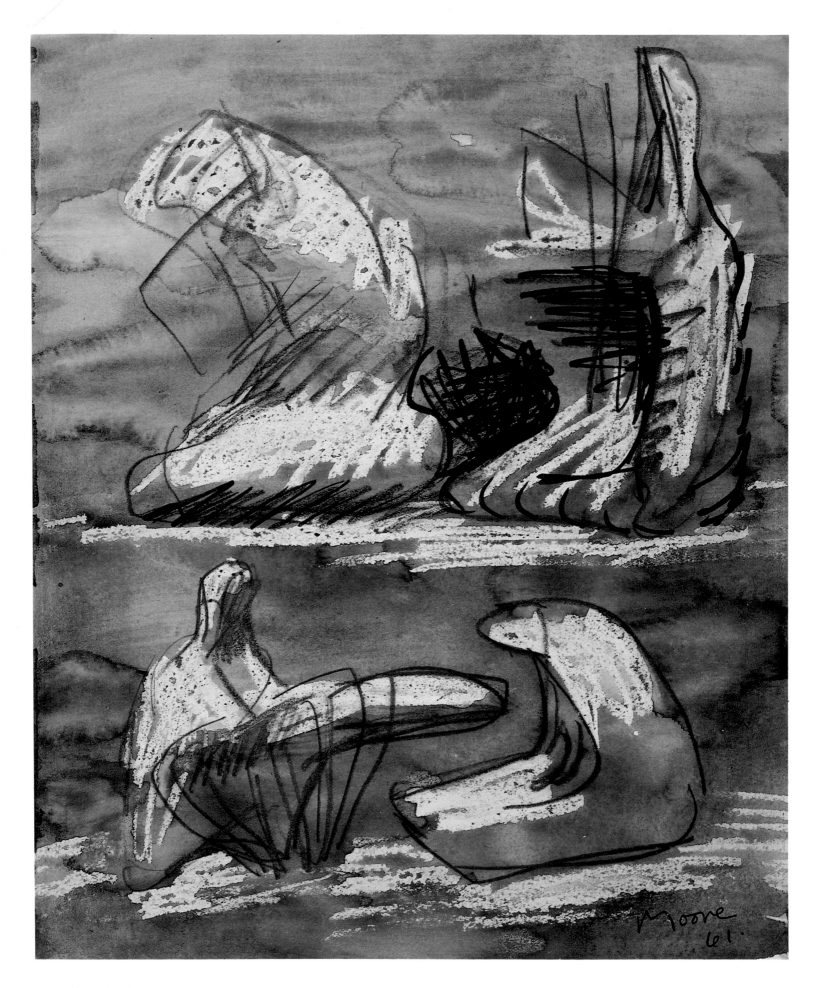

87 (left)
Page from Sketchbook 1961–62
Two Reclining Figures 1961
white wax crayon, watercolour wash, ink,
crayon
292 x 242 mm
The Henry Moore Foundation
HMF 3053

Moore began making two-piece Reclining
Figures in 1959: in the process of enlarging a
maquette, he separated the two halves and
thus made the figure into an occasion for
patently opposing portions that could in any
case, as in cat. 84, seem separate in character.

These sketches show him considering two
different compositions of this sort – or
perhaps reconsidering: the upper sketch
strongly recalls **Two-Piece Reclining Figure
No.1** (LH 457).

88
Two Piece Reclining Figure: Maquette No.3
1961
L 20.5 cm bronze edition of 9
The Henry Moore Foundation
LH 475

Three maquettes for two-piece figures (cats.
88–90) show both Moore's inventiveness and
his persistence. The wide gap between the two
pieces in cat. 90, and also their formal
contrast, test our willingness to read this
group as in any sense representing a figure at
all. Yet we can and do, and seem eager to do
so. We cannot perhaps ascribe a particular
character to it though we may see the vertical
portion as indicating alertness. The wide
separation does, however, make us conscious
of the surface and space of the base which
now become important elements in the piece.

Depending on our angle of view, cat. 88
can look like a three-piece sculpture. Again

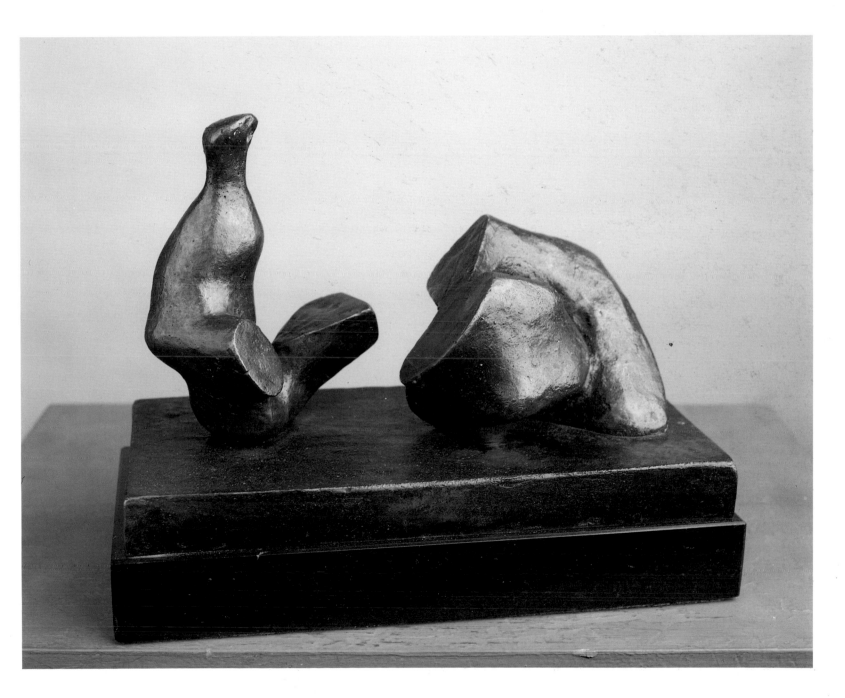

the upper portion is alert and vertical; the rest, here, is heavy and inert.

The upper part in cat. 89, with its emphatic waist, leaves us in no doubt that we are looking at a female figure, even though her head has been diminished to a spike. Because of that, we can accept that the other element refers to her belly, hips and legs. The way one part penetrates the other inevitably offers sexual connotations.

89 (below)
Two Piece Reclining Figure: Maquette No.5 1962
L 15 cm bronze edition of 6
The Henry Moore Foundation
LH 477

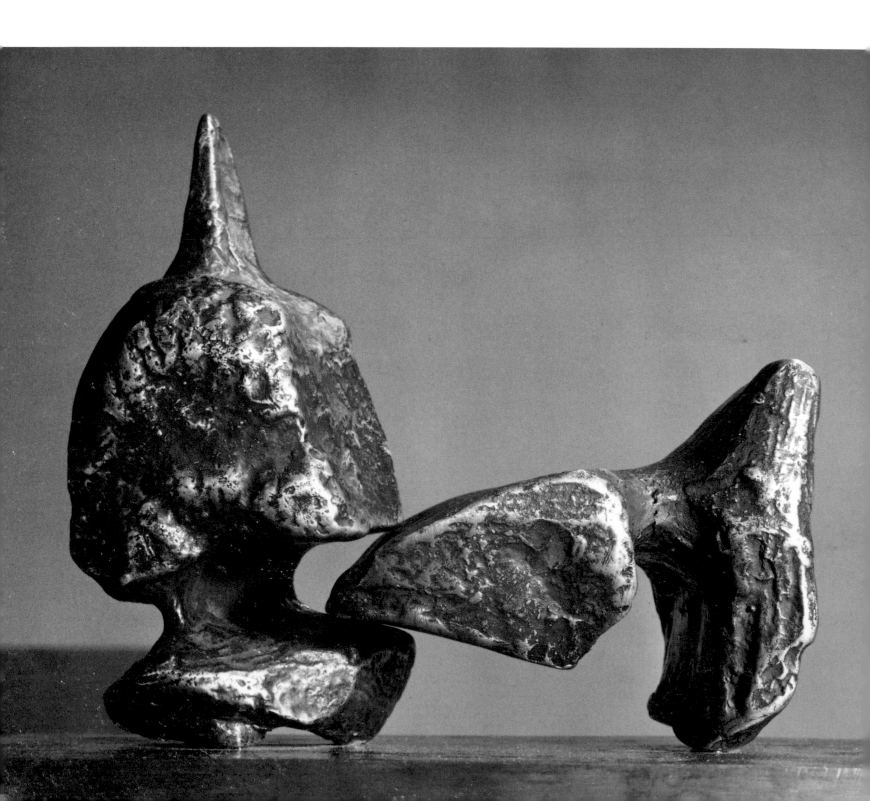

90
Two Piece Reclining Figure: Maquette No.2 1961
L 25.5 cm bronze edition of 9
The Henry Moore Foundation
LH 474

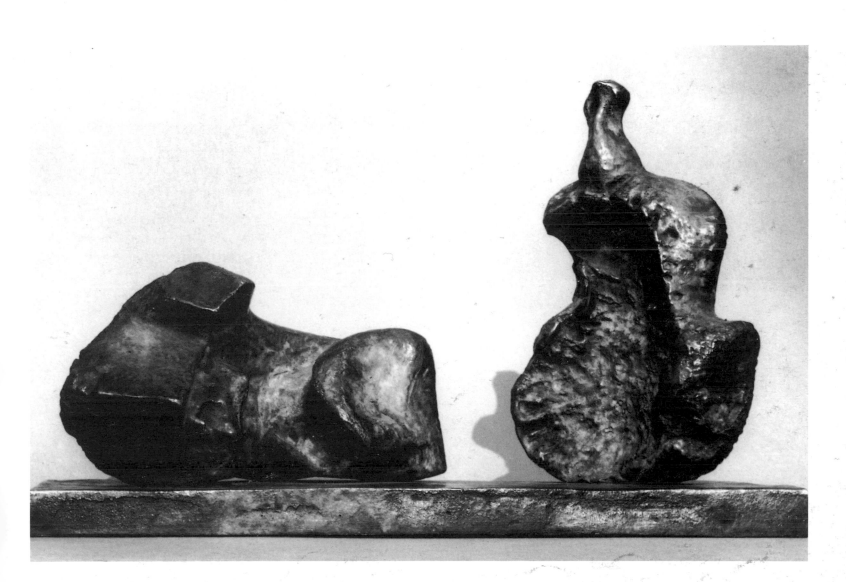

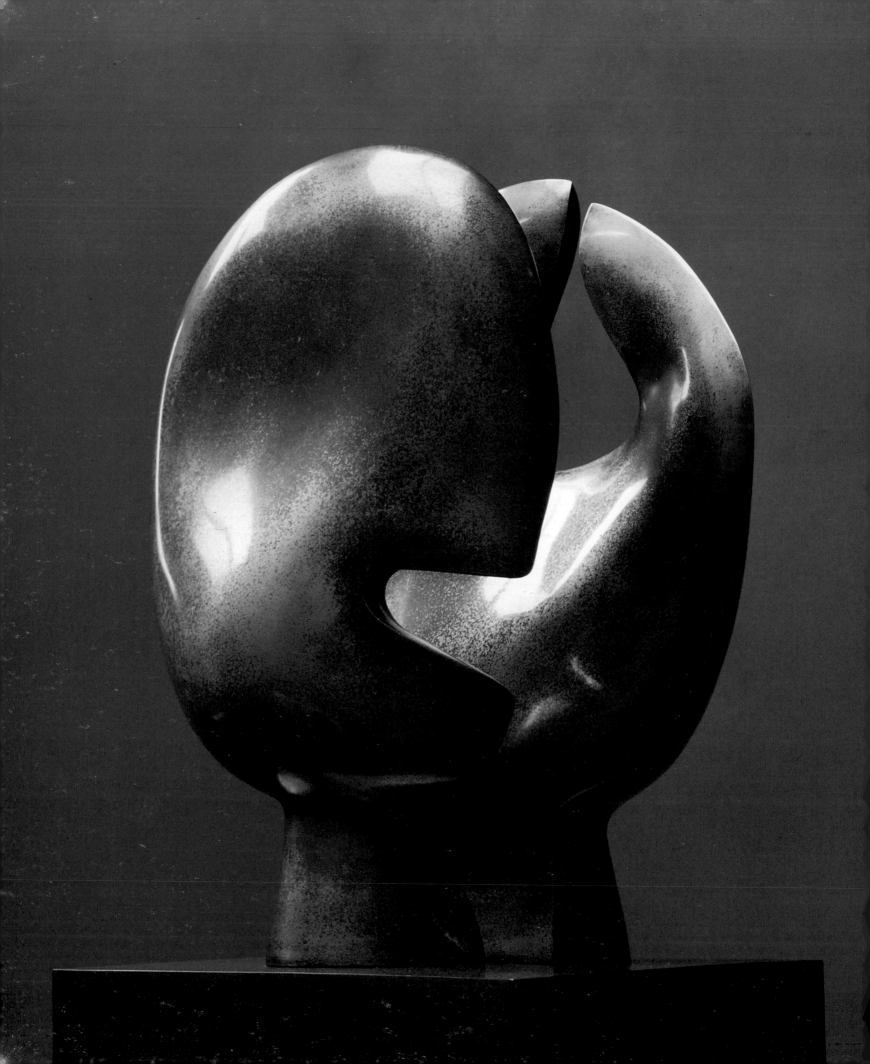

91 (left)
Moon Head 1964
H 57 cm bronze edition of 9
The Trustees of the Tate Gallery, London
LH 521

In the case of cat. 36 we were able to glimpse
a face in the convex surface with its three
dots. Here, the connotations are partly those
of a moon, or its shadow, passing across
another heavenly body. At the same time, we
can hardly fail to read the section cut out of
one disc as a mouth, while the other, leaving
an opening near the top of the disc, appears to
turn it into a stretching hand. The sculpture,
which had its origin in Moore's study of fine
bone forms, was first called 'Maquette for
Head and Hand'; two years later when the
larger bronze casts were made Moore had
recognised its association with the moon and
had the casts treated to give them a yellowish
patina and produce a glow of light between
the two discs [Compton 262–3].

92
Maquette for Atom Piece 1964
H 15 cm bronze edition of 12
The Henry Moore Foundation
LH 524

In 1963 Moore was approached by the
University of Chicago with the request for a
sculpture to commemorate their work in
nuclear physics. He hesitated, wondering how
his kind of sculpture, almost always related to
organic natural forms, could symbolise such
work. In the end the University and he agreed
that a development of a Helmet Head idea he
was working on, starting from a bone, would
well meet the needs of the commission. A
working model followed this maquette, and
from that the large sculpture was evolved, its
name being changed from 'Atom Piece' to
'Nuclear Energy' for the interesting reason
that in English 'piece' and 'peace' sound the
same [Compton 263]. Moore would certainly
not have wanted any sculpture of his to seem
to associate peace with atomic bombs.

The swelling form of the sculpture
suggests the mushroom cloud resulting from
an atomic explosion. Because of this the large
3.5-metre sculpture, highly polished in that
part, is a daunting as well as a beautiful sight.

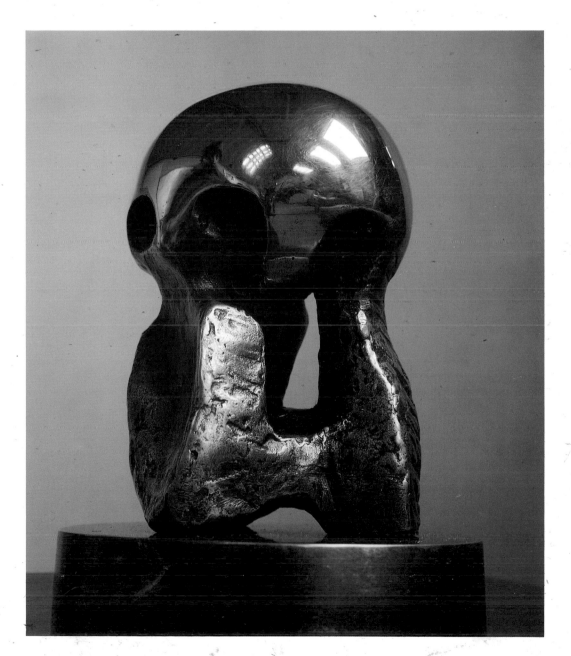

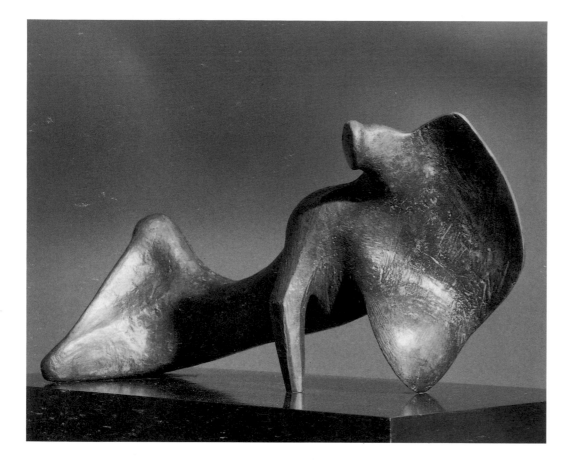

93
Reclining Figure: Cloak 1967
L 37 cm bronze edition of 9
The Henry Moore Foundation
LH 565

Moore's fascination with the edges and
membrane forms of thin bones shows in
several of his 1960s sculptures (we noted it in
the case of cat. 91). Here it provides the
impulse to a Reclining Figure, which seems
to start from two bones brought together for
the 'cloak' end and the legs.

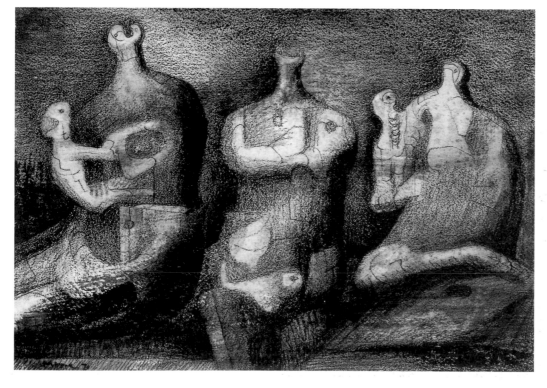

94
Three Seated Mother and Child Figures 1971
charcoal, wash, Indian ink wash, chinagraph
298 x 432 mm
The Henry Moore Foundation
HMF 3314

Moore's continuing interest in the Mother
and Child theme, among the many other
subjects he treated in the 1960s and 1970s, is
manifest in this triple drawing, each figure
showing a surprisingly massive, even
ungainly form, lacking the grace that had
tended to characterise his treatment of the
theme after the early **Maternity** of 1922
(cat. 7).

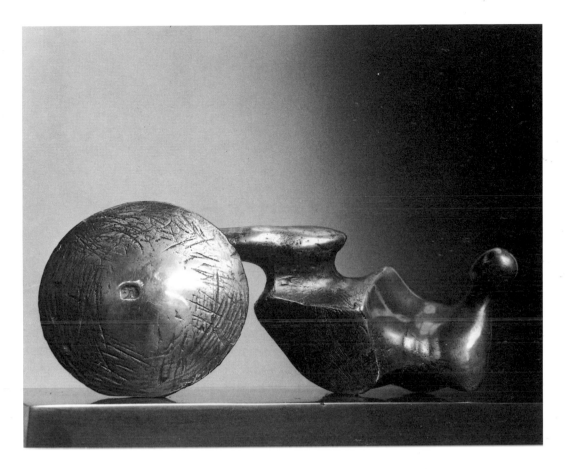

95

Maquette for Goslar Warrior 1973
L 24.5 cm bronze edition of 9
The Henry Moore Foundation
LH 640

We met the Warrior theme in cat. 74, of 1956.
Here it becomes more dramatic and more
complex. The warrior is not falling but seems
to be rebelling against death and failure,
lifting his head and straining against the
shield that now becomes a source of strength
for him. The first large cast of this sculpture
was set up in the German city of Goslar;
hence the title.

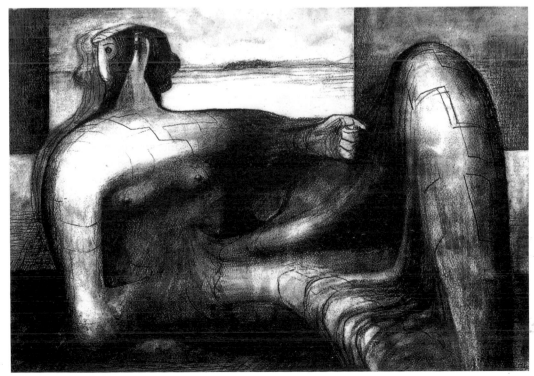

96

Reclining Woman in a Setting 1974
charcoal, pastel and watercolour wash, black
conté, black chinagraph
330 x 483 mm
The Henry Moore Foundation
HMF 73/4(17)

This is one of the strongest figure studies of
Moore's last decades: broad forms, a powerful
but restful pose, a typical play of swellings
against hollows. The grainy marks of the
charcoal are modified by the unifying
watercolour washes, and the figure is set into
a context of building and landscape that adds
to its dramatic expression.

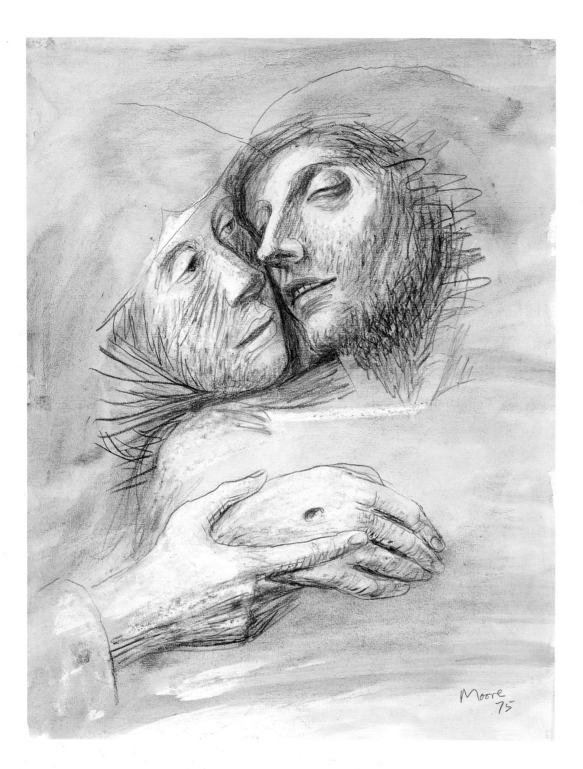

97

Study after Giovanni Bellini's 'Pietà' 1975
pencil, charcoal, wax crayon, watercolour,
gouache
428 x 324 mm
The Henry Moore Foundation
HMF 75(14)

Moore greatly admired the art of Giovanni
Bellini, knowing it first from works in the
National Gallery, London, and then
additionally from his travels to Paris and in
Italy. The Bellini *Pietà* that occasioned this
drawing is in the Brera, Milan. Moore was
undoubtedly moved by the understated pathos
of the image – the subject is a particularly
poignant form of the Mother and Child theme
– but as a sculptor he was especially interested
in the dialogue between the two hands, one
alive, one dead, and of the two heads, almost
touching but with a deep psychological as well
as physical chasm between them.

98
Reclining Figure: Bone 1975
L 157.5 cm Travertine marble
The Henry Moore Foundation
LH 643

This is the most abstract of the Reclining Figures, and only thanks to our familiarity with Moore's previous essays in carving and modelling the theme can we recognise it. In fact, this marble carving is an exceptionally elegant transcription of the theme. The Travertine (see comments on cat. 76) provides much of the surface interest and the sweeping lines of the whole piece provide a strong sense of vigour and motion. There is a modelled figure by Rodin, *Adèle*, that has a similar sweep along the body, an arching back and projecting breasts and belly.

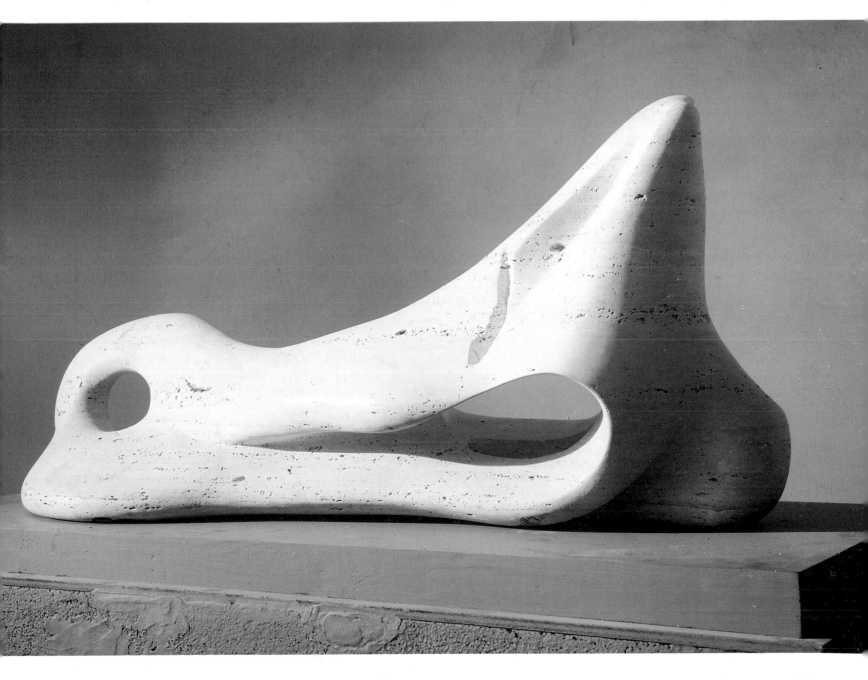

...ng Model for Reclining Mother and Child 1974–75
L 59 cm bronze edition of 9
The Henry Moore Foundation
LH 648

Moore here develops a theme we have so far met only in his drawings, that of the Reclining Mother and Child (see cat. 13; also cat. 58). The swaddled child suggests a very primitive form, scarcely foetal, let alone a baby formed as fully as the mother is. The contrast is disturbing, and relates the meaning of the sculpture to the mother's instinctual love of her progeny.

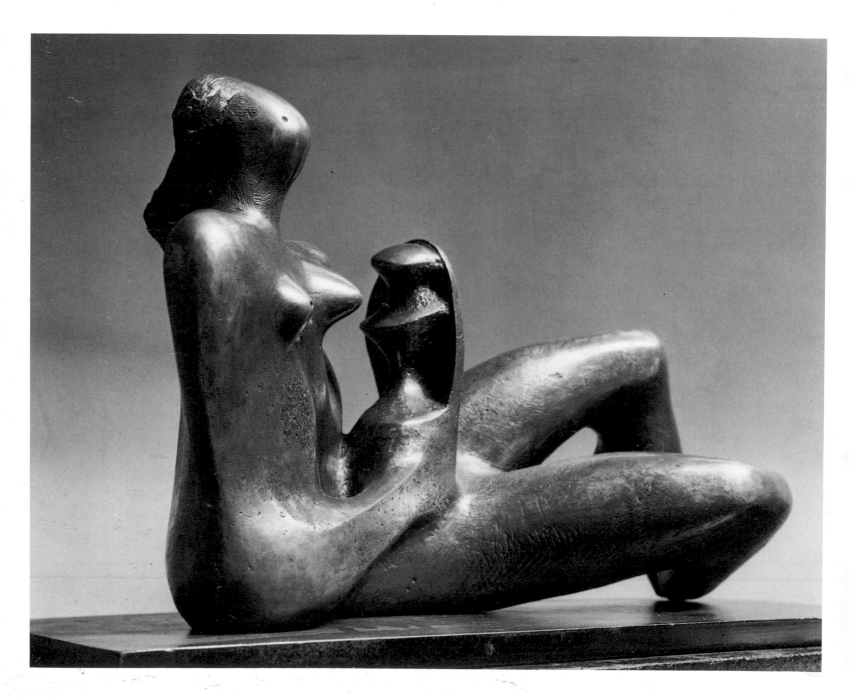

100

Working Model for Three Piece Reclining Figure: Draped 1975
L 112 cm bronze edition of 9
The Henry Moore Foundation
LH 654

Three parts form this Reclining Figure, one of them evidently derived from the thin bones that had been absorbing Moore's attention for some time. The arrangement is exceptional in that the drapery and the leg sections are side by side, lessening the sense of dialogue and sequentiality provided by Moore's usually more linear arrangements in other versions of the subject. The cut-off end of the thin bone also introduces a new note: it signals an inorganic intervention in nature's forming processes.

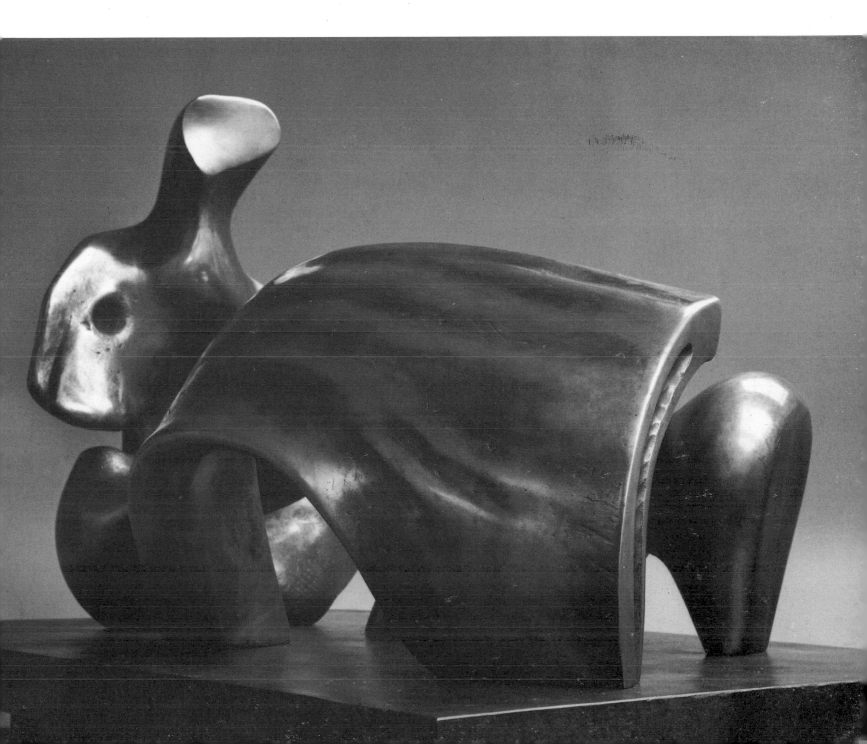

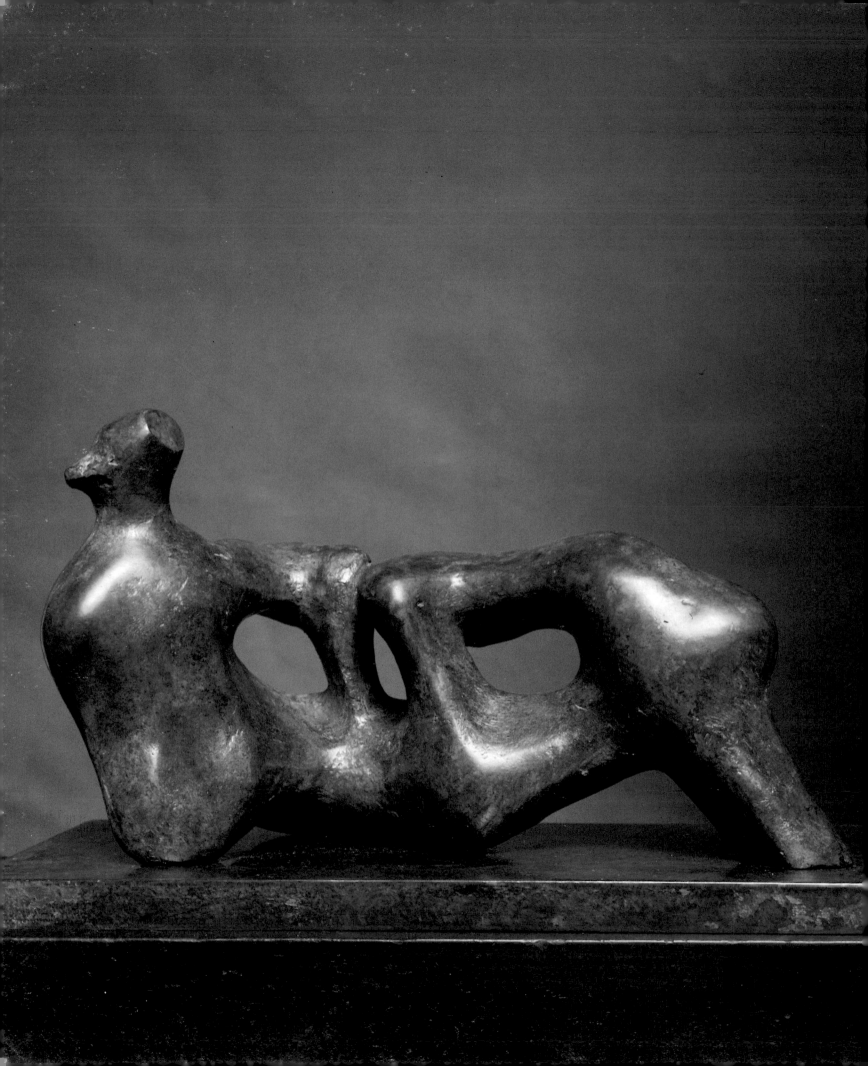

101 (left)
Maquette for Reclining Figure: Holes 1975
L 23.5 cm bronze edition of 9
The Henry Moore Foundation
LH 656

Susan Compton has rightly pointed out that
the forms of this maquette, the basis for a fine
elmwood carving completed in 1978, recall
the play of curving forms Moore used so
fruitfully in the 1930s [Compton 267]. The
figure also hints at the dialogue and
sometimes opposition between the two parts
of a two-piece Reclining Figure.

102
Working Model for Reclining Figure: Prop 1976
L 80 cm bronze edition of 9
The Henry Moore Foundation
LH 677

Here too, although the figure is of one piece,
we sense the action of the two-piece idea, the
alert half contrasting with the inert leg
portion. The total form sharply recalls the pre-
Columbian Mexican figure, the Chacmool,
that gave such an important impetus to
Moore in the 1920s and may be said to have
launched him on the Reclining Woman
sequence – though of course his quick
response to it proves that the interest was
already at work in him.

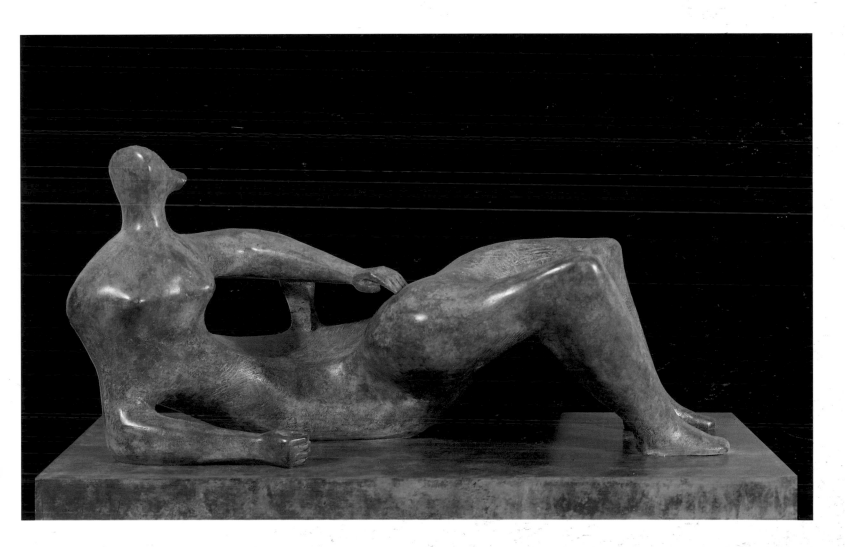

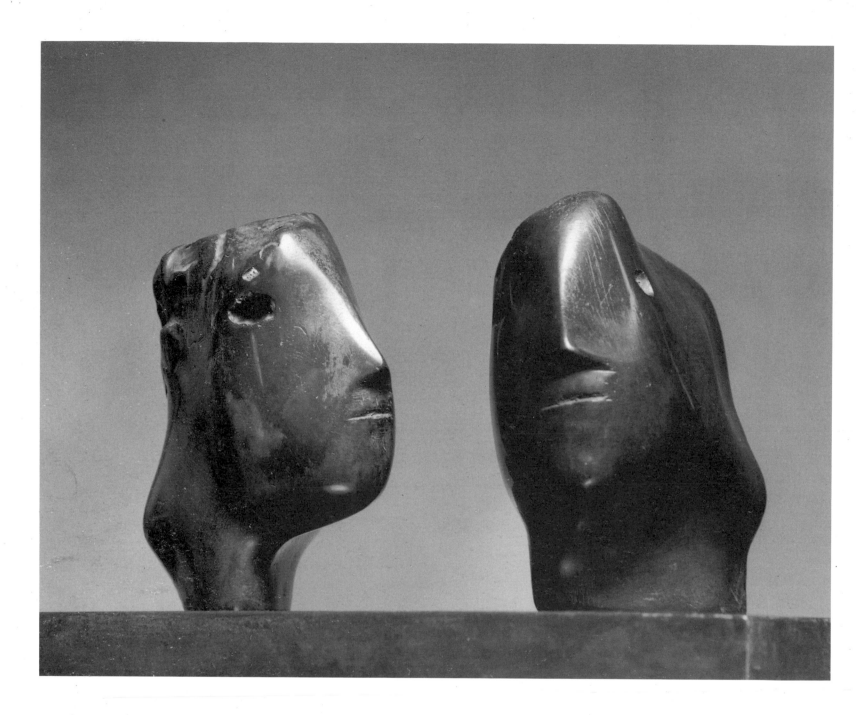

103
Twin Heads 1976
L 16 cm bronze edition of 9
The Henry Moore Foundation
LH 700

These two heads suggest, in their duality, both the separate torsos of cat. 85 and the double head–hand of cat. 91. They are twin heads, the same head twice, and we may wonder at their gender. Moore made many drawings of women in some benign interaction (cat. 63 serves as an instance), but this head offers contradictory clues as we look at it from different angles. He made a larger carving of one such head in the same year, in, exceptionally, black marble; its forms are slightly more rounded than the modelled version.

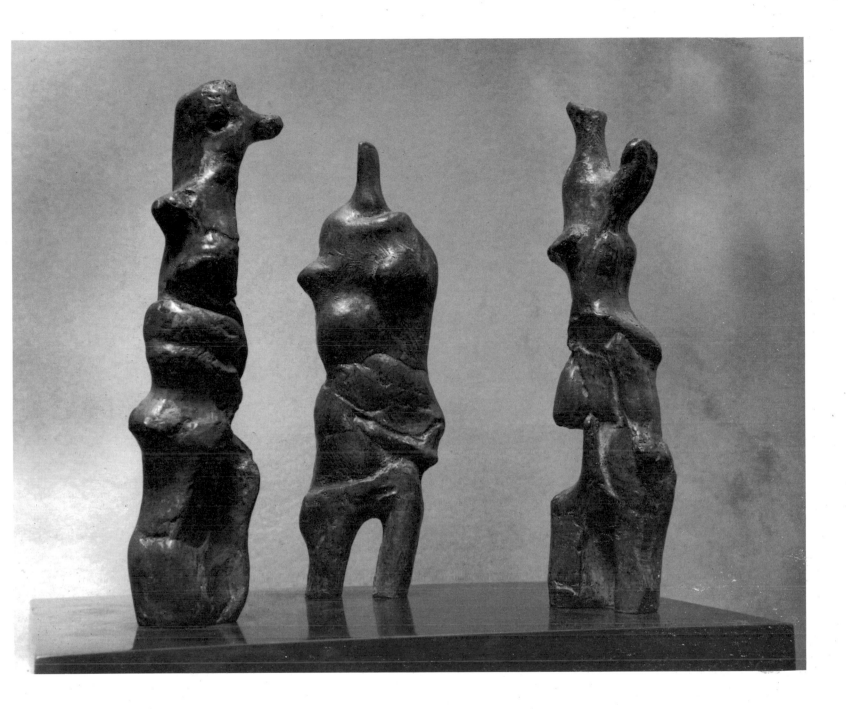

104
Three Upright Motives 1977
H 20 cm bronze edition of 7
The Henry Moore Foundation
LH 715

The art critic John Russell has called the
group of three individual Upright Motives
(LH 377, 379, 386) Moore made in the 1950s
'as arresting an image as has been created in
the twentieth century' [Russell 173]. It held
Moore's interest too; he went on making
Upright Motives as separate sculptures.

Here he returns to the theme of three
Motives standing together. On the stage of the
sculpture's base, the three awesomely
distorted figures, compilations of parts like
some totem poles rather than integrated
images, exercise extraordinary dramatic power.

105

Mother and Child: Arms 1976
L 80 cm bronze edition of 9
The Henry Moore Foundation
LH 698

This lively sculpture relates to the drawings
and sculptures (for example, cat. 58, and the
Rocking Chair sculpture, cat. 64) in which
Moore recorded his pleasure in watching his
wife and child at play. Here too the pose is
extraordinarily energetic.

Three Bathers – After Cézanne 1978
L 30.5 cm bronze edition of 7
The Henry Moore Foundation
LH 741

In 1961 Moore bought a small Cézanne painting of three bathing women under trees, one of the studies associated with Cézanne's attempt to create a modern image of the ancient Golden Age dream. Moore told an interviewer it was 'the only picture I ever wanted to own . . . the joy of my life', but also stressed that it was useful to him: 'the type of woman he portrays is the same kind as I like.

Each of the figures I could turn into a piece of sculpture, very simply. . . Not young girls but the wide, broad, mature woman' [James 190–3]. Seventeen years later, when he was eighty, Moore made a sculpture of the three women set into the space indicated for them by the painter.

It is a remarkable essay in exploration as well as transcription. It omits the landscape and concentrates on the relationship between the figures. Moore had to guess at some parts – for example, the left arm of the woman standing by the lake, not visible in the painting – and it is striking that he played down, or could not find a sculptural form for,

the agitation expressed in the women's gestures and wild hair and in the brushmarks with which they are described. In making his model of the picture, Moore necessarily stabilised the fluent, almost Expressionist image.

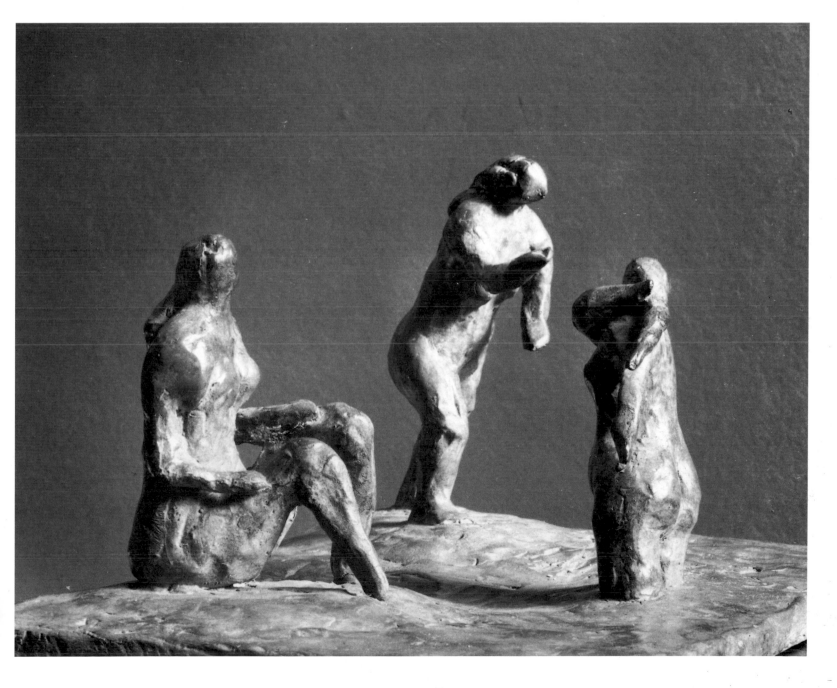

107
**Working Model for Two Piece Reclining
Figure: Cut** 1978–79
L 94.9 cm bronze edition of 9
The Henry Moore Foundation
LH 757

The cut noted in cat. 100 becomes a highly
dramatic feature in this two-piece figure,
where, but for it, an integration between the
upper and lower portions of the body
appeared to have been achieved.

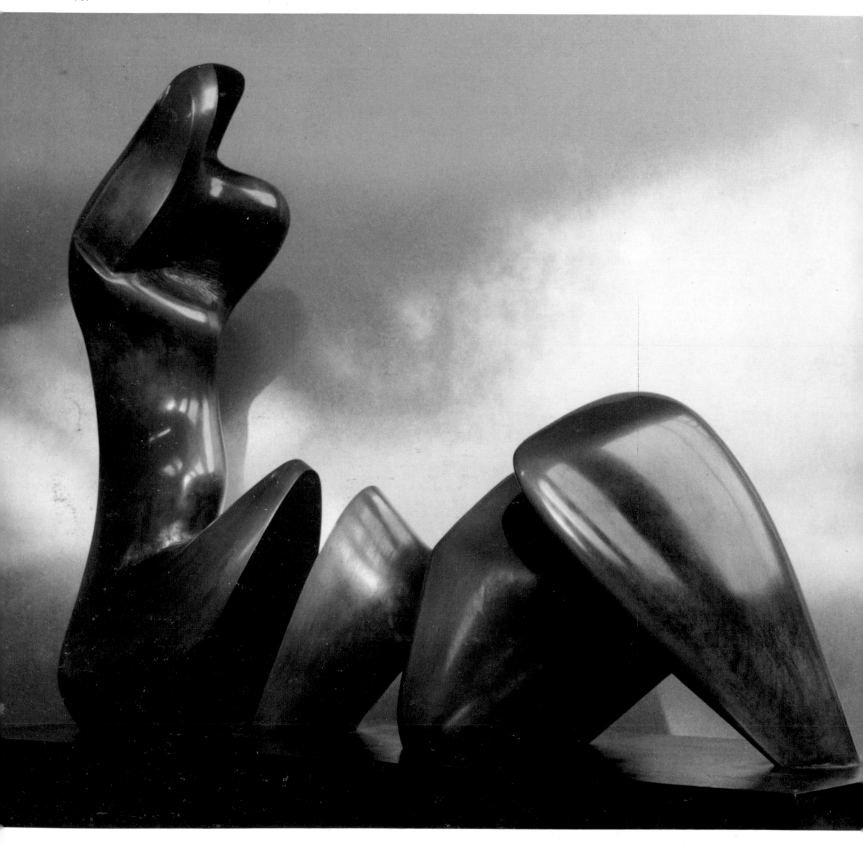

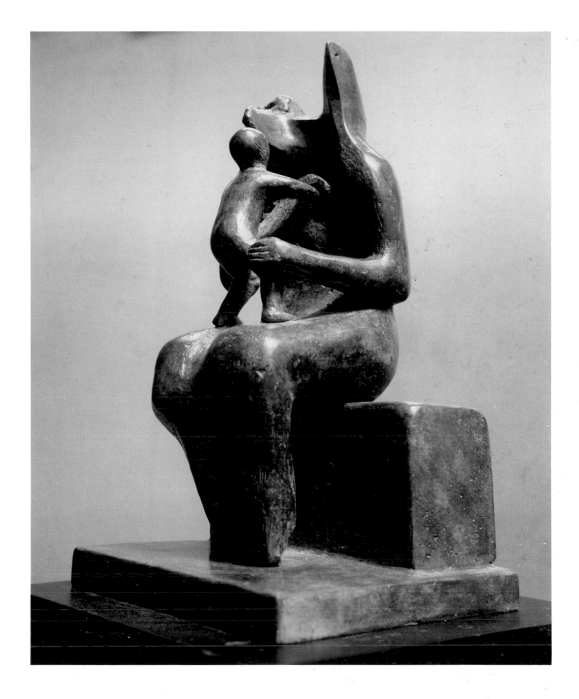

108
Mother and Child: Towel 1979
H 27 cm bronze edition of 9
The Henry Moore Foundation
LH 763

The contrast here between the naturalistically rendered child and the much more abstracted mother to some extent countermands the intimacy of the action portrayed, of a mother drying her child with a towel. We noted a similar contrast within the **King and Queen** figures (cat. 71), but here the contrast is between the two figures and seems to place them in some sort of opposition – between generations, perhaps, or between old and new.

109

Reclining Figure and Ideas for Sculpture
1980
pencil, wax crayon, charcoal, pastel,
watercolour, ballpoint pen
250 x 354 mm
The Henry Moore Foundation
HMF 80(227)

Moore has in several drawings used this
arrangement of showing a main image in the
middle and framing it with a border full of
secondary images. It is a convention known
from nineteenth-century prints, where it was
used mostly to extend the narrative. There is
certainly no narrative connection here
between the Reclining Figure of the centre
area and the diversity of images around it;
most of them relate to actual or imagined
sculptures, but some of them are graphic
motives rather than sculptural ones.

110

Working Model for Reclining Woman: Elbow
1981
L 86.5 cm bronze edition of 9
The Henry Moore Foundation
LH 809

It is striking that in several of his later bronzes Moore sought smoother, shinier surfaces than earlier, when even untextured surfaces were usually kept dark and inert. (See a number of pieces: cats. 91, 92, 100, portions of 105 and, especially, 107). Such shiny surfaces bring a sensation of swiftness. The eye glides over them, quickly assimilating curves and angles, so that the whole piece takes on qualities of motion though the subject or pose may speak only of stillness. The sweep of the legs, in particular, plus the energetic action of the left arm impart movement to this bronze, not unlike that achieved by sweeping lines alone in the Travertine figure, cat. 98.

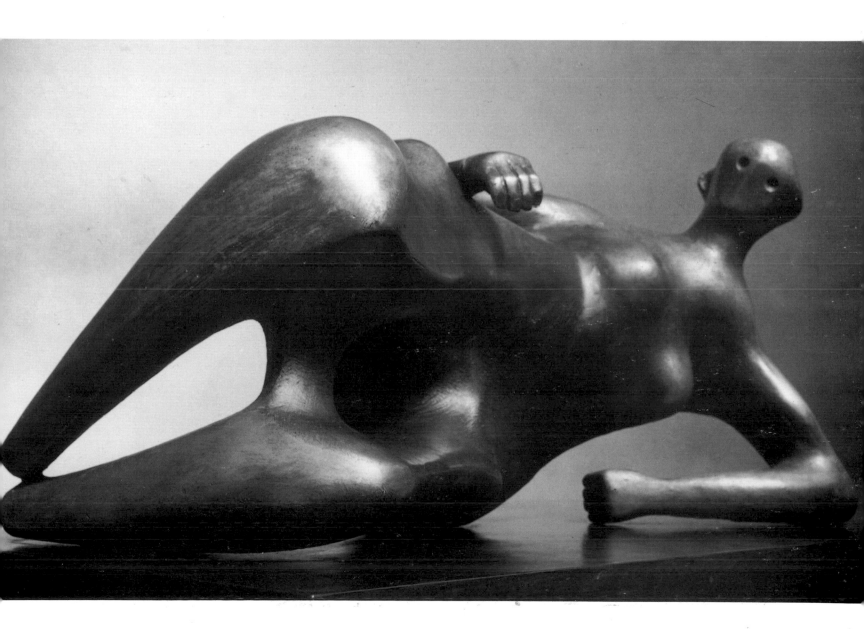

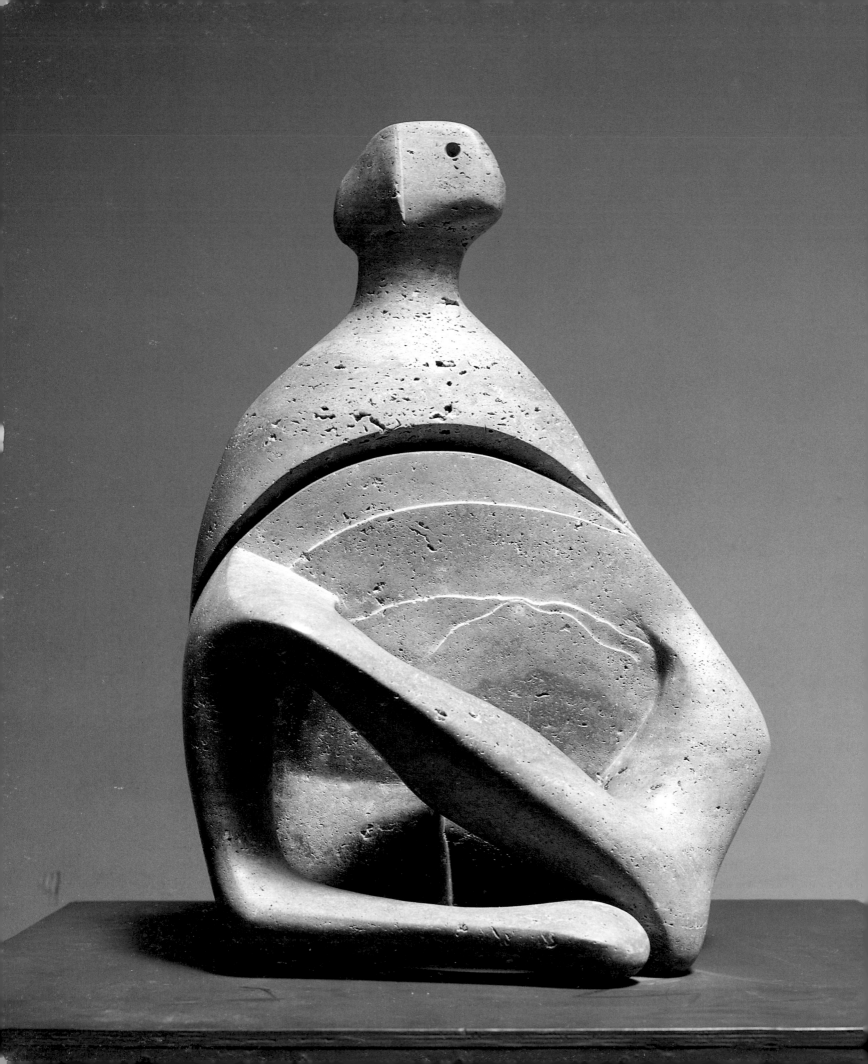

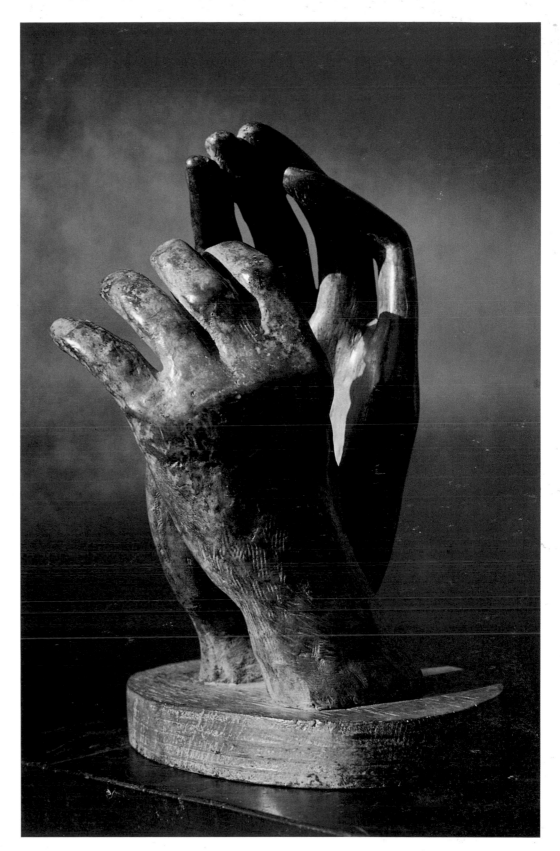

111 (left)

Girl with Crossed Arms 1980
H 72 cm Travertine marble
The Henry Moore Foundation
LH 776

The texture of Travertine marble plays a
particularly prominent part in this sculpture,
whose forms are otherwise relatively simple.
(See comments on cat. 76 and cat. 98 for
other works in Travertine.) The sweep of the
breast is repeated in cuts that suggest natural
stratification rather than the sculptor's
intervention.

112

Mother and Child: Hands 1980
H 19.4 cm bronze edition of 7
The Henry Moore Foundation
LH 785

Many sculptors have drawn and modelled
hands by way of study. Rodin made sculptures
of pairs of hands and associated them with his
god-like creativity.

These hands came out of Moore's work
towards a Mother and Child sculpture. Their
gesture is protective, healing. Their formal
character is naturalistic, but Moore has
avoided attending too literally to detail or to a
skin-like surface.

113
Working Model for Draped Reclining Mother and Baby 1982
L 78.5 cm bronze edition of 9
The Henry Moore Foundation
LH 821

We noted, with regard to cat. 99, that the theme of the Reclining Mother and Child is surprisingly rare in Moore's work. (I believe that when we confront one of his Reclining Figure sculptures, especially the large ones, we ourselves become the child.) Moore became a grandfather in 1977. This Mother and Child sculpture is one of the most comforting of them all: here, more than ever, he gave us 'a big form protecting a little form', his definition of the theme [Hedgecoe 155].

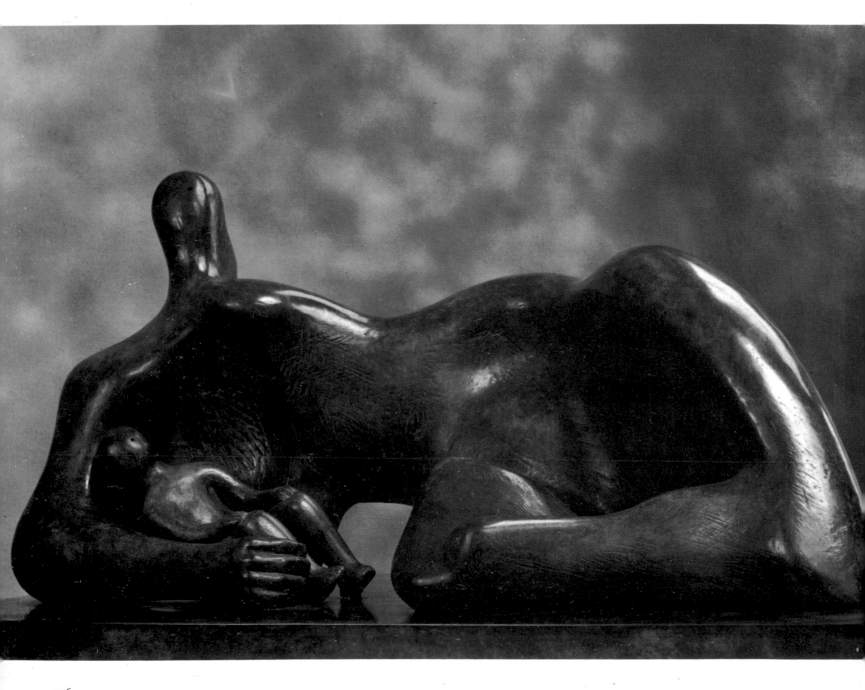

Working Model for Draped Reclining Mother and Baby

114
Working Model for Mother and Child: Hood
1982
H 76 cm bronze edition of 9
The Henry Moore Foundation
LH 850

A large Travertine version of this working
model was carved in 1983 for St Paul's
Cathedral in London after Moore had been
invited to make a sculpture for this important
location. The possibility of another Madonna
and Child had been mooted and the thought
took root. 'I can't get this Madonna and Child
out of my mind. It may be my last work, and I
want to give it the feel of having a religious
connotation' [Berthoud 413]. The result is one
of the most boldly abstracted of Moore's
figurative works.

We saw a similar child in cat. 99, where it
contrasted with the more naturalistic form of
its mother. Here, both figures are far from
naturalistic yet the note of protection is
sounded clearly and is partnered by another
note, the religious one of presenting the child
to the worshipper. The recess in which the
child lies is a mandorla as well as the
mother's womb; its brightness provides a
radiance around the child of a sort often
shown in traditional paintings and spoken of
by the mystics.

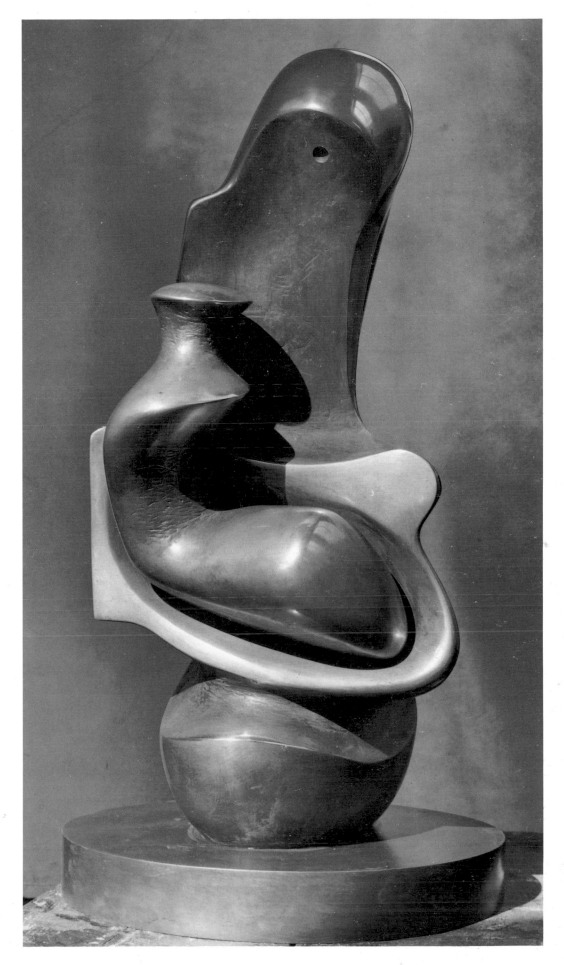

115

Man Drawing Rock Formation 1982
charcoal, black chinagraph, white chalk and pencil over lithographed frottage
321 x 402 mm
The Henry Moore Foundation
HMF 82(437)

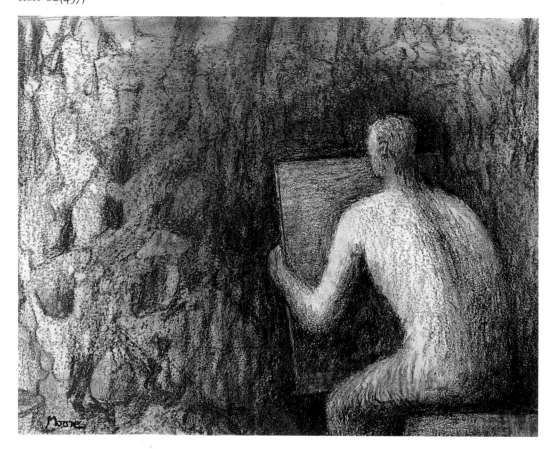

Many meanings resonate from this beautiful image. It is of course a sort of self-portrait and also a portrait of all artists. The solitary figure, recalling a miner (see cat. 51), sits at work before nature at her most inscrutable, most ancient. His need to know and by some means to appropriate what is before him is matched by the knowledge that he can never match it, let alone surpass it. He is temporal, nature survives; with luck his work, at best an approximation incorporating some human significance, will survive for a while. Moore spoke often of Leonardo's point that an old wall could give an imaginative artist a host of ideas for subjects, but there is also something despairing in the thought that, surrounded by history, by our present world and our hopes for the future, we should still need to seek ideas for art. Cézanne is perhaps the most famous artist to have devoted hours of

observation and recording to the stone surfaces and plant-life of a quarry. Moore based his drawing on a rubbing taken from a rough surface – he has used Max Ernst's term 'frottage' for it – and this takes us into the realm of Surrealism and the thought that the darkness before which the artist sits is the unconscious.

116
Three Fates 1983–84
Tapestry woven in 1983–84 at West Dean
College from a drawing executed by Henry
Moore in 1943
243 x 350 cm
The Henry Moore Foundation

TAP 27

Several modern artists have had tapestry versions made of their works. Thirty tapestries have been made after Moore drawings; in no case was the drawing made as the basis for a tapestry. Moore enjoyed helping the weavers cope with the problem of finding tapestry equivalents for the many different sorts of marks and textural effects he used in his drawings: the problem and its solution will have reminded him of all art's need to find effective equivalents rather than attempt an absolute copy. The success of tapestries, in greatly enlarging the original image and in translating it into another medium without loss of character or dignity, speaks of skills backed by infinite care.

The drawings chosen were generally of a benign character. This is particularly so in the case of cat. 117 which shows a young mother and her child and may be a generalised portrayal of the sculptor's daughter Mary and her son, Gus.

Cat. 116, **Three Fates**, sounds a graver note, especially as the central Fate is about to cut the thread of someone's life. Moore was to die two years after this tapestry was finished, but the drawing was done in 1943, during the war. It has a markedly classical character.

The Reclining Figure is complete and at rest in a landscape setting, a relaxed and comforting image.

117 (left)
Mother and Child Holding Apple 1982–83
Tapestry woven in 1982–83 at West Dean
College from a drawing executed by Henry
Moore in 1981
316 x 212 cm
The Henry Moore Foundation
TAP 25

118
Draped Reclining Figure in a Landscape 1986
Tapestry woven in 1986 at West Dean College
from a drawing executed by Henry Moore in
1981
203 x 274 cm
The Henry Moore Foundation
TAP 29

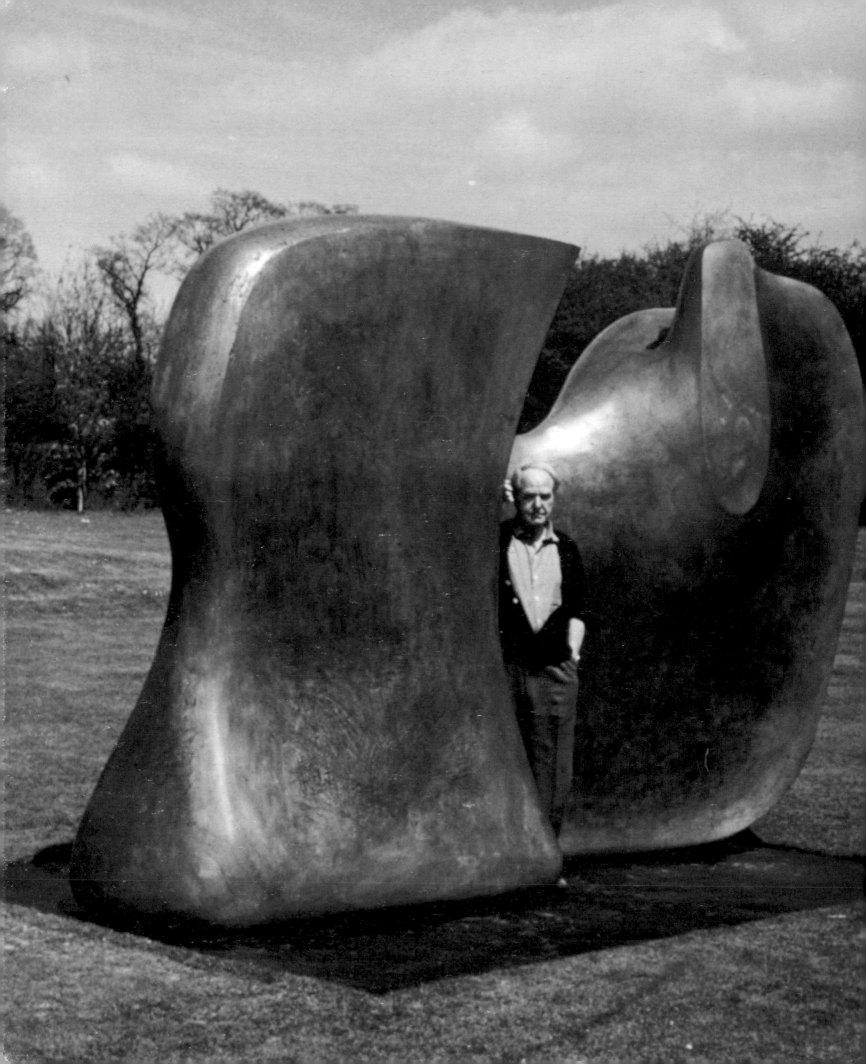

Human Figure and Form in the Sculpture of Henry Moore

by Irina Kokkinaki
State Pushkin Museum of Fine Art, Moscow

The twentieth-century range of images of the human form is dominated either by 'proto-man' (the appeal to archetypes and the collective unconscious as explored by Jung) or by 'super-man' (the will to power, both power of ideas and material power). The superman was an important motif for the Futurists, and has become particularly prominent in the art and sculpture of totalitarian regimes. For virtually any of the currents in contemporary art the human form, with its potential for personifying ideas, represents one of the ways of stating a manifesto. The individual is 'diffused' by art, entering it not through portraiture, but via other avenues. And in this sense, for the sculpture of the twentieth century, any human being represents not a portrait, but rather a human figure. For Henry Moore the 'human figure' is first and foremost the form.

The course of Moore's artistic development was determined by his attraction to the vital, natural principle, to archetypal forms. He wrote: 'The significance of the form undoubtedly depends on innumerable associations in human history. For example, rounded forms express the idea of fertility and ripeness, probably because the Earth, women's breasts and most fruits are round, and these . . . forms are essential, since they constitute the underlying truth of our habits of touch'.

While it retains an internal memory of the discoveries made by Epstein, Brancusi and Lipchitz, the form in Moore's sculpture is visually closest to some aspects of Jean Arp's work. But the creation of the form in the work of Arp and Moore is inspired by different intentions, and they are therefore not considered as part of the same tendency. At the same time, this suggests that their art can be considered as the natural antinomy of a single process in twentieth-century sculpture.

In the work of both artists the form is ambivalent and represents life free of subject. It can be considered on the level of pure abstraction, when the eye rests on an ideal line, an almost dematerialised surface (as in Arp's work), or (as in Moore's) when it inspects irregularities and depressions in the bodies, adapting to their tensed motive energy. The form can also make hidden or overt reference to a certain range of objects. In Arp's work these include the seated woman, forms resembling living organs, such as kidney, breast, bone, etc., the plant and animal world – starfish, stems – and the microscopic world – cells, vacuoles, plasma, molecules. In Moore's work they are rocks, bones, pebbles, roots, tree trunks and the bodies of animals and human beings.

The associative order in Moore's work focuses less on the object than on the energy hidden within it. His sculptures refer our imagination to the three dimensions in which the drama of life is played out, materialised in the form by the forces of attraction/repulsion, gravity/flight, tension/relaxation, calm/movement. All these energies are similarly present in Arp's work, but with an ironic, almost ludic overlay.

Moore spoke of being obsessed by two themes: the Reclining Figure and the Mother and Child. Whereas for Arp drawing, relief and sculpture are more or less independent areas of work, Moore's art is essentially

Left: Henry Moore with **Knife Edge: Two Piece** 1962–65

centripetal, and he defines that centre in the spatial world – as the form in landscape. Landscape gives to the form the anonymity of a boulder, a sea shell, a fragment of bone: the figure can be reconstructed from these or can turn into them. Thus in Moore's art the natural form and the human figure pass into one another and back again. 'A sculpture is like a journey. Going around it, you are always finding something new. The three-dimensional world is full of surprises, whereas the two-dimensional world . . . is lifeless', wrote Moore. The responsibility of placing his form in landscape gives rise to the ontological seriousness with which energy acts in the form, as if 'in life'.

One of the constant motifs in Moore's work is the Internal/External form. The interaction between internal and external forms is a paradigm of the link between the mother's womb and fruit, between fruit and seed, between skeleton and skin, snail and shell, body and armour, butterfly and cocoon. This universal relationship always interested him, as a means of creating plastic structures which would engender an endless series of associations with events in nature linked to birth, growth, existence and dying. In this way his sculptures become participants in everyday life, characters in the collective unconscious – that is, they are invested with the sense of being 'subjects' rather than objects. In the wider sense this is also the relationship between the human 'I' and the 'mask' in the world, the mode of existence in the allotted span, so that the placing of one form inside another may contain the additional sense of confinement. Thus in the **Helmet** (cat. 41), the 'shell' is overcome by its contents which are drawn towards the external, outside the confines of the space bounded by the helmet form. The head of the human-like figure comes up against its armour, attempting to free itself from the frames erected above it.

The external can protect the peace of the internal,

safeguarding its existence in the world, as in the Mother and Child sculptures where the position of the mother's arms forms a refuge for the child. In some of the Two Forms pieces one is about to devour the other, opening its maw and thus becoming external to the swallowed form. The instinctive principle is here developed to the extent where forms seem to be moved by Darwin's law of natural selection. These works have an amusing suggestion of abstract subjectivity.

The figures of warriors are particularly interesting. The prototype for the figures of the Seated and Falling Warriors (see, for example, cat. 74) was a pebble found on the sea shore which suggested to Moore a mangled human body with its legs amputated. The shield, which is pushed out into space and suggests an endless series of external attacks, is a shell cut down to shield size, an unsupported barrier, an imagined shelter symbolising eternal struggle. The penetrating images of the warriors show something akin to existential angst – a principle which is perhaps missing in Arp's work. The eyes and the mouths which gape, as if howling, in Moore's Reclining Figures, are like the natural holes in the pebble, fixing for ever the 'grimace' of the stone. And this mimicking of the stone adds a further element of disquiet: his solitary figures are a metaphor for the longing for eternity.

Because of their monumental nature, when Moore's works are mounted on grass it is as if it were a pure, natural surface, rather than an artificial environment. The place of Arp's form is a more or less artificial and intramural environment – the interior.

Arp looks as it were through the eyepiece of some instrument, observing, in sacramental silence, the flow, glide and roll of particles, the 'eternity of the interior'. He hears no sounds, for this is primarily the world of microscopic particles, the crystallisation of transformations of the world, where life matures secretly and

silently: it is the movement of molecules, the opening of buds. Removed from the context of the infinity of nature, these highly select, almost incubational forms and combinations of forms hatch out on a metaphysical level. They are metaphysical because they are under the microscope, and generally in any artificially framed field of vision, life continues according to its own laws.

The vitality of Arp's forms, living in a sort of elysium, is more imitational: the passage of time rolls out from them. His 'constellations' in particular give a sense of other-worldly intangibility, of an artificial garden cultivated 'on the other side', of an ideal copy with evaporating energy. Arp is attracted to the un-sullied whiteness of plaster and coloured wood, the slippery-smooth surface of bronze. The combination of forms – the 'co-incidence' – creating a fortuitous harmony is fixed for ever by the artist.

'A sculpture should contain something permanent, it continues for ever,' said Moore. And the harmony of his works has a different source. His form has the brutal calm and the majestic slow march of geological move-ments; its sound is the sound of time. His 'human' is a 'fossil' form; it must be read as having existed in nature before history, before culture, before the artist refined it into a masterpeice. (If it is classical, it is with a primor-dial classicism, in the sense that nature is classical.) His **Seated Figure: Armless** (cat. 75) has a primal muteness which can be heard, like a crystal-clear note, 'pure as from birth' (Mandel'shtam). The position of his figures appears unpremeditated; the low pedestals of his reclin-ing figures emphasises their closeness to the earth, their openness to the four winds. It is as if, in their aesthetic perfection, priority is given not to the artist's idea but to the natural principle. The form must carry within itself evidence of its antiquity, the action of 'Time's army' – the winds, water, the earth. These forces leave an imprint on the surface of the form, in roughnesses,

scratches, fissures. Even the polished surface of some of Moore's figures is different from that of Arp's works. Moore likens them to the pebble rounded by the waves, cast up on the shore and remaining there for ever 'until summoned back'. The material of his sculptures displays its natural qualities, its own inherent meaning.

The principle behind the combination of form and world in Moore's sculpture is not so much textural and visual similarity as time, for the form is the pluperfect of space, its past anterior tense. This is eternity, 'recorded' by form deposited on the shore of the earthly world.

In an ontological sense, Moore's classic family groups can be seen as the conclusion of the history of the form, the apogee of its existence. If they do have a nuance of genre, it is counterbalanced by the essential emphasis on the interaction of the figures. The family continues to be placed in the landscape, embodying the primordial union. It is also the occasion for the combi-nation of several large forms – the forms of the personified Father, Mother and Children.

The 'Adamite' **King and Queen** (cat. 71) symbolises the original dominion, with the seated man and woman in their primitive crowns eternally keeping watch over the line of the horizon entrusted to them as their patri-mony, doomed to reign eternally in boundless space.

Moore, the twentieth-century artist, returns to the human form through space and time, which he uses to bridge the abyss created between man and the world by civilisation. In placing the human figure in a neutral landscape which bears no marks of history, he intu-itively answers the fundamental question of the twentieth century – that of 'lost man'. He unites the pinnacle of creation with its base – the world – for with-out foundations the building cannot stand.

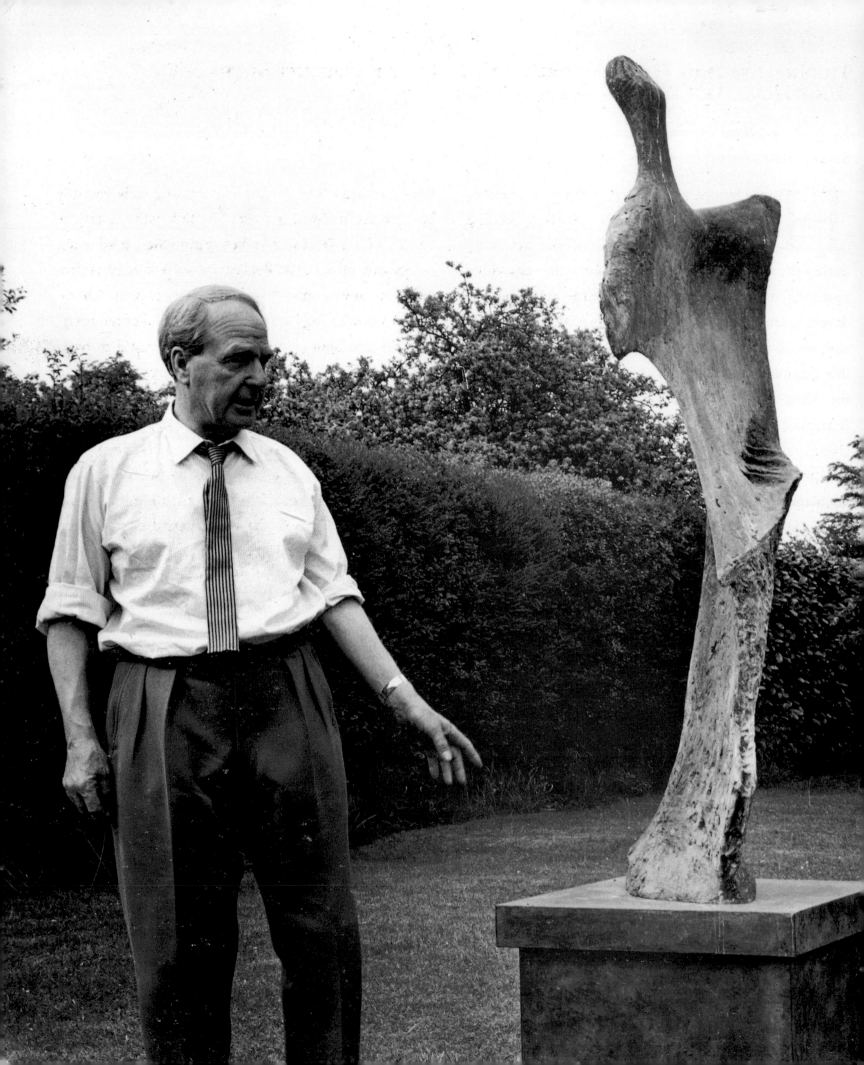

The Influence of Henry Moore's Work on the Emergence of the Soviet 'Unofficial Art' of the 1960s and 1970s

by S. I. Kuskov

STATE PUSHKIN MUSEUM OF FINE ART, MOSCOW

Henry Moore was the first of the great contemporary West European sculptors to become known to the Moscow unofficial art circle during the period known as the 'spring' – the years after 1956. As the revived Soviet avant-garde continued to develop, Moore's work remained especially important, and was an inspiring influence on representatives of this original 'second culture'. Later they came to know the other great sculptors of the West, Zadkine and Brancusi, Giacometti and Archipenko, Lipchitz and Gabo.

For the artists struggling to renew their sculptural language, Moore's work symbolically embodied the whole history of contemporary sculpture after Cubism, post-Cubism and the other geometric trends of the 1910s and 1920s. The geometric line of the avant-garde – Suprematism, Constructivism, etc. – had been developed to the full in the context of the Russian and Soviet avant-garde of the early twentieth century, and indeed the innovations of such artists as Malevich, Tatlin, Lissitzky and others had exerted a noticeable influence on the development of world art. But this was not the case with the tendencies in contemporary art, which had not been taken up and interpreted in the local context by the time the evolution of the avant-garde was forcibly broken off. Subsequently, during the 1930s and after, the Iron Curtain made it impossible for such tendencies either to arise in the Soviet Union or to be noticed by Soviet artists. It was only around 1956 that chinks of light appeared through the curtain, and only recently has it been finally torn down. The link with the artistic culture of the West was broken during the period when the dogma of Socialist Realism seemed to hold unbroken sway. It was only in the atmosphere of liberalisation and hopes of change which marked the end of the 1950s that the dissident creative intelligentsia dared to overthrow this theory. As a result Soviet artists came late to the discovery of both the half-forgotten heritage of the Russian avant-garde and all that had happened in the development of Western art in the middle decades of the century. Striving to make up for what they had missed, they were forced to live, as it were, in several times at once, because the whole period of the emergence of Western modernism, from the late 1920s to the 1960s, was unfolded before them at once, albeit in fragments – for the lack of information still made itself felt.

In this atmosphere the artists assimilated all the experience of the great trends, the defining movements, the recurrent themes and new types of art. The general principles, positions and aims were understood. But their attention was drawn particularly to the brightest personal embodiments of these general spirits of the times – the artists who had already moved beyond the context of movements and groups by virtue of their own independent significance. On the one hand, Moore's art was a manifestation of general tendencies which had not been able to develop in the Soviet Union – the trends in abstract and Surrealist sculpture of the 1930s and the post-war decades; on the other, it was attractive because of the powerful individuality of the solitary

Left: Henry Moore in the garden at Hoglands with **Working Model for Standing Figure: Knife Edge** 1961

147

artist, whose work cannot be directly identified with any one specific artistic movement. The Soviet artists were also particularly drawn to Moore's marked orientation towards Nature, his willingness to learn from it, which was nevertheless so different from the naturalist tradition, the 'realist' models imposed from above by official academic art.

The unofficial artists, known as the 'Shestidesyatniki', or Sixties Group [a reference to the original Shestidesyatniki of the 1860s – a group of public figures and social thinkers in Russia], the 'children of the first spring', made no compromise with official culture, even when it subsequently began to allow for moderate innovation, within limits prescribed from above. The new art was subjected to renewed persecution, particularly after the notorious Manège exhibition of 1962, which was closed after a barrage of ferocious criticism, and the majority of these artists disappeared from the surface of artistic life. They began to work in a cultural underground, an environment which created a specific type of artistic behaviour, a particular style of life and thought.

For this generation, however, the most important issue was not movements, but individuals. They felt acutely the need to express their time through a personal, original vision, to achieve authentic artistic experience, to feel the force of inventiveness at each step of their development. Independence, autonomy, a degree of innovation and internal truth, discernible in the work, were the elements valued above all others. Here, it seems, the classico-modernist idea of the artist as individualist/creator/outsider reached its final, original stage. All of this is typical of the independent Shestidesyatniki, many of whom retain the characteristic features of their generation even now, developing their tradition no longer so much outwards as inwards, and continuing to yield interesting creative results. Moore's work – so independent, so autonomous in

essence, endowed with the monumental force of influence, open to society and yet retaining within it the artist's unspoken secret – was very much in harmony with the aesthetic consciousness of the Shestidesyatniki. They were attracted by this deeply individual art, subjective in attitude and yet emerging on a level of timeless, eternal, universal human themes, combining a contemporary language and a deep affinity with the archetypes of antiquity. This synthesis of the apparently incompatible was important to other artists as well as those who were immediately involved in three-dimensional spatial expression: the circle numbered few of these.

Sculpture in general, and particularly monumental work, was made difficult both by the fact that the new art had been driven into basements and attics, and by the shortage of materials and other difficulties encountered by the unofficial artists. The system of administrative bans, which made it completely impossible for the unofficial artist to realise his ideas in the environment, urban or natural, was a further obstacle. It was perhaps even more difficult to overcome the inertia of academic training in sculpture than it was in painting and drawing: the pressure of the tradition of monumental propaganda made to order – the mania for idealised giants – was too strong. The unofficial artists were not usually self-taught. They bore the burden of the academic school, of art colleges. This injection of semi-official aesthetics required strong antidotes and still stronger creative personalities. Reinterpreting the form of monumental sculpture in a new key, freed from ideology and artistically original, was a task few were up to. This is perhaps why the fairly extensive unofficial artists' network of the Shestidesyatniki included only two internationally known sculptors. These two sculptors of the Moscow avant-garde are very different from one another in almost everything except the tendencies which draw them close, in the Soviet context, to the

tradition of Moore, who was equally valued by both. They are the late V. Sidur and Ernst Neizvestny, who now lives and works outside the USSR, but who developed as a sculptor and as a unique thinker in the late 1950s and early 1960s.

From the very beginning of the 'spring' Neizvestny was drawn into the burgeoning artistic life: he was socially active, and at once became one of the chief representatives of the dissident artists, leading the opposition to the official aesthetics. He rapidly gained authority in the circle of independent artists, standing at the epicentre of this group and forming his own sphere of influence. Neizvestny's role in the events surrounding the 1962 Manège exhibition is well known. At this exhibition the new art was misunderstood and attacked by the government delegation, headed by Khrushchev, which visited it. In a polemic with Khrushchev, Neizvestny boldly defended the right to experiment; his subsequent ambivalent relations with the former head of state ended with a reconciliation, and Neizvestny worked on the memorial on Khrushchev's grave in the Novodevichy cemetery in Moscow. Subsequently, right up until his emigration, Neizvestny exerted a strong influence over an artistic circle which was relatively narrow but nevertheless important in the emergence of the revived avant-garde: he had authority as an artist, a thinker and generally as an individual. This was an environment in which, as far as external circumstances allowed, any information on new foreign art received an enthusiastic response, and was actively assimilated and interpreted in the light of the artists' own considerations. It is therefore not surprising that Moore's work had an influence not only on Neizvestny, but also, less directly, on such painters as Yankilevsky, Sooster, Vechtomov and others. This influence is felt particularly in the penchant for fantastical biomorphic structures, as if they were depicting imaginary sculptures in the ideal landscape of a picture somewhere on the boundary between the abstract and Surrealist tendencies.

The question of the more specific influence of Moore's work on Neizvestny is problematic, as certain contradictions are apparent, and it is very difficult to give a direct answer to the question of whether Neizvestny is an opponent of Moore's tradition or a 'successor', essentially related, although with a very different style. On the other hand, Neizvestny spoke of Moore's work with great respect and interest, and by virtue of his role in the Moscow circle – as both a sculptor and a propagandist for contemporary art – he naturally contributed to Moore's influence on the Moscow group of unofficial artists. Much later, after his emigration, Neizvestny indicated his intention and wish to participate in a joint exhibition with Moore; this did not take place for external reasons, but was of great significance and undoubted value to Neizvestny. In one interview he emphasised the relationship of Moore's sculpture to the primordial landscape, the natural spatial sculpture of caves and rocks. He was excited by the capacity of Moore's sculptures to grow into space, a capacity no less significant than the organic form of the sculptures themselves. Nevertheless, in his early theoretical work *The Synthesis of the Arts* Neizvestny challenged Moore's work: while accepting that it was innovative, he suggested that Moore was a master of classical 'monologuic' sculpture, with which he contrasted his own conception of 'dialogue' – sculpture as an open system, expressly unfixed, as if in a process of conflict, emergence, metamorphosis. In using the term 'monologuic' Neizvestny was obviously referring to the monolithic nature of the plastic mass in Moore's work, together with the predominantly majestic, calm, even static mode which prevails however 'deformed' the figure (for example in the **King and Queen**, cat. 71). Moore's sculpture is concentrated within itself, while

Neizvestny proposes a sort of decentralisation, almost a destruction of the classical integrity. This was the opportunity to clarify his own position in a debate with a great master; for Moore, although he was not shown in Soviet museums, was already a world figure, and a polemic with a genuine authority, a movement away from the rules of the teacher, is a sign of awakening independence.

Nevertheless, the qualities of the sculpture which embody the idea of dialogue for Neizvestny suggest continuity with Moore's tradition rather than conflict. The principal vehicle for the dialogue is dual openness: the openness of a sculptural volume which was once closed to the external space, and an openness of meaning, to subsequent interpretations. The plastic formal openness of the sculpture is carried and communicated by the voids, gaps and breaks in the sculptural mass, everything that is linked to the action of what we might call the 'negative volume', in which the work is dynamised from within by the cavity, depression or hole, appearing charged with a hidden volcanic energy. The break in the surface and the mass is a breach in the static self-closure, the entrance of the sculpture into the external space: at the same time the sculpture in some sense absorbs its surroundings through the cavities and fissures. In the twentieth-century tradition of sculpture this constructive, creative role of negative volume or 'empty space' is perhaps most fully expressed in Moore's work. And in this Neisvestny is his successor.

But there is another kind of openness: openness to understanding and interpretation, when the enigmatic reticence of the image draws the viewer into active dialogue with the work. It is presupposed that there are many possible ways of understanding. In constructing the image/symbol as a prophetic riddle which should perplex and rouse to understanding, using the language of hints, plastic metaphors and other allegories,

Neizvestny reveals his link with the esoteric traditions of former cultures and resurrects the inspirational force of archetypes. Ultimately, his images are to be united, synthesised into a 'Tree of Life': the very plan makes reference to the prototypes of ancient cosmogonies.

The experience of Moore, who was no stranger to myth-making or to recasting the heritage of past civilisations and primitive art, has inspired the artists of the post-Moore period, particularly those who have resolved these problems in the context of sculpture. Here Neizvestny's closeness to Moore's ideas is particularly clear.

Unlike Neizvestny, Sidur developed largely in isolation, although with historical distance his work can certainly be viewed in the context of the Moscow unofficial art of the 1960s and 1970s. None of the retrospectives of this movement (exhibitions, publications, etc.) could have been conceived without reference to his heritage, and not without reason. The very figure of Sidur the outsider, tending towards philosophical generalisations and prophetic utterances in his work, and also to exclusive independence in his quest, was entirely within the spirit of the Shestidesyatniki mentality. Sidur was an artist who developed late, but intensely and with rich results. His mature style can be recognised around the 1960s, although he had long had an inclination towards art and had trained at an industrial art school (the Stroganov school), and had been consistently approaching his most organic forms of expression over almost twenty years, during the 1940s and 1950s. It was only in middle age, in the midst of the 'spring', that his style and vision formed definitively. In terms of his personal life, this was the period following his heart attack in 1962 when, in his own words, Sidur had for the second time 'glimpsed over the edge of life and understood that I might not have had time!' The first time he had found himself on the border between life

and death was when he was wounded at the Front. Miraculously he survived, enduring an agonising operation on his shattered jaw.

The experience of war, which coloured the rest of Sidur's life, and of serious illness, which never left him in his later years, not only made its mark on his work but essentially defined his world of images and his overall scope. His difficult personal life contributed to the heightened drama of his view of life in general, giving many of his works a suggestion of tragic pathos; in contrast to the official art, however, he emphatically rejected all literary overtones and external 'propagandist' effects. His awareness of the fragility of life prompted him to work as if for the last time, concentrating all his forces on the task in hand, thinking of it as a sort of testament. He strove to invest each plastic result with a commanding force of inspiration, an expression of monumental resonance, although since he worked in the cultural underground and was solitary even within the unofficial circle, he remained an artist for the few. The exception to this was the series of plans for monuments to the victims of war and genocide in Germany, which were so important to him. None of these was made in the Soviet Union, although Sidur's work was virtually the only manifestation of the monumental style in Soviet sculpture with any kind of life.

Sidur's language developed from the promptings of an internal need, and was based on powerful intuition and sensitivity to contemporary artistic tendencies. His mature work shows clear analogies with Moore's formal considerations. Sidur admitted that he had come to know Moore's work late. Nevertheless, Moore's was the first name he mentioned in a list of the contemporary sculptors closest to him. Because of the lack of information on Western contemporary art Moore was not among Sidur's teachers, but he proved to be in inner harmony with him: he was recognised as an older pre-

decessor and distant confederate as soon as the information gap had been filled. This happened at the beginning of the 1960s: the recognition of Moore's tradition as his own coincided with the definitive formulation of Sidur's creative method. Before this there was a period of searching by trial and error, when echoes of Moore arose in Sidur's work arbitrarily and intuitively. This stemmed from Sidur's own temperament and from the logic of his process of internal development. Everything was prompted by the need to find the plastic form which would represent his own intrinsic philosophy. The two artists also had in common their choice of guiding cultural codes, and their methods of relating the principles of intellect and will to the unconscious in art, the spontaneity of the artist and his trust in his material. Common features can also be seen at the anthropological level, where they help to preserve the human image and at the same time to overcome the anthropocentric 'monologuic' closedness of the human body in the classical tradition: to create a non-classical model of figurative representation which goes beyond passive imitation of reality, beyond the old aesthetic formed by European humanism of the three previous centuries. Here we can see both Sidur's closeness to the ideas of Neizvestny and the participation of both sculptors in Moore's tradition.

It is no accident that references to pre-classical cultures and to Nature's moulding of form should be among the principal tenets of these sculptors – they are the marks of the common purpose which form the subject of the present paper. Sidur, given his life experiences and his world-view, was not and could not be an artist of the purely plastic, a seeker of formal harmony. In notable contrast to the innovators of the early part of the century, he also rejected the applied, designer principle. Neither 'beauty' nor 'function' were for him the definitive values: his focus was on the existential drama.

Unlike the former Russian avant-garde, who were in many ways Utopian, Sidur was an anti-Utopian artist, at times approaching the misanthropy of 'heroic pessimism'. His basic themes and sources of images were the horrors of war, aggression, violence, cruelty – suffering and purification through catharsis. His personal world and his created myth focus on the sphere of distress and horror. His vision often creates images of the frightening or the repellent; his deformations are not a plastic method creating an aesthetic effect, but a symbolic expression of human vulnerability and mortality. The deformations carry within themselves the stress and tension of suffering flesh, but Sidur never steps over the line into hysterical images or excessive descriptiveness. His language is referential, with a strong abstract element. The collapse of physical existence is conveyed by a method diametrically opposed to naturalism and physiological recording. Similarly, Sidur did not follow the classical European tradition – the line from Callot to Goya to Dix – in his expression of the horrors of war. He is closer to contemporary works in which the theme of anti-war protest is expressed through a complex plastic metaphor: Picasso's *Guernica*, for example, or Zadkine's memorial to Rotterdam, *The Destroyed City*.

Sidur's visual style shows a greater affinity with Moore than with Zadkine, however. The geometric, Cubist line is generally alien to Sidur: he is closer to Moore's organic form. However, this link with Moore is with the creator of the more abstract sculptures rather than with the documentary, representative style of the London Underground drawings. Sidur's themes are close to the content of this series, but in terms of form he has much more in common with Moore the visionary, Moore the poet of form, the sculptor, the myth-maker, the creator of symbols. Despite the genuine spirit of his pacifism and his exposure of himself as an artist, Sidur does not document or moralise – rather he bears witness and warns, through his allegories, using the obscure language of oracles and prophecy to bring the hidden out into the open, the news of the desperate, catastrophic nature of existence, the fate of mortals in the world. The irrational element of fate is perceived as a cosmic law which can be expressed through the words of poetry and the language of sculpture. Even chaos reveals a secret harmonious structure, just as for Heraclitus the eternal enmity between all things lies at the heart of existence. This interpretation is sometimes revived in contemporary culture. For Sidur the 'glimpse of chaos' is a sort of natural philosophy, but his attitude to nature is devoid of all sentimentality. Reality is seen as aggressive, completely arbitrary fate, which, once it is cast into images, can be read as a sort of terrible epic. Hence the duality of the artist's position: ethically he opposes war and death, aesthetically he makes them his basic theme. He exorcises horror through the magic form, turning the forces of destruction into a support for creation and artistry. Negativism at the level of themes and subjects is complemented by the constructive, sculptural role of 'negative volume' which, as with Neizvestny, renders the sculpture open to the external space.

In Sidur's work the element Thanatos and the grim expression of horrifying images are combined with manifestations of the force of Eros, whose half-hidden or overt presence can be felt in a number of the artist's most important works, sometimes sublimated in the sensual biomorphism of abstract forms, sometimes spilling out quite explicitly, on a Dionysian scale, in the series of drawings which are closely linked to Sidur's sculptural fantasy world. In this context his work recalls the significance of sublimated sensuality and the complexes of the unconscious in Moore's forms and imagery. Sidur said: 'I am more and more convinced

that the sources, the roots from which we grow – both I and my older contemporaries, Moore, Lipchitz and others – are the same. I felt myself to be one of the last in a dying line of classicists at the close of our millennium.' These were the common roots, the sources in which antiquity, the ancient past, could be seen alongside the contemporary tradition – and not merely ancient Greece, but perhaps even more the heritage of the great civilisations of the East, of Egypt, of Assyrian–Babylonian culture: the most ancient monumental art. But this turn towards the past is not expressed, in Sidur's work or in that of the other unofficial artists who carried on a dialogue with the world of tradition, in superficial style and direct borrowing.

Paradoxically, the turn to memory, to the images of the 'imaginary museum', coincided with a tendency towards continual renewal of the artistic language, and towards rapid reunification with the international process of contemporary art. These artists focused especially on those tendencies of the European avant-garde which had not yet been claimed and assimilated. In addition to overcoming the oppositions between art and Nature, tradition and innovation, antiquity and modernity, intellect and the unconscious, they were also overcoming the opposition between West and East, building bridges between the Russian and European cultures. There is clear evidence of this in the area we have examined here, the common themes and images in the work of the Soviet Shestidesyatniki and that of Henry Moore.

Chronology

This shortened chronology lists only the major events in Henry Moore's life;
a more detailed version is available from the Henry Moore Foundation.

1898 30 July: Henry Spencer Moore born at Castleford, Yorkshire.

1902–10 Attended elementary school in Castleford.

1910 Won scholarship to Castleford Secondary (later Grammar) School.

1915 Trained as an elementary school teacher by practice in local schools.

1917 Enlisted in the Civil Service Rifles, 15th London Regiment; gassed at the Battle of Cambrai.

1918 Attended army physical training course; promoted to instructor and lance corporal; volunteered for active service but reached France just before Armistice Day.

1920 Sculpture department set up at Leeds with Moore the sole student.

1921 Won scholarship to the Royal College of Art, London, to study sculpture.

1924 Took part in mixed exhibition at the Redfern Gallery, London; awarded Royal College of Art travelling scholarship; accepted seven-year appointment as instructor at the RCA Sculpture School.

1925 Visited Paris, Rome, Florence, Pisa, Siena, Assisi, Padua, Ravenna and Venice.

1928 First one-man exhibition at the Warren Gallery, London.

1929 Married Irina Radetsky; completed relief sculpture on the north wall of the Headquarters of the London Underground.

1930 Exhibited in the British Pavilion at the Venice Biennale.

1931 Resigned from teaching post at the Royal College of Art; first sale abroad, to the Museum für Kunst und Gewerbe, Hamburg; second one-man exhibition at the Leicester Galleries, London.

1932 Became first head of sculpture in new department at Chelsea School of Art.

1933 Chosen to be a member of Unit One.

1934	Visited Altamira, Madrid, Barcelona, Les Eyzies; publication of the first monograph on his work (by Herbert Read).
1936	Served on the Organising Committee and participated in the International Surrealist Exhibition at the New Burlington Galleries, London.
1938	Took part in the International Exhibition of Abstract Art at the Stedelijk Museum, Amsterdam.
1940	Began shelter drawings in London Underground; moved from London to Perry Green, Hertfordshire.
1941	Appointed an Official War Artist; appointed a Trustee of the Tate Gallery (1941–56); first retrospective exhibition at Temple Newsam House, Leeds, with Graham Sutherland and John Piper.
1942	Appointed to the Art Panel of the Council for the Encouragement of Music and Art (later the Arts Council of Great Britain).
1943	First one-man exhibition abroad, at Buchholz Gallery, New York.
1945	Created Honorary Doctor of Literature, University of Leeds.
1946	Birth of his only child, Mary; first visit to New York for travelling retrospective which opened at the Museum of Modern Art.
1947	Travelling exhibition opened at the Art Gallery of New South Wales, Sydney.
1948	Appointed member of the Royal Fine Arts Commission (1948–71); visited Venice for one-man exhibition in the British Pavilion at the XXIV Biennale, where he won the International Prize for Sculpture.
1949	Exhibition at Palais des Beaux-Arts, Brussels, which travelled 1949–1951 to Paris, Amsterdam, Hamburg, Düsseldorf, Bern and Athens.
1951	First retrospective at the Tate Gallery; **Reclining Figure: Festival** exhibited at the Festival of Britain; toured Greece on the occasion of his exhibition in Athens.
1953	Awarded International Sculpture Prize at the 2nd São Paulo Bienal; visited Brazil and Mexico.
1954	Commissioned to design a relief in brick for the new Bouwcentrum, Rotterdam.

1955	Appointed Member of the Order of the Companions of Honour; appointed Trustee of the National Gallery, London (1955–74).
1957	Awarded prize at the Carnegie International, Pittsburg; awarded the Stefan Lochner Medal by the City of Cologne.
1958	Installation of **Reclining Figure** outside the Unesco Headquarters in Paris; appointed Chairman of the Auschwitz Memorial Committee.
1959	Awarded Foreign Minister's prize, 5th Biennale, Tokyo; travelling exhibition opened at the Zachenta Gallery, Warsaw.
1961	Exhibition at the Scottish National Gallery of Modern Art, Edinburgh.
1963	Invested with the insignia of a Member of the Order of Merit (Civil Division); awarded the Antonio Feltrinelli Prize for sculpture by the Accademia Nazionale dei Lincei, Rome.
1964	Appointed member of the Arts Council of Great Britain.
1965	Visited New York for installation of **Reclining Figure** at the Lincoln Center.
1966	Visited Canada for presentation ceremony of **Three Way Piece No. 2: The Archer** in Nathan Phillips Square, Toronto; elected Fellow of the British Academy.
1967	Visited America for unveiling of **Nuclear Energy** on the University of Chicago campus; created Honorary Doctor, Royal College of Art, London.
1968	Awarded the Order of Merit by the Federal Republic of Germany; Einstein Prize by the Yeshiva University, New York; retrospective at the Tate Gallery, London, to mark his seventieth birthday; exhibition at the Rijksmuseum Kröller-Müller, Otterlo, where he received the Erasmus Prize.
1971	Elected Honorary Fellow of the Royal Institute of British Architects.
1972	Visited Italy for the opening by HRH The Princess Margaret of retrospective exhibition at Forte di Belvedere, Florence; awarded Premio Internazionale 'Le Muse', Florence.
1973	Awarded Premio Umberto Biancamano, Milan; created Commandeur de l'Ordre des Arts et des Lettres, Paris.
1974	Visited Canada for the installation and opening of the Henry Moore Sculpture Centre at the Art Gallery of Ontario, Toronto.

1975 Exhibition at the Tate Gallery on occasion of gift of graphics by the artist.

1976 Exhibition of war drawings at the Imperial War Museum, London.

1977 Inauguration of the Henry Moore Foundation at Much Hadham; exhibition at the Orangerie des Tuileries, Paris; exhibition at Art Gallery of Ontario, Toronto, which travelled to four venues in Japan and then to the Tate Gallery, London, in 1978.

1978 Gift of thirty-six sculptures to the Tate Gallery; eightieth birthday exhibitions at the Tate Gallery, the Serpentine Gallery, London, and Bradford.

1980 Awarded the Grand Cross of the Order of Merit of the Federal Republic of Germany; **The Arch** given to the Department of the Environment for permanent position in Kensington Gardens, London.

1981 Elected Full Member of Académie Européenne des Sciences, des Arts et des Lettres, Paris; travelling exhibition opened in Madrid.

1982 The Henry Moore Sculpture Gallery and Centre for the Study of Sculpture opened by HM The Queen as an extension to Leeds City Art Gallery.

1983 Awarded Mexican Order of Aguila Azteca; exhibition at the Metropolitan Museum of Art, New York.

1984 Created Commandeur de l'Ordre National de la Légion d'Honneur when President Mitterand visited Much Hadham.

1985 Awarded Bulgarian Order of St Cyril and St Methodius (First Degree).

1986 31 August: died at Perry Green, Hertfordshire; 18 November: Service of Thanksgiving for the Life and Work of Henry Moore in Westminster Abbey, London.

Selected Bibliography

Catalogues Raisonnés

Henry Moore: Complete Sculpture. Volume 1, 1921–48 (Sculpture and Drawings), edited by Herbert Read, 1944; revised edition 1957, edited by David Sylvester. Volume 2, 1949–54, edited by David Sylvester, 1955. Volume 3, 1955–64, edited by Alan Bowness, 1965. Volume 4, 1964–73, edited by Alan Bowness, 1977. Volume 5, 1974–80, edited by Alan Bowness, 1983. Volume 6, 1981–86, edited by Alan Bowness, 1988. Lund Humphries / Zwemmer, London.

Henry Moore: Catalogue of Graphic Work. (Volume I), 1931–72, edited by Gerald Cramer, Alistair Grant and David Mitchinson, 1973. Volume II, 1973–75, edited by Gerald Cramer, Alistair Grant and David Mitchinson, 1976. Volume III, 1976–79, edited by Patrick Cramer, Alistair Grant and David Mitchinson, 1980. Volume IV, 1980–84, edited by Patrick Cramer, Alistair Grant and David Mitchinson, 1988. Cramer, Geneva.

Selected Publications

Argan, Giulio Carlo: Henry Moore. First published by Fabbri, Milan, 1971, Abrams, New York 1973; Praeger, New York 1974.

As the Eye Moves ... A Sculpture by Henry Moore, photographs by David Finn, words by Donald Hall. Abrams, New York 1970.

Berthoud, Roger: The Life of Henry Moore. Faber, London; E. P. Dutton, New York 1987.

Clark, Kenneth: Henry Moore Drawings. Thames and Hudson, London; Harper and Row, New York 1974.

The Drawings of Henry Moore, edited by Alan G. Wilkinson. Garland, New York 1984.

Fezzi, Elda: Henry Moore. Hamlyn, London 1971; Crown Publishers, New York 1972.

Finn, David: Henry Moore: Sculpture and Environment. Abrams, New York 1976; Thames and Hudson, London 1977.

Garrould, Ann, and Valerie Power: Henry Moore: Tapestries. Diptych, London 1988.

Grigson, Geoffrey: Henry Moore. Penguin Books, Harmondsworth 1943.

Grohmann, Will: The Art of Henry Moore. First published by Rembrandt Verlag, Berlin 1960; Thames and Hudson, London; Abrams, New York 1960.

Hall, Donald: Henry Moore: The Life and Work of a Great Sculptor. Gollancz, London; Harper and Row, New York 1960.

Henry Moore, edited with photographs by John Hedgecoe, words by Henry Moore. Nelson, London; Simon and Schuster, New York 1968.

Henry Moore at the British Museum, introduction and commentary by Henry Moore, photographs by David Finn. British Museum Publications, London 1981: Abrams, New York 1982.

Henry Moore: Drawings, edited by Ann Garrould. Thames and Hudson, London; Rizzoli, New York 1988.

Henry Moore: Energy in Space, photographs by John Hedgecoe. Bruckmann, Munich; New York Graphic Society, Boston 1974.

Henry Moore: Heads, Figures and Ideas, comment by Geoffrey Grigson. Rainbird, London; New York Graphic Society, Boston 1958.

Henry Moore Maquettes, text by Erich Steingräber. Pantheon Edition, Studio Bruckmann, Munich 1978.

Henry Moore: Mother and Child Etchings, introduction by Gail Gelburd. Raymond Spencer Company, Much Hadham 1988

Henry Moore: My Ideas, Inspiration and Life as an Artist, photographs by John Hedgecoe. Ebury Press, London; Chronicle Books, San Francisco 1986.

Henry Moore on Sculpture, edited by Philip James. Macdonald, London 1966; Viking, New York 1967, revised 1971.

Henry Moore: Sculpture, edited by David Mitchinson, introduction by Franco Russoli. Polígrafa, Barcelona; Macmillan, London; Rizzoli, New York 1981.

Henry Moore: Unpublished Drawings, edited by David Mitchinson. Fratelli Pozzo, Turin; Abrams, New York 1971.

Henry Moore: Wood Sculptures, photographs by Gemma Levine. Sidgwick and Jackson, London; Universe Books, New York 1983.

Henry Moore's Sheep Sketchbook. Thames and Hudson, London and New York 1980.

Hodin, J. P., Henry Moore. First published by De Lange, Amsterdam 1956; Zwemmer, London 1958.

Homage to Henry Moore, special issue of the XXe siècle review, edited by G. di San Lazzaro. XXe Siècle, Paris; Zwemmer, London; Tudor, New York 1972.

Jianou, Ionel: Henry Moore. Arted, Paris; Tudor, New York 1968.

Large Two Forms: A Sculpture by Henry Moore, preface by Kenneth Clark, introduction by William T. Ylisaker, photographs by David Finn. Abbeville Press, New York 1981.

Melville, Robert: Henry Moore: Sculpture and Drawings 1921–1969. Thames and Hudson, London; Abrams, New York 1970.

The Moore Collection in the Art Gallery of Ontario, text by Alan G. Wilkinson. Art Gallery of Ontario, Toronto 1979; revised edition entitled Henry Moore Remembered, Art Gallery of Ontario / Key Porter, Toronto 1987.

Museum Without Walls: Henry Moore in New York City from the Ablah Collection, introduction by J. Carter Brown, photographs by David Finn and Amy Binder. Book of the Month Club, New York 1985.

Neumann, Erich: The Archetypal World of Henry Moore. Routledge, London; Pantheon Books, New York 1959; Harper and Row, New York 1965; Princeton University Press, Princeton, New Jersey 1985.

Packer, William: Henry Moore: An Illustrated Biography, with photographs by Gemma Levine. Weidenfeld and Nicolson, London; Grove Press, New York 1985.

Read, Herbert: Henry Moore, Sculptor: An Appreciation. Zwemmer, London 1934.

Read, Herbert: Henry Moore: A Study of His Life and Work. Thames and Hudson, London 1965; Praeger, New York 1966.

Read, Herbert: Henry Moore: Mother and Child. Unesco / Collins, London; New American Library, New York 1966.

Read, John: Henry Moore: Portrait of an Artist. Whizzard Press / André Deutsch, London; Hacker, New York 1979.

Russell, John: *Henry Moore*. Allen Lane, London; Putnam, New York 1968; revised edition, Penguin Books, Harmondsworth 1973.

Spender, Stephen: *Henry Moore: Sculptures and Landscape*, introduction by Henry Moore, photographs by Geoffrey Shakerley. First published in Norway by J. M. Stenersens, Oslo 1978; Studio Vista, London; Clarkson Potter, New York 1978.

Strachan, Walter: *Henry Moore: Animals*. Aurum Press / Bernard Jacobson, London 1983.

With Henry Moore: The Artist at Work, photographs by Gemma Levine. Sidgwick and Jackson, London; Times Books, New York 1978.

MAJOR EXHIBITION CATALOGUES

Henry Moore, text by James Johnson Sweeney. Museum of Modern Art / Simon and Schuster, New York 1947.

Sculpture and Drawings by Henry Moore, text by David Sylvester. Arts Council of Great Britain, London 1951.

Henry Moore: Sculpture 1950–1960, text by Bryan Robertson. Whitechapel Art Gallery, London 1960.

Henry Moore: Stone and Wood Carvings. Marlborough Fine Art, London 1961.

Henry Moore, text by David Sylvester. Arts Council of Great Britain, London; Praeger, New York 1968.

Henry Moore. Rijksmuseum Kröller-Müller, Otterlo / Museum Boymans-Van Beuningen, Rotterdam 1968.

Henry Moore Exhibition in Japan, 1969 text by David Thompson. Mainichi Newspapers, Tokyo 1969.

Henry Moore: Drawings, Watercolours, Gouaches, text by Alan G. Wilkinson. Galerie Beyeler, Basel 1970.

Henry Moore: Carvings 1961–1970, Bronzes 1961-1970, M. Knoedler, New York / Marlborough Gallery, New York 1970.

Elephant Skull: Original Etchings by Henry Moore. Galerie Cramer, Geneva 1970.

Moore e Firenze, edited by Giovanni Carandente. Il Bisonte, Florence 1972, revised 1979.

Henry Moore in America, text by Henry J. Seldis. Los Angeles County Museum of Art, Los Angeles / Praeger, New York; Phaidon, London 1973.

Auden Poems / Moore Lithographs. British Museum, London 1974.

Henry Moore by Henry Moore Exhibition, text by John Russell. Mainichi Newspapers, Tokyo 1974.

Henry Moore: Skulptur, Teckning, Grafik 1923–1975, text by Anne Seymour. Henie-Onstad Kunstsenter, Høvikodden Stockholm / Kulturhuset, Nordjyllands Kunstmuseum, Ålborg 1975.

Henry Moore: Graphics in the Making, text by Pat Gilmour. Tate Gallery / Idea Books, London 1975.

ExpoHenry Moore, edited by Georg Müller. Zürcher Forum, Zurich 1976.

The Drawings of Henry Moore, text by Alan G. Wilkinson. Art Gallery of Ontario, Toronto 1977; Tate Gallery, London 1978.

Henry Moore: Sculptures et Dessins, introduction by Dominique Bozo. Editions des musées nationaux, Paris 1977.

Henry Moore: 80th Birthday Exhibition. Bradford Art Galleries and Museums, Bradford 1978.

Henry Moore at the Serpentine, text by David Sylvester. Arts Council of Great Britain, London 1978.

The Henry Moore Gift, introduction by John Russell. Tate Gallery, London 1978.

Henry Moore: Drawings 1969–79. Wildenstein, New York / Raymond Spencer Company, Much Hadham 1979.

Henry Moore: Maquetten, Bronzen, Handzeichnungen, text by Gerhard Bott. Eduard Roether Verlag, Darmstadt 1979.

Tapestry: Henry Moore & West Dean. Victoria and Albert Museum, London 1980.

Henry Moore: Sculture, Disegni, Opere Grafiche, text by Andrea B. Del Guercio. Galleria Comunale d'Arte Moderna, Forte dei Marmi 1982.

Henry Moore. Samsung Foundation of Art and Culture, Seoul 1982.

Henry Moore: Head-Helmet. Durham Light Infantry Museum and Arts Centre, Durham 1982.

Henry Moore: Early Carvings 1920–1940, texts by Ann Garrould, Terry Friedman and David Mitchinson. City Art Galleries, Leeds 1982.

Henry Moore en Mexico: Escultura, Dibujo, Grafica de 1921 a 1987. Instituto Nacional de Bellas Artes-Cultura, Mexico City 1982.

Henry Moore, text by José María Salvador. Museo de Arte Contemporàneo, Caracas 1983.

Henry Moore: 60 Years of His Art, text by William S. Lieberman. Metropolitan Museum of Art, New York; Thames and Hudson, London 1983.

Henry Moore: Skulpturen, Zeichnungen, Grafiken. Habarta Kunsthandel & Verlag, Vienna 1983.

Henry Moore: Shelter and Coal Mining Drawings, text by Julian Andrews. Ministerium fur Kultur der Deutschen Demokratischen Republik, Berlin 1984.

Henry Moore: Mutter und Kind. Skulpturenmuseum Glaskasten, Marl 1984.

Henry Moore: The Reclining Figure, texts by Steven W. Rosen, David Mitchinson and Ann Garrould. Museum of Art, Columbus, Ohio 1984.

The Art of Henry Moore, text by David Mitchinson. Hong Kong Urban Council 1986.

The Art of Henry Moore, texts by David Mitchinson and William Packer. Metropolitan Art Museum, Tokyo; Art Museum, Fukuoka 1986.

Henry Moore: New Delhi 1987, edited by Ann Elliott and David Mitchinson, text by Norbert Lynton. National Gallery of Modern Art, New Delhi; British Council, London 1987.

Mother and Child: The Art of Henry Moore, edited by Gail Gelburd. Hofstra Museum and University, Hempstead, New York 1987.

Henry Moore, edited by Susan Compton. Royal Academy of Arts / Weidenfeld and Nicolson, London; Scribner's, New York 1988.

Henry Moore, edited by David Mitchinson. Fondation Pierre Gianadda, Martigny; Electa, Milan 1989.

ACKNOWLEDGEMENTS

The exhibition *Henry Moore: The Human Dimension* was selected by Ann Elliott, Exhibition Officer of the Visual Arts Department of the British Council, London, and David Mitchinson, Curator of the Henry Moore Foundation, Much Hadham, in consultation with Dr Irina Danilova, the Deputy Director of the State Pushkin Museum of Fine Art, Moscow.

The organisers would like to thank the curators and staff at the Benois Museum, Petrodvorets, and the State Pushkin Museum of Fine Art, Moscow, and the following individuals who helped in the realisation of the exhibition and the catalogue:

Gene Alcantara

Jean Askwith

Philip Blackman

Alan Bowness

Alla Butrova

Angela Dyer

John Farnham

Elena Gagarina

Mikhail Gurevich

Joanna Gutteridge

Tim Harvey

Craig Henderson

Irina Kokkinaki

Vladimir Kudryavtsev

Sergei Kuskov

Norbert Lynton

Michel Muller

Andrei Nakov

Jovan Nicholson

Inna Orn

Richard Riley

Terry Sandell

Don Schooling

Lena Skorokhodova

Penny Steer

Julie Summers

John Taylor

Nina Vernova

Malcolm Woodward

Packing and transport: Momart Ltd

Pedestals and showcases: Oxford Exhibition Services

Most of the exhibits have been borrowed from the Henry Moore Foundation, with some important loans from the following collections:

Arts Council of Great Britain, London

Birmingham Museum and Art Gallery

British Council, London

Hirshhorn Museum and Sculpture Garden, Washington DC

Imperial War Museum, London

Leeds City Art Gallery

Manchester City Art Gallery

Tate Gallery, London

Wakefield Art Gallery

Whitworth Art Gallery, University of Manchester and a private collection in New York

BENOIS MUSEUM, PETRODVORETS
17 June – 15 August 1991

PUSHKIN MUSEUM OF FINE ART, MOSCOW
3 September – 9 October 1991